BRITISH ROMANTIC
PAINTING

BRITISH ROMANTIC PAINTING

RAYMOND LISTER

The right of the
University of Cambridge
to print and sell
all manner of books
was granted by
Henry VIII in 1534.
The University has printed
and published continuously
since 1584.

CAMBRIDGE UNIVERSITY PRESS
Cambridge
New York Port Chester
Melbourne Sydney

Publisher's Note

The idea for this book originated in discussions with the Pevensey Press, Cambridge. The Pevensey Press has been responsible for the commissioning and editing of the text and for the entire production process.

Published by the Press Syndicate of the University of Cambridge
The Pitt Building, Trumpington Street, Cambridge CB2 1RP
32 East 57th Street, New York, NY 10022, USA
10 Stamford Road, Oakleigh, Melbourne 3166, Australia

© Raymond Lister and the Pevensey Press 1989

First published 1989

Edited and produced by The Pevensey Press, Cambridge

Design and production in association with Book Production Consultants, Cambridge

Typesetting by Cambridge Photosetting Services, Cambridge
Printed by Kyodo-Shing Loong Ltd, Singapore

Library of Congress Cataloging in Publication Data applied for

British Library Cataloguing in Publication Data

Lister, Raymond, 1919–
British romantic painting
1. British paintings, ca. 1700 – ca. 1850 – Critical studies
I. Title
759.2

ISBN 0 521 35604 0 hard covers
ISBN 0 521 35687 3 paperback

Contents

Note on the text

The sign † in front of an artist's name indicates that work by that artist is reproduced elsewhere in the book.

Introduction

The paintings and drawings reproduced in this book were all created during the Romantic era, a period difficult to define exactly. There have been active Romantic elements during every period of human history, but what may be termed the Romantic spirit had a dominant influence on every nuance of western thought and art during the hundred-odd years *c.* 1750–1860. When the Romantic era is mentioned in this book, it is this period that is signified.

There are many areas and manifestations of Romantic painting, some apparently in opposition to one another, and it is the purpose of this introduction to guide the reader through some of the more important of them, and to explain the characteristics which have earned them the label 'Romantic'. But one thing above all characterises Romantic art: it is concerned with the particular, for example with the individuality of a sitter in a portrait, with the singularity of an insect's wing-cases or the colouring of a bird, with the unique qualities of a view and the variations wrought by light, mist or storm, and not least with particular manifestations of human diversity and irregularity.

Initially the connotation of the word 'Romantic' tended to be ironic, and it was generally applied to what contemporaries considered absurd, for instance imaginary tales set in the days of chivalry. But as early as 1659 the theologian Henry More (1614–87) was equating it with an aspect of the imagination: 'I speak especially of that imagination, which is most free, such as we use in romantick inventions.' In 1666 Samuel Pepys (1633–1703) used it to describe a scene in which loyal seamen offered to revenge the death in battle of their commander, Sir Christopher Myngs (1625–66), thus equating it with high sentiment. By around 1710, tales of imagination and sensibility and the scenes and landscapes described in them were being taken more seriously, and the term 'Romantic', applied to them, came to signify 'imaginative', 'interesting', 'exotic', 'unusual' or 'beautiful'. The word was used all over Europe, and although its precise meaning differed from country to country, Romanticism transcended borders and nationalities.

There were several significant precursors of Romanticism, notably the idea of the Sublime, of which a chief exponent was the statesman–philosopher Edmund Burke (1729–97); the Picturesque, whose major prophet was the Rev. William Gilpin (1724–1804); and Neoclassicism, promulgated by the German archaeologist and art critic Johann Joachim Winckelmann (1717–68). To the warp of this tapestry was added, at the outbreak of the French Revolution in 1789, the weft of the idea of human freedom.

The initial inspiration for the Sublime came from a first-century Greek treatise on the subject, attributed by medieval scholars to 'Longinus'; it was influential for centuries, and especially so in eighteenth-century England. A central passage is quoted by Richard Payne Knight (1750–1824) in *An Analytical Inquiry into the Principles of Taste* (1805): 'Longinus observes that the effect of the sublime is *to lift up the soul; to exalt it into ecstasy; so that, participating, as it were, of the splendors of the divinity, it becomes filled with joy and exultation; as if it had itself conceived the lofty sentiments which it heard.*'

At first the idea of the Sublime was applied in particular to poetry, but by the middle of the eighteenth century it was also being used in connection with painting. Here the prototype was at first the serene Raphael, but later, especially under the influence of Sir Joshua Reynolds, the passionate Michelangelo was considered at least equally impressive. Thus the Sublime was initially equated with beauty and divinity, but subsequently the violent and colossal became the norm.

In his *Philosophical Enquiry into the Origin of our Ideas of the Sublime and Beautiful* (1756), Edmund Burke identified images of terror, power, obscurity and infinity as dominant springs of the most powerful aesthetic emotion, producing sensations of a higher order in the beholder than those generated by beauty – which he characterised as smooth, harmonious and delicate.

> Whatever is fitted in any sort to excite the ideas of pain, and danger, that is to say, whatever is in any sort terrible, or is conversant about terrible objects, or operates in a manner analogous to terror, is a source of the *sublime*; that is, it is productive of the strongest emotion which the mind is capable of feeling. When danger or pain press too nearly, they are incapable of giving any delight, and are simply terrible; but at certain distances, and with certain modifications, they may be, and they are delightful, as we every day experience.

The cult of the Sublime manifested itself in all areas of painting: portraiture, landscape, seascape, architecture, history, the supernatural. Whatever its kind, the subject was presented and portrayed, not merely to reproduce its natural appearance, but to involve the viewer in experiencing its inscape and responding emotionally. Reynolds's portrait of *Sarah Siddons as the Tragic Muse* (plate 4) is sublime portraiture (the pose of the sitter is based on classical sculpture and on that of Isaiah in Michelangelo's Sistine Chapel frescoes); Francis Towne's watercolour of *The Source of the Arveiron* (plate 14) is sublime landscape; J. M. W. Turner's *The Interior of the Colosseum: Moonlight* (British Museum) is architectural sublime, his *Snow Storm: Hannibal and his Army crossing the Alps* (plate 34) is historical sublime; and George Stubbs's *Horse attacked by a Lion* (plate 5) is a splendid example of sublime terror. Each of these subjects is portrayed in a dramatic, ecstatic or overwhelming light; even the Towne landscape, though calmer than the two Turners, seems to hold a mighty force and tension within its firm inked outlines.

The theory of the Picturesque was evolved during the eighteenth century; the first significant use of the word was in 1712, by the poet Alexander Pope (1688–1744). Though different in emphasis from the main thrust of Romanticism, it remained one of its formative elements. The Picturesque outlook was essentially objective, centring on the composition of a prospect, on its idealistic visual properties, on elements in it that could be associated with classical literature and painting, and on the informed, critical appreciation it aroused in the spectator; the purely Romantic approach was subjective, interest being centred on the effect of the landscape on the emotions of the artist or of its beholder. But in both, the human response to the created world, especially landscape, was central. The Picturesque was above all the art of landscape, both in painting and in the creation of landscape itself by such scenic gardeners as William Kent (1684–1748), Lancelot 'Capability' Brown (1715–83) and Humphrey Repton (1752–1818).

Full appreciation of the landscape was fostered by the work of a number of poets of the Picturesque. *Grongar Hill* by John Dyer (1700?–58), published in 1727, is an early specimen of the Romantic outlook expressed in a Picturesque poem, for a description of the landscape is followed by a particularisation of its hidden elements:

'Tis now the raven's bleak abode;
'Tis now th'apartment of the toad;
And there the fox securely feeds;
And there the pois'nous adder breeds
Conceal'd in ruins, moss and weeds . . .

The most influential poems of the Picturesque were *The Seasons* (1726–30) and *The Castle of Indolence* (1748) by James Thomson (1700–48); they anticipated much of the Romantics' subject-matter and imagery. Of comparable importance was the 'Elegy in a Country Churchyard' (1751) of Thomas Gray (1716–71). The rustic life portrayed in this poem was artificial, yet based on reality. Gray's nearest equivalent in painting was †Thomas Gainsborough, whose interpretations likewise omitted some of the unlovely realities of his subjects. The sensitivity to light and atmosphere in the poetry of William Collins (1721–59), for example his *Ode to Evening* (1746), has its parallel in the landscapes of the early Romantic painter †Richard Wilson.

Of prose writers on the Picturesque the most important as a populariser of the idea was the Rev. William Gilpin, whose *Three Essays: on Picturesque Beauty; on Picturesque Travel; and on Sketching Landscape* (1792) encouraged amateur watercolourists to venture into the countryside to make their own records of the landscape. Soon manuals of instructions for amateur painters became a publishing industry. Typical of William Gilpin's illustrated books of Picturesque tours are *The Wye and South Wales* (1782), *The Lakes* (1789) and *The Highlands* (1800). In Gilpin's attitude the distance of the Picturesque from the Sublime is especially apparent: he was attracted to a blander type of beauty, to what he called 'that particular quality, which makes objects chiefly pleasing in painting'. His direct influence on painting was probably not extensive, yet †Turner is known to have copied some of his illustrations as a young man, and other artists knew about his opinions, even if their knowledge came by way of William Combe's popular metrical satire *The Tour of Dr Syntax in search of the Picturesque* (1809).

Many artists sought Picturesque landscapes abroad. Much of what they discovered appealed strongly to the Romantic outlook, and gave rise to paintings of subjects from the itinerary of the Grand Tour and other areas of Europe (see plates 14, 19, 20, 33, 51, 65). With the expansion of trade and empire, more exotic subjects were painted by artists who had travelled to the East ('to shake the Pagoda Tree'), to the South Seas, or even to Australasia. John Frederick ('Spanish') Lewis (1805 76) depicted harem scenes; Edward Lear, represented here by one of his natural history drawings (plate 61), is also famous for his landscapes painted around the Mediterranean, in India and in the Near East; and George Chinnery (1748–1847) portrayed life in Bengal and China.

Neoclassicism was the artistic expression of the philosophic Enlightenment of the eighteenth century, itself a system of thought dominated by empirical reasoning. Neoclassic art sought to emphasise line, as did many Romantic painters, including, in their different ways, †Francis Towne and †William Blake. It sought to tame nature by idealising and ennobling it, and here it contradicted Romanticism, which sought out nature in its wildest aspects. Above all, and this is of greatest interest in the present context, Neoclassical artists looked to an idealised past for their inspiration, and so did many Romantics. The difference was that while Neoclassicists centred their attention on Rome and especially Greece, the Romantics tended (though not exclusively, see plate 7) to take their subjects from the Middle Ages, the Renaissance, or even prehistory, myth and legend. This was especially true of the Preraphaelites, the brotherhood founded by †William Holman Hunt, †Dante Gabriel Rossetti and †John Everett Millais, who were

later joined by other painters. They reacted against contemporary trends in painting, and sought to return it both in spirit and technique to the precursors of Raphael, and to achieve a close and accurate depiction of nature. But though the Neoclassicists and Romantics like the Preraphaelites focussed their sights on different periods, they shared an attempt to rediscover a past Utopia and attain to its ideals. Typical Neoclassical artists were James Barry (1741–1806), who decorated the Great Room of the Royal Society of Arts in the Adelphi, London, with murals of allegorical and classical subjects (1777–83); and †John Flaxman (1755–1826), who designed classical jasperware for Wedgwood, and whose sculptures and paintings epitomised the Neoclassical movement. Yet both artists also produced work that was in the mainstream of Romanticism.

Romanticism developed against the politically turbulent background of the French Revolution, the Napoleonic Wars and the American War of Independence. Though shock waves from these events were felt in Britain, the effect of the French Revolution and its sequels was less intense than in continental Europe, for Britain was cut off from the mainland for long periods between 1793 and 1815. Where the Revolution did kindle enthusiasm for its ideals, the Terror caused revulsion at the outcome. William Blake walked the streets of London wearing the revolutionary red bonnet, and William Wordsworth (1770–1850) visited France with high hopes in 1791, but both were soon disillusioned. Britain in fact afforded less scope for revolutionary zeal than Europe, for the British social system was more democratic and less rigid than that of most foreign regimes; there was some blurring of class divisions and the lower classes had greater scope for individual expression.

Attention to the rights of the individual was encouraged also by works such as *The Rights of Man* (1791–2) by Thomas Paine (1737–1809), and was supported by an awareness of contemporary social movements and upheavals. The cult of the individual gave an impetus to the Romantic cult of the hero or superman, of which Napoleon Bonaparte (before he spoilt the illusion by declaring himself Emperor) was a prototype. (Beethoven at first saw Bonaparte as a hero and intended to dedicate his Symphony No. 3 *The Eroica* to him, but tore the name off the score when he heard of his coronation, labelling it instead 'to celebrate the memory of a great man'.) The other great Romantic hero (or anti-hero) was Satan, who had been treated as such by Milton in *Paradise Lost*. The Romantics saw Satan as a spirit of energy-charged vitality, terrible and therefore sublime (see plate 27), and nowhere nearing resemblance to the bestial Fiend of conventional theology.

The attitude of many Romantics to religion and mortality was ambivalent, at the least – frequently non-christian, even anti-christian. To Blake, for example, Man was a Promethean figure, bound to his rock, a victim of Jehovah and, although powerless to escape his torment and his fate, defiant. Lord Byron (1788–1824), himself the subject of a cult as a flawed hero, in his *Cain: A Mystery* (1821) portrayed Cain as a man puzzled by Jehovah and turning to Lucifer for enlightenment. On the other hand some Romantics were devout, even conventional Christians; such were †Samuel Palmer and †William Holman Hunt. And some adopted an eclectic freedom of thought in religious matters: Palmer's friend †Edward Calvert, at one time a devout Christian, turned to an enlightened paganism, and tried to unite the teachings of Socrates and Christ into a philosophical framework of his own devising.

The worship (the word is not too strong) of the individual led also to new and deep interest in varieties of psychology, emotions and responses. The ideal norm, to which the Neoclassicists aspired, was superseded by delineation of particular, distinctive and (by

some artists) fantastic or grotesque states of being and mind.

Some of the more *outré* manifestations of the study of human variety are exemplified by the overtones of ambiguous sexuality in works such as the portrait of Prince William Frederick by George Romney (plate 10), and in *Lady Caroline Lamb in the Costume of a Page* by Thomas Phillips (plate 32). Not that the Romantics despised straightforwardly heterosexual love, as is evident in the studies of it by Thomas Stothard, William Etty, Edward Calvert and George Richmond (plates 24, 45, 50 and 58). But they loved to peer into the dark waters of the subconscious in their studies of human emotions. That particularly Romantic archetype, the *femme fatale*, the subject of *La Belle Dame Sans Merci* by John Keats (1795–1821; see plate 49), especially attracted the Preraphaelites. Dante Gabriel Rossetti depicted her in many forms, particularly in his later work. Others among the later Romantic artists were attracted by the *tristesse* of love. Examples here are Millais' *Ophelia* (plate 73) and *April Love* by Arthur Hughes (plate 74). In *Disappointed Love* (plate 48), Francis Danby feelingly expresses the melancholy of ill-starred young love, depicting a young lover preparing perhaps to cast herself into the watery grave to which she has just consigned her love letters.

Suicide (which naturally carried implications of terror) fascinated many Romantics. A prototype was the young hero in Goethe's *The Sorrows of Young Werther* (1774), who took his own life after being crossed in love. The preoccupation was a symptom of a despairing, mournful outlook, a *mal de siècle*. Suicides were not uncommon among artists: they included the painter †Benjamin Robert Haydon, the poet Thomas Chatterton (see plate 23) and, very possibly, the poet Percy Bysshe Shelley (1792–1822), drowned while sailing during a storm in Italy.

†John Henry Fuseli, one of the most influential artists of the era (he became professor of painting at the Royal Academy), had above all the Romantic desire to peer beneath the surface into the intricacies, functioning and malfunctioning of the human psyche, and in this he was a master. He entered into the whole range of psychological disturbance and perversity, from transvestism to sadism, from fetishism to dementia; he was known to contemporaries as 'Principal Hobgoblin Painter to the Devil'. Yet he cannot himself have been wholly immoral, for his contemporary †William Blake, a transparently honest and decent man, admired him, and wrote of him:

> The only Man that e'er I knew
> Who did not make me almost spew
> Was Fuseli: he was both Turk & Jew –
> And so, dear Christian Friends, how do you do?

Returning the compliment, Fuseli said that Blake was 'damned good to steal from', and several of his works confirm that he did just that.

Fuseli's work is unnatural – even against Nature: 'Damn Nature! – she always puts me out', he once said. Notwithstanding, like many Romantics, he took an active interest in nature: he was an enthusiastic amateur entomologist. His interest in the enigmas of psychology is evident in his portrayal of the frantic *Mad Kate* (Freies Deutsches Hochstift, Frankfurt am Main), his portrait of a somewhat predatory *Mrs Fuseli with her Work Basket* (Art Gallery, Auckland, New Zealand), and his interpretation of the hysterical *Garrick and Mrs Pritchard as Macbeth and Lady Macbeth* (Kunsthaus, Zurich), which may be contrasted with Zoffany's more straightforward painting of the same subject (Garrick Club, London).

Although Fuseli seems to have been completely heterosexual, a voyeuristic interest in

lesbianism is strongly apparent in his work (plate 18). He is much occupied with strange forms of female hairdressing; in a drawing in the Kunsthaus, Zurich, a woman has her hair dressed to resemble the keys and scroll of a violoncello, perhaps indicating that she was an instrument to be played on to arouse a response to a seducer's desires. In another series of drawings, Fuseli illustrates the inversion of the accepted roles of male and female, with the man assuming the passive position while his virago mistress dominates him, switch in hand (Kunsthaus, Zurich).

The case of Richard Dadd, a later artist who peered into the unquiet soul, is different: Fuseli was sane, Dadd insane; Fuseli deliberately probed alien forces, Dadd's experiences in the hell of his frantic mind were in spite of himself. Dadd's was not the melancholy insanity of the poets William Cowper (1731–1800) and John Clare (1793–1864), but something more energetic, a devouring insanity which fed upon itself, which left destruction as well as creation in its path. Dadd's works, including *The Fairy-Feller's Master Stroke* (plate 64) and *Crazy Jane* (The Bethlem Royal Hospital, London), afford some inkling of the Romantic horrors of his mind.

Many psychological ambiguities come together in the shadowy and ambivalent art of †Simeon Solomon. Active at the end of the Romantic era and later, he was a precursor of the Symbolists, and his work sums up many of the more wayward aspects of Romanticism. At an early age he was influenced by Dante Gabriel Rossetti, a far greater artist, whose essays in the evocation of psychological disturbance and nightmarish terror are represented here by *How They Met Themselves* (plate 72): Rossetti called his black and white version of this his 'Bogie pen and ink' (Fitzwilliam Museum, Cambridge).

The works of †Sir Joshua Reynolds are in direct contrast with this preoccupation with unconforming aspects of humanity. One of the earlier Romantics, his work includes some of the best portraits painted by any artist of the English school at any date. They meet the essential requirement of portraiture in that they portray the sitters with intimate concentration on their individual characters; but they also transcend this and become symbols: in the case of *Master Thomas Lister* (plate 3), of the blooming qualities of boyhood and of the exaltation of nobility, and in the case of *Sarah Siddons as the Tragic Muse* (plate 4), of the inscape of tragedy.

The portraits of Reynolds's contemporary and rival, †Thomas Gainsborough, are of at least equal quality. Gainsborough painted his portraits almost without exception *in toto*, whereas Reynolds painted only the head – the background, draperies, clothing and accessories being supplied by assistants. Like many other Romantics, Gainsborough sought to transform the images of the mundane world into what †William Blake called 'One continued Vision of Fancy and Imagination'. In his portrait of Johann Christian Fischer (plate 6), music is the key to the transformation, as it is also in his equally fine *Ann Ford, later Mrs Philip Thicknesse* (Cincinnati Art Museum), in which the sitter supports a cittern on her lap while leaning on a pile of music books on a table, while a viola da gamba and its bow stand against a wall in the background. Elsewhere he uses landscape settings which in some instances recall the grandeur of Watteau, as in *Henry Frederick, Duke of Cumberland with his Wife Anne* (collection of H.M. the Queen); in other works, and more frequently, his transformations consist of soft-textured imagery, as in *Mrs Richard Brinsley Sheridan née Elizabeth Linley* (National Gallery of Art, Washington) and *The Morning Walk* (National Gallery, London).

In contrast to the symbolic and idealising characterisations of Reynolds and Gainsborough, portraits by some other artists of the era are completely unblinking

delineations of individual character, with defects of appearance and personality, where they exist, accurately reported. The almost brutally realistic miniature of an unknown man by Ebenezer Gerard (plate 42) reveals introspection and doubt; in Johann Zoffany's portrait of *John Cuff with an Assistant* (plate 8) the extrovert and happy personality of the craftsman is contrasted with the modest reserve of his assistant.

†George Romney and †Sir Thomas Lawrence give a further dimension to interpretative portraiture. Romney's art is strongly theatrical, as indeed were many of his subjects, for example his vulnerable *Lady Hamilton as Miranda* (Philadelphia Museum of Art) and *Sidonian Reflections* (private collection), an analytic portrayal of three different head studies of Sarah Siddons as a demented Lady Macbeth. His portrait of Prince William Frederick (plate 10) has distinct theatrical elements, for example the extravagantly regal posture of the subject.

Many of the portraits of Sir Thomas Lawrence, who came under Romney's influence, are equally dramatic. One of his greatest is that of Pius VII (collection of H.M. the Queen), in which the heroic Pope, who had excommunicated Napoleon Bonaparte and was then imprisoned by him, is depicted in a brooding setting, with encircling gloom and bright distance, and, in a distant gallery, two of the masterpieces of sculpture in the Vatican, the Apollo Belvedere and the Laocoön. Lawrence's taste for the dramatic is represented here by his Byronic portrait of Charles William Bell (plate 30). A similar style of portrayal was also used by †Sir Henry Raeburn, who sometimes set his figures in Scottish landscapes, which were considered incomparably Romantic *coups d'oeil*; such is his portrait of Sir John Sinclair (plate 25).

In their quest for the particular, Romantic artists turned also to humbler aspects of humanity, which they portrayed especially in genre (that is, broadly speaking, scenes from everyday life) and in book illustration. In addition to his illustrations of animal life, †Thomas Bewick, the great Northumberland engraver, created a series of anecdotal tailpieces for his books, notably his *History of British Birds*, in which every aspect of rural life was depicted, from *An Early Morning Thief surprised* (plate 22) to *An Old Woman attacked by a Gander*, and from *The Pigsty Netty* [i.e. *Privy*] to *Skating on a Frozen River*. These not only relieve what might have been a monotonous series of bird illustrations, but provide a detailed, and usually droll, commentary on the contemporary bucolic world.

Several of the other artists whose work is represented here were also illustrators, among them Thomas Stothard, William Blake, John Martin, Samuel Palmer, Daniel Maclise, Philip Henry Gosse, Dante Gabriel Rossetti and Sir John Everett Millais. One of the greatest of all, who made book illustration his principal sphere, was George Cruickshank (1792–1878); his illustrations to Dickens's *Oliver Twist* and for several novels by W. Harrison Ainsworth (1805–82) mark a watershed in Romantic book illustration. Almost equally famous, as 'Phiz', was Hablot K. Browne (1815–82), whose portrayals of Dickens's characters have fixed themselves in the imaginations of generations of readers (plate 63).

As in Bewick's work, commentary on country life is a dominant feature of the paintings of George Morland (see plate 29), but his subjects are often sentimentalised; his artisans and peasants live in an idyllic make-believe world unrelated to the reality of poverty, insanitary cottages and exploited labour. This is the blandest aspect of the Picturesque: an interest in the humble, domestic side of life and an urge to make it charming and attractive. Morland's attention to bucolic life is a reminder of that important figure in British Romanticism, the untutored 'natural' poet. Such were James Hogg (1770–1835), 'the Ettrick Shepherd', John Clare (see plate 66), and Robert

Bloomfield (1766–1823), author of *The Farmer's Boy* (1800). Bloomfield was also a maker of Aeolian harps, instruments that were (not surprisingly) popular during the Romantic era – shut in a casement, they conjure harmonies from the wind. The spirit of the work of such poets is reflected in paintings exemplified here by William Mulready's *The Younger Brother* (plate 43).

Attention to individual states of existence in humanity was paralleled by the observation of nature and the exploration of Man's environment, especially landscape. In the early decades of the Romantic era, much landscape painting was inspired by the paintings of Gaspar Dughet ('Poussin', 1615–75), Nicolas Poussin (1594–1665), Salvator Rosa (1615–73), and above all Claude Gellée (Lorrain, 1600–82), whose influence was widely diffused by the publication of mezzotints of his *Liber Veritatis* (1777) by Richard Earlom (1743–1822). The work of these artists, which had in turn emanated from the pastoral tradition of painting initiated by Giorgione (1477/8–1510) and Titian (*c.* 1488/90–1576), did much to awaken the emotive Romantic ordering of landscape.

The Romantic painters never merely reported what was there for everybody to see; they interpreted and rearranged it. Samuel Palmer encapsulated their attitude when he wrote of Claude: 'Ordinary landscapes remind us of what we see in the country; Claude's, of what we read in the greatest poets, and of *their* perception of the country, thus raising our own towards the same level.' To an extent the same is true of Dughet. On the other hand Nicolas Poussin combined, in a homogeneous intellectual whole, imaginative landscape and statuesque yet vital articulations of biblical events and classical myths. In this way he endeavoured to re-create a vanished Golden Age, a sublime heroic world, but one more intellectually conceived than Claude's pensive yearnings for a vanished Arcadia.

Poussin's influence is evident throughout the work of one of the earlier, indeed archetypal, British Romantic landscape painters, [†]Richard Wilson. Wilson's usual indebtedness to Poussin rather than Claude was succinctly expressed by Thomas Wright in his *Life of Richard Wilson* (1824), in which he contrasted Wilson's 'grand, majestic, and well selected forms' with Claude's painting of 'nature's littlenesses'.

Salvator Rosa provided another dimension to landscape painting, one eagerly seized upon by many Romantic landscape painters seeking sublime effects: that of terror and of the horrid. In his *Castle of Indolence* Thomson made a pregnant comparison of Rosa's, Claude's and Poussin's outlooks:

> Whate'er Lorrain light-touched with softening hue,
> Or savage Rosa dash'd, or learnèd Poussin drew.

The wild and savage aspect of landscape depicted by Rosa is central to the work of [†]Loutherbourg, [†]Ward and [†]Turner.

Poussin's elegance and Rosa's wildness come together in Wilson's *Cader Idris* (Tate Gallery, London). Here a brooding atmosphere of mystery underpins the imaginary aspect of its subject; the name is Welsh for 'Chair of Idris', a legendary giant, and the mythological reference helps the painter to centre the viewer's attention on the subject's emotive essence. Wilson's interpretation is appropriately sublime: vastness, accentuated by the tiny human figures; agoraphobic terror, suggested by the almost perpendicular face of the crater above the tarn; the rugged and broken surface of the landscape, and the dark, almost gloomy passages of the foreground and middle distance – all these produce a feeling of inquietude in the beholder.

Wilson's *Classical Landscape* (plate 1) is also emotionally charged, but in a different way. It lacks the drama of *Cader Idris*, and illustrates vividly the artist's debt not only to Poussin but to Claude, for it has a slight but pervading Claudian note of melancholy, of nostalgia, an enigmatic feeling of unease, called up by the beautiful evening sky, so perfect but so evanescent, soon to be succeeded by the disappointing gloom of night and the cold rawness of dawn.

In the works of †Francis Towne a fresh view of landscape is achieved by a combination of outlined form and lambent colour. The beauty of Towne's landscapes is lyrical rather than epic, deriving more from Claude than from Poussin or Rosa. His art is intellectual and cool, and affords a notion of landscape which relies primarily on a beauty derived by arrangement and order and the reduction of the shapes and surfaces of the subject to an almost abstract pattern, strongly outlined (as if engraved or etched) around areas of smooth surfaces and bright gem-like colours.

As with Towne, so later in the landscapes of †John Sell Cotman there is a strong tendency towards abstraction, while conserving the topography of the subject; in other words Cotman stylised nature without losing reality. His art can be compared to music with rhythms of pattern supported by harmonies of colour, and it sustains the claim of Walter Pater (1839–94), himself an adherent to Romantic tenets, that 'All art constantly aspires towards the condition of music.'

The tendency towards abstraction is also evident in the work of Thomas Jones. His *Buildings in Naples* (plate 19), townscape rather than landscape, similarly uses simplifying principles, in this instance to reduce the view to a pattern of rectangles (anticipating the compositions of the twentieth-century artist Ben Nicholson). At the same time Jones's composition succeeds in portraying the essential haecceity or thisness of a group of otherwise ordinary buildings. Jones also painted landscapes in which he appears to have anticipated the Roman landscapes painted in the 1820s by Jean-Baptiste Camille Corot (1796–1875).

Abstraction of a different kind was used by some Romantic artists as a starting point, enabling them, as it were, to create recognisable form out of chaos. Thus †Thomas Gainsborough built up his landscapes from groupings of such unpromising materials as lumps of coal and cork, clay and sand, broccoli, lichen and moss; and †Alexander Cozens began his imaginary compositions from blots splashed haphazardly over his paper. Cozens himself said, 'I scruple not to affirm, that too much time may be employed in copying the landscapes of nature herself'; it is probable that his method influenced Gainsborough, who met him during a visit to Bath. †John Robert Cozens painted more conventionally than his father Alexander, yet he combined topographical accuracy with imaginative and emotive interpretation.

When J. R. Cozens became insane and was placed in the care of the alienist Thomas Monro (see commentary to plate 20), a number of his sketches were made available to Monro, who asked †Thomas Girtin and †J. M. W. Turner to make watercolour copies of them, Girtin making the drawings and Turner applying the colour. In this way his example helped to lay a foundation for what Girtin and Turner were later to achieve in imaginative landscape.

Girtin was one of the most notable of all English watercolourists, and his interpretations of English landscape were supported by a magnificent mastery of technique. The landscape painter Frederick Christian Lewis (1779–1856) spoke of the 'sword-play of Girtin's pencil' in referring to his clear, clean and decisive brushwork, and Samuel and Richard Redgrave, in their *A Century of Painters of the English School*

(1866), drew attention to 'the extreme harmony of the boldly opposed tints painted cleanly and sharply up to one another'. Girtin died young, and Turner is said to have stated that 'Had Girtin lived I should have starved.' Although this is probably apocryphal, it is also probably true that, without Girtin's example of breadth of invention combined with warmth of feeling and superb technique, the work of many contemporary landscapists, including Turner and Constable, would not have developed quite as it did, and certainly not so quickly.

William Henry Pyne ('Ephraim Hardcastle', 1769–1843) told how Girtin would sketch a picturesque view, draw it and colour it by day, but would later visit the scene by twilight, so that he could add the effects of fading light, of changing reflections, and of the increased grandeur of buildings. The drawing would then be 'wrought with bold and masterly execution, [leading] to that daring style of effect which he subsequently practised with so much success'. Anticipating Turner, Girtin lifted landscape from what until then had been an arrangement of forms and depicted it under the effects of weather, in an endeavour to use every meteorological phenomenon and every nuance of light and mood to depict life at its most cosmic and profound.

Turner was not only the greatest of the Romantic landscape painters, but one of the greatest landscape painters of any age. His work both in oil and in watercolour gave new scope to the elemental forces of weather, the immensities of landscape, and the transitory effects of light and atmosphere. Not that it was always so, for his earlier work is much more traditional and almost derivative, owing much to Poussin and Claude. But by his middle and late years, wherever and whatever he painted, he was preoccupied by the magnitude of mountain and precipice, the vastness of sea and sky, or the infinity of light and its effects – sometimes all in the same work – and, in the response he evokes, he fulfils Burke's dictum that 'Whatever therefore is terrible, with regard to sight, is sublime too . . . for it is impossible to look on any thing as trifling, or contemptible, that may be dangerous.'

The extreme and disturbing nature of Turner's vision of landscape received a perceptive contemporary response from the essayist William Hazlitt (1778–1830) in the weekly *Examiner* in 1816:

> A musician, if asked to play a tune, will select that which is the most difficult and least intelligible. Shakespeare took the greatest delight in his 'conceits', and some artists among ourselves have carried the same principle to a singular excess . . . We here allude particularly to Turner, the ablest landscape-painter now living, whose pictures are however too much abstractions of aerial perspective, and representations not properly of the objects of nature as of the medium through which they are seen . . . They are pictures of the elements of air, earth and water. The artist delights to go back to the first chaos of the world . . . All is without form and void. Someone said of his landscapes that they were *pictures of nothing, and very like.*

Turner's work is an object lesson in the reciprocity between poetry and painting, a mirror-image of Horace's aphorism in his *Ars Poetica*, 'Ut pictura poesis' (As with the painter's work, so with the poet's). Like many Romantic artists, he drew on poetry for the inspiration, or explication, of his astonishing images. In his lectures as Professor of Perspective at the Royal Academy he frequently quoted the poetry of Thomson to illustrate his points, and in catalogue entries for his work he often provided verse commentaries, quoted from others or composed by himself.

Turner's consciousness of the Sublime extended also to contemporary developments

17

in the landscape. For example in *Newcastle on Tyne* (British Museum) he exploited the effects of industrial haze – an aspect of the industrial Sublime, in which the smoke of industry replaced natural mists, and the fires of forges and foundries, of kilns and smelting works, rivalled the setting sun, while in the contrasting darkness shadowy figures of gangs of workers replaced the struggling soldiery of history paintings such as *Snow Storm: Hannibal and his Army crossing the Alps* (plate 34).

Many of the effects depicted by Turner's contemporary †John Martin were also based on contemporary industrial vistas: in his mezzotint illustrations for Milton's *Paradise Lost* the setting of 'The Hollow Deep of Hell' was possibly inspired by a scene in a coalmine, and the tunnel-like scene in 'At The Brink of Chaos' may have been suggested by the design of parts of the Thames Tunnel. The blazing explosive conflagration in *The Great Day of His Wrath* (plate 46) is perhaps indebted to the glowing, smoky industrial landscapes of the industrial north. But Martin's paintings are not naturalistic – they are overstatements, nineteenth-century previsions of Hollywood spectaculars. Mountains explode, whole towns and communities are overturned, mankind is swamped beneath unimaginably vast tidal waves, pandemonium is unleashed through all the nations, and civilisation crumbles as the world ends (Martin was influenced by contemporary millenarianism). No Romantic horror could exceed this primal terror, yet Martin's work is not really sublime; it is sensational, even frightening, but unlike Turner's vast interpretations of nature, it fails to touch the soul.

The other towering figure among landscape painters of the period was †John Constable. Initially a follower of Wilson and much influenced by Dutch landscape painters, Constable eventually created work of a totally different kind from Turner's. Though like him he painted the effects of light and weather on the landscape, his art, which was largely concentrated on the portrayal of his native East Anglian landscape, is more intimate than Turner's. To present-day tastes it is at its best in sketches and studies (e.g. plate 36), in which he shows light dancing on many surfaces. His finished works, though brilliant set-pieces, lack the vibrating points of light, flicked, carelessly it seems, from his brush on to a sketchbook leaf, producing with the minimum of pigment the effect of a shower, or of light on a stream.

Such adroitness enabled Constable to record the rapidly changing mutations of cloud forms. These records were intended primarily as studies for his finished landscapes, but they are at the same time minutely observed notes that would have done credit to a scientific observer; in this respect he shared in the scientific interest in nature which was an important ingredient of Romantic art.

It was not merely for the sake of accurate detail that Constable concentrated on clouds; they are the most important element in skyscapes, and to Constable this made them of prime interest. 'It will be difficult,' he said, 'to name a class of landscape in which the sky is not the key note, the standard of scales and the chief organ of sentiment.' This is one important factor which differentiates his outlook from Turner's: Constable found his inspiration in the open skies and low-lying hedges and meadows of Suffolk, whereas Turner's was most often derived from mountains. (To their contemporaries this put Turner in a higher class of sublimity.) And whereas Constable's clouds assumed the importance of mountains, Turner's were vaporous: Hazlitt compared them to 'tinted steam'.

The whole of Constable's thought and practice was dominated by a deep respect for nature. 'When I sit down to make a sketch from nature,' he said, 'the first thing I try to do is, *to forget that I have ever seen a picture.*' He greatly admired the great amateur

naturalist Gilbert White of Selborne (1720–93), whose mind he once said he had always envied. As he put it: 'What is painting but an imitative art? An art that is to *realise, to feign*.' In a sense his art *was* imitative, but he never merely copied nature; he invested his imitation with a vivid imagination that investigated every delicate difference of light and shade, the inner tension of every shape and its relationship to others, the inner rhythm of every natural form, the intrinsic beauty, in his own words, of 'the sound of water escaping from mill dams, willows, old rotten planks, slimy posts and brickwork'.

Constable stands with such painters as [†]Reynolds, [†]Stubbs and [†]Ward, in as much as they subtly and unobtrusively combined the real and the ideal without losing the particularity of their subjects; in this respect they approached the outlook of the Neoclassicists, who sought an ideal in everything. At the opposite extreme are the fervent and fantastic works of such painters as [†]Fuseli, [†]Alexander Runciman, [†]Benjamin West and [†]John Hamilton Mortimer, which express or suggest the dominance of emotional turbulence, and draw on the long European tradition which included Michelangelo, Caravaggio (*c.* 1573–1609) and Rosa.

The spirit that prompted Turner's portrayals of the effects of industry on the landscape and Constable's analyses of cloud forms was not shared by all Romantic painters. One group of young artists in the 1820s and 1830s vigorously set their faces against science and industry and, inspired by [†]William Blake, looked for, and found, the essence of the Virgilian pastoral in an English countryside which, apart from areas in the commercial midlands and north, was still, at least on the surface, idyllic. The central figure of this group was [†]Samuel Palmer, who throughout his life, but especially during a brief period beginning about 1824, sought successfully to portray the poetry of earth in works so intense that they sometimes bordered on the hallucinatory.

He and his friends, who included [†]Edward Calvert, [†]George Richmond (later to become a highly successful portrait painter) and [†]Francis Oliver Finch, centred their youthful activities at Shoreham in Kent. Here, calling themselves 'the Ancients', and with 'Poetry and Sentiment' as their motto, they shared a highly charged religious vision that transformed the Kent landscape into an earthly paradise, drenched in moonlight during a perpetual harvest.

To Palmer and his friends, landscape, and indeed the whole of nature, was a microcosm of man's soul. The poet Samuel Taylor Coleridge (1772–1834) could have been speaking for them when he wrote.

> In looking at objects of nature . . . as at yonder moon dim glimmering through the dewy window pane, I seem rather to be seeking, as it were asking, a symbolical language for something within me that forever and already exists, than observing anything new. Even when that latter is the case yet still I have always an obscure feeling, as if that new phenomenon were a dim awakening of a forgotten or hidden truth of my inner nature.

Similarly William Wordsworth, in his Preface to the 1800 edition of *Lyrical Ballads* by Coleridge and himself, wrote of poetry being 'the image of man and nature'. His claim that 'all good poetry is the spontaneous overflow of powerful feelings', and should show how ideas and feelings are associated in a state of excitement, clearly connects with the attitude of Romantic painters such as Turner, Constable, Ward and Palmer. The intense, subjective observation of nature was also linked to human emotions in the verse of the Aldeburgh poet, the Rev. George Crabbe (1754–1832), whom Byron described as 'Though nature's sternest painter, yet the best'. His grim evocations of mood within

narrative tales, of which 'Peter Grimes' is now the best known, reflected his own tendency to melancholy, induced at times by his addiction to opium.

The same intent regard was applied to the teeming details of the many-layered life contained in the landscape, from mighty trees and luxuriantly liveried flowers to the tiniest insects and microscopic botanical constructions. The popularisation of science through works like Philip Henry Gosse's *Seaside Pleasures* (1853) and *Evenings at the Microscope* (1859) demonstrated to artists how much previously hidden and unimagined beauty had become available to them. They were not slow to exploit it. John Ruskin, while capable of depicting broad and noble prospects (plate 65), preferred to dwell upon the 'minute particulars' of nature, which he painted with the intensity of a botanist peering through a microscope. He once described how

> On fine days, when the grass was dry, I used to lie down on it and draw the blades as they grew, with the ground herbage of buttercup or hawkweed mixed among them, until every square foot of meadow, or mossy bank, became an infinite picture and possession to me, and the grace and adjustment to each other of growing leaves, a subject of more curious interest to me than the composition of any painter's master-piece.

While working on *Ophelia* (plate 73) Millais actually did use a magnifying glass so as to lose no particular of a flower or a leaf. This attitude owed much to the example of contemporary natural history illustrations of scientists, not only of Gosse (plate 60), but also of Thomas Henry Huxley (1825–95), Edward Lear (plate 61), and many more.

The Romantics perceived a world of harmonious beauty in nature, yet were conscious also of its sublimely terrifying aspect, characterised by Alfred Tennyson:

> For nature is one with rapine, a harm no preacher can heal;
> The Mayfly is torn by the swallow, the sparrow spear'd by the shrike.
> (*Maud* IV. 4)

The elemental power of nature is typified by *Bulls fighting, with the Castle of St Donat in the distance* by James Ward (plate 31) and *Carting Timber* by David Cox (plate 41). Although each subject is set within landscape, the setting is secondary: in Ward's painting, to the might and temper of the great bulls fighting, and in Cox's watercolour, to the temper of the weather.

Nature's gentler side is illustrated by the work of †Thomas Bewick. Like Gosse, Bewick viewed nature with an eye sharpened to perceive minute particulars, leaving out nothing, adding nothing – nature itself was sufficient. In this he showed a typically Romantic tendency to apprehend natural creation transcending all else. His compositions depicted not only birds (or mammals), but the settings in which they were found, settings which, he said, seem

> kindly to offer shelter to an undergrowth of hazel, – Whins, Broom, Juniper & Heather, with the Wild rose & Woodbine & brambles – beset with clumps of Fern & Foxglove – while the edges of the mossy braes are covered with a profusion of wild flowers which 'blow to blush unseen' [Gray, 'Elegy'] or which peep out among the creeping groundlings, the bleaberry, wild strawberry, Harebell, violet & such like.

A similar delight in nature's profusion of individual species informs Millais' painting of the underwood and flora in *Ophelia*.

John Linnell's *Shepherd Boy playing a Flute* (plate 47) evokes a happy bucolic

atmosphere of the kind distilled in Virgil's *Eclogues* and *Georgics*; it suggests a view of rural life which ignores the all-too-often poverty-stricken reality. Linnell believed that the masses should be educated and their condition improved, but in this painting he indulged in a little gentle escapism. By contrast, the nature paintings of the Preraphaelite William Holman Hunt, and of many of his contemporaries, are sermons. In *The Hireling Shepherd* (plate 71), Hunt, like Linnell, portrays a contemporary bucolic scene, but makes its pastoral aspect the vehicle for a lesson in high-Victorian morality. Yet at the same time the Romantic spirit of the work is unmistakable, especially in the minute and accurate depiction of the foreground herbage, of the protagonists and their clothing, and of the cornfield; it is as delicately wrought, as closely observed, as Gosse's *Three-horned Chafer*, Edward Lear's *Red and Yellow Macaw*, Madox Brown's *Last of England* and Millais' *Ophelia* (plates 60, 61, 69, 73). But it lacks the breadth of imagination, the superb magisterial organisation present in the work of Turner and Constable and their great predecessors. The manual skill is unmistakable, but it is the skill of a consummate craftsman rather than that of a great interpretative artist.

The influence of contemporary scientific thought is particularly evident in the work of Joseph Wright of Derby. He attended the meetings of the scientific club known as the Lunar Society (because it met when the moon was full, so that the absence of street lighting did not impede attendance), and he numbered among his friends Josiah Wedgwood (1730–95), Joseph Priestley (1733–1804) and Erasmus Darwin (1731–1802). True to the Romantic spirit, Wright portrayed not only the scientific content of his subjects, but especially, their emotive undertones, investing them with sublimity through his use of dramatic lighting, as in *An Experiment on a Bird in the Air Pump* (plate 9).

George Stubbs was even more deeply involved in scientific study, and one of the results of this involvement was his series of engravings of *The Anatomy of the Horse* (1766), for which he dissected the carcasses of his subjects – often becoming so engrossed that he hardly noticed when they reached an advanced state of putrescence. As a painter of horses Stubbs profoundly influenced the work of two great French artists, Eugène Delacroix (1798–1863) and Théodore Géricault (1791–1824). Clearly they were aware of works like Stubbs's *Horse attacked by a Lion* (plate 5); this is notably evident in Delacroix's *Horse frightened by a Storm* (Museum, Budapest) and *Horses fighting in a Stable* (Louvre, Paris), and it is known that Géricault owned prints by Stubbs. Stubbs's interest ranged beyond the equine, however; for example, he illustrated Dr John Burton's *An Essay towards a Complete New System of Midwifery* (1756). Such probings into anatomical detail were encouraged by the emancipation of thought, speculation and interest fostered by contemporary social attitudes.

Scientific optical equipment was used by Philippe Jacques de Loutherbourg in his entertainment, the Eidophusikon (plate 28), a forerunner of such spectacles as *son et lumière* and ultimately of the planetarium. But Loutherbourg also painted landscapes and seascapes full of Romantically sublime terror (plate 15), and in 1805 he published *The Romantic and Picturesque Scenery of England and Wales, from Drawings made expressly*. He was also one of the first artists to seize on the drama of industrial landscapes, for example in his *Iron Works, Coalbrookdale*, of which an aquatint by William Pickett (*fl.* 1792–1820) was published in 1805.

In the wake of the Neoclassicists, and influenced by Poussin, some Romantic artists were drawn to classical mythology; for example Thomas Gainsborough used the story of Diana and Actaeon as the foreground for one of his inimitable landscapes (plate 7). But on the whole they preferred the mysterious and abnormal manifestations of native or

nordic mythology, folklore and prehistory. An epic tale of heroic deeds in the misty British past is illustrated in Alexander Runciman's *The Death of Oscar* (plate 11). Constable's *Stonehenge* (plate 37) reflects a widespread preoccupation with the origins and purpose of this ancient monument, which gave rise to books such as William Stukeley's *Stonehenge: A Temple restor'd to the British Druids* (1740) and William Cooke's *An Enquiry into the Patriarchal and Druidical Religion* (1754), in which Druidism is viewed as a part of the ancestral religion of the Jews and Christians.

Northern European folklore and myth provided much of the material for the works of the Irish painter †Daniel Maclise. He illustrated the 1846 edition of Moore's *Irish Melodies*, in which one of his most attractive designs, accompanying the poem 'The Origin of the Harp' and based on his painting now in the City of Manchester Art Galleries, shows a beautiful sea-siren weeping for her lost lover, her right arm outstretched towards a rock, and with strands of her hair hanging from it like the strings of a harp; soon she will be completely metamorphosed. Nothing could be more wistful than this lovely being, sinking her identity into the form of an instrument whose strings will recall her unrequited love for evermore.

Sir Joseph Noël Paton found his mythological inspiration in the faerie world, for instance in *The Reconciliation of Oberon and Titania* (plate 68). This was not necessarily the fairytale world of nursery stories, but a primitive sphere, excitingly erotic, often morbidly cruel, and full of psychological unease, recalling in some passages details from the works of Hieronymus Bosch (*c.* 1450–1516) or Pieter Brueghel the Younger (1564–1637). Small animals are tortured by thorns wielded by malignant goblins or fairies, whose expressionless snake-like eyes are set in otherwise apparently innocent faces – unpleasantly reminiscent of children who pull wings off live flies for fun. But all this is decked out with jewelled, coruscating surfaces and glittering colours: Noël Paton shared with his contemporary John Austen Fitzgerald (1832– *post* 1906) the gift of clothing his strange world in a highly decorative setting.

As we have already seen, many Romantics were. like the Neoclassicists, dissatisfied with the contemporary world, and they searched the past not only for a perfect Golden Age, but also for evidence of past errors which may have led to outbursts of divine wrath and terror. Many of their subjects were taken from biblical history which, especially under the scrutiny of new modes of thought and outlook, provided many rich themes, from such gentle scenes as *Christ blessing Little Children* by William Blake (plate 26) to vast apocalyptic catastrophes like John Martin's *The Great Day of His Wrath* (plate 46).

Blake was not only one of the greatest of Romantic artists, he was one of the most original creative writers of the age, indeed of any age. He fulfilled his resolve,

> I must Create a System or be enslav'd by another Man's.
> I will not Reason & Compare: my business is to Create.

His attitude to all things, was wholly original. He was fearless in expressing his opinions, and unconventional in his views of Christian belief, clearly perceiving the difference between the tribal god of the Old Testament and the divine human Saviour of the New: 'Thinking as I do that the Creator of this World is a very Cruel Being, & being a Worshipper of Christ, I cannot help saying: "the Son, O how unlike the Father!" First God Almighty comes with a Thump on the Head. Then Jesus Christ comes with a balm to heal it.' This difference is illustrated in *Christ blessing Little Children* and *Satan smiting Job with Sore Boils* (plate 27). In the latter the Old Testament Jehovah has given Satan leave to torment the innocent Job, so as to test his faith. In the former, the Saviour gives

his blessing to the innocent; he is a figure of hope, symbolising the positive good of which Man at his best is capable. As Blake said in his *Everlasting Gospel*:

Thou art a Man, God is no more,
Thy own humanity learn to adore.

A more conventional but overtly dramatic view of a biblical event is depicted in *Saul and the Witch of Endor* by Benjamin West (plate 13). West frequently chose biblical subjects to convey sublime awe and fear, notably the apocalyptic *Death on the Pale Horse* (Pennsylvania Academy of Fine Arts, Philadelphia) and *The Opening of the Seals* (Detroit Institute of Arts). A contemporary account of the terrible figure of Death in the former work, with upraised hands clutching thunderbolts, appeared in an unsigned article in the periodical *La Belle Assemblée or Bell's Court and Fashionable Magazine* in 1808 and indicates that West had achieved his desired effect: 'His form, in the language of Milton, is "without form" – It is dissolving into darkness – it is in awful and terrible obscurity – All the legions of hell are in his train, they are seen in the opening perspective, and terminate the distances almost in the immensity of space.'

West's contemporary John Hamilton Mortimer also chose apocalyptic subjects to evoke sublime terror. His painting of *Death on the Pale Horse*, now lost, is known through a preliminary drawing (British Museum), a watercolour (Victoria and Albert Museum) and an etching. It was obviously a powerful work, with the grisly presence of Death, his crown askew on a cerecloth billowing from his head and shoulders, riding his hell-steed (comparable with the one in Fuseli's *Nightmare*, plate 17) and conquering all in his path. Of Mortimer's biblical subject reproduced here, *Nebuchadnezzar recovering his Reason* (plate 16), it is interesting to note that although his interpretation differs considerably from Blake's more alarming colour-printed drawing, *Nebuchadnezzar* (Tate Gallery), he greatly admired Blake's work.

In contrast to those of West and Hamilton, the biblical paintings of William Dyce are notable for a serenity which he had derived from the work of the German Nazarenes (comparable with the English Preraphaelites), with whom he was closely associated. The sense of stillness and the intent rendering of detail suggest that the painter regarded his subjects with an unblinking stare. This led in some works to flatness, to a lack of depth; but at its best, as in *Jacob and Rachel* (plate 55), Dyce's work is superbly vital. Like many other Romantics, he had a deeply religious view of nature; he believed that the painter's mission was to represent details as God had created them. Apart from religious subjects, he painted landscape – including the well-known *Pegwell Bay* (Tate Gallery) – portraits, genre, and historical and mythological themes.

As well as biblical history, the less remote past was grist to the mill of Romantic artists, and under the influence of writers of historical novels, such as Sir Walter Scott (1771–1832) and Mrs Ann Radcliffe (1764–1823), they turned especially to the medieval Gothic world. This was also reflected in contemporary architecture, such as Strawberry Hill, the gothicised residence of Horace Walpole (1717–97), and Fonthill Abbey (1795), the palace built by James Wyatt (1746–1813) for William Beckford (1759–1844), author of the exotic novel *Vathek* (1786). The Gothic style in painting is illustrated here by the portrait of Queen Victoria and the Prince Consort in medieval costume by Sir Edwin Landseer (plate 53).

On the whole, painting of scenes from secular history flourished less in Britain than on the continent, where a lead was given by such splendid masters as Jacques-Louis David (1748–1825) and Jean-Auguste Ingres (1780–1867); but occasionally individuals,

not always history painters by inclination, produced outstanding examples. Some subjects record contemporary happenings, others are imaginative interpretations of past events. Typical of the first is the terror-ridden *Watson and the Shark* by John Singleton Copley (plate 12); of the second, one of the most sublime examples is Turner's *Snow Storm: Hannibal and his Army crossing the Alps* (plate 34). It was the first of a series of Carthaginian subjects Turner painted, and was followed between 1814 and 1817 by *Dido building Carthage* and *The Decline of the Carthaginian Empire* (both National Gallery, London).

Scottish history, a prime source of stirring episodes, provided highly dramatic subjects for the artist David Scott, as in the broodingly atmospheric *Wallace, Defender of Scotland* (plate 56). Scott's historical and legendary spectrum also ranged more widely, from *Russian Soldiers interring their Dead* (Glasgow University), depicting an episode during the Polish revolt of 1830–1, to *Philoctetes left on the Isle of Lemnos by the Greeks* (National Gallery of Scotland, Edinburgh).

Plays in which history and legend were intermingled were continually produced in the theatre during the Romantic period. In one of his professorial *Discourses* (No. XV) at the Royal Academy, Fuseli put what he called 'the delineation of character' on a par with the drama, and indeed episodes from plays occur frequently in contemporary painting. Scenes from Shakespeare were depicted often, and, given their narrative connotations, may be considered surrogates for history subjects; such are *Imogen and the Shepherds* by James Smetham (plate 67) from *Cymbeline*, and *The Death of Ophelia* by Sir John Everett Millais (plate 73) from *Hamlet*. Individual performers in plays by Shakespeare were painted by (among others) Zoffany and Fuseli, who both portrayed Garrick and Mrs Pritchard in *Macbeth* (Garrick Club, London; Kunsthaus, Zurich), and by Francis Hayman (1708–76), illustrator of editions of the plays, who portrayed *Spanger Bury and Mrs Elmy in 'Hamlet'* (Garrick Club, London).

Romantic artists' enthusiasm for Shakespeare was at least partly due to the engraver and publisher John Boydell (1719–1804), who opened a Shakespeare Gallery in Pall Mall in 1789. Here he exhibited thirty-four paintings of Shakespearean themes by noted British artists, including Reynolds (*Puck*, Collection of the Earl Fitzwilliam) and Fuseli (*Titania and Bottom*, Tate Gallery; *Titania's Awakening*, Winterthur, Kunstmuseum). By 1802 the number of paintings had increased to 162, and in the same year they were engraved and published in a nine-volume edition of Shakespeare's plays.

Other artists besides those who received Boydell's extensive commissions portrayed Shakespearean themes and subjects: examples include Blake (*Jacques and the Wounded Stag from 'As You Like It'*, British Museum), Alexander Runciman (*King Lear on the Heath*, National Gallery of Scotland), Rossetti *(The Death of Lady Macbeth*, City Museum and Art Gallery, Birmingham), and Arthur Hughes (*Ophelia*, City Art Gallery, Manchester).

The Romantic ballet, which flourished c. 1830–50, inspired many notable contemporary works of art. The pre-Romantic ballet had taken its subject matter from classical mythology and from heroic and pastoral themes. This was overturned by the Romantic ballet, which dealt with fairy tales, exotic love themes, and northern legends; and the very technique of ballet was transformed (see commentary to plate 62). One of the artists most closely associated with the ballet was †Alfred Edward Chalon, whose representations of dancers, widely reproduced by lithography, inspired the most enchanting prints of the early nineteenth century. Sometimes, in addition to their balletic content, they brought Romantic echoes from distant and mysterious places and periods, from the east, and from distant parts of Europe. Marie Taglioni (1804–84), one

of the greatest of all ballerinas, is shown time after time in her most famous role in the ballet *La Sylphide* (music by Jean-Madeline Schneitzhoeffer (1785–1852), choreography by Filippo Taglioni (1777–1871), the ballerina's father): this was set in Scotland, the country of glens, mountains, mists and distinctive national dress which so constantly recurs in Romantic art.

Opera, too, attracted the painter of Romantic theatre scenes, and *divas* sat for their portraits: Claudine De Begnis (1800–53) was painted by A. E. Chalon as Fatima in the exotic opera *Pietro l'Eremita* (National Portrait Gallery, London) and Catherine Stephens, Countess of Essex (1794–1882), who in 1813 appeared at Covent Garden in *Artaxerxes*, was painted *c.* 1822 in operatic costume by Samuel de Wilde (1748–1832; Garrick Club, London). Scenes from various ballets and operas were engraved and published in Charles Heath's delightful book *Beauties of the Opera and Ballet* (1845), itself a monument to Romantic book production.

The Romantic era witnessed the decline of the visual tradition established during the Renaissance. By the 1860s artists were taking a new direction, tending to set aside psychological and empirical values, focussing on form for form's sake, and inaugurating what may loosely be termed modern art: impressionism, post-impressionism, abstraction. Painters such as Turner and Constable had demonstrated the properties of light and atmosphere, and had heralded the dissolution of form which was to appear in the work of Claude Monet (1840–1926), Vincent Van Gogh (1853–90), James McNeill Whistler (1834–1903) and Camille Pissarro (1830–1903). Blake was an important precursor of (among other things) art nouveau, presaging, in certain designs in his illuminated books and in some of his watercolours, the serpentine linear convolutions of that style evolved by (for example) Aubrey Beardsley (1872–98). Thomas Jones in his compositions of cityscapes, and Francis Towne and John Sell Cotman in their landscapes, anticipated the pursuit of abstraction which gave rise to developments in post-impressionism, exemplified in the work of John Tunnard (1900–71) and the American Robert Motherwell (b. 1915).

Samuel Palmer's early work (*c.* 1825–35) demonstrated what could be achieved by combining the visual approach of northern painters such as Albrecht Dürer (1471–1528) and Adam Elsheimer (1578–1610) with a simplification of forms and perspective, enriched at the same time with what he called 'the thousand repetitions of little forms'; his vision has inspired painters of the English school in the present century, notably John Craxton (b. 1922).

During the twentieth century, and particularly during the 1940s, there was a return to the Romantic attitude. The most outstanding artists of the mid-century whose work can be called Romantic include David Jones (1895–1974), Leslie Hurry (1909–78), Graham Sutherland (1903–80), John Piper (b. 1903), Ceri Richards (1903–71), Michael Ayrton (1921–75) and Keith Vaughan (1912–77). From 1926 until his death Robin Tanner (1904–88) etched some of the finest modern plates in the Palmer tradition. In painting that tradition, allied to Preraphaelite inspiration, continues in the work of some of the members of the self-styled Brotherhood of Ruralists, among them Peter Blake (b. 1932), Graham Ovenden (b. 1943), David Inshaw (b. 1943) and Ann Arnold (b. 1936).

So long as people exist so will Romanticism. It is an elemental part of the psyche, sometimes dormant, more often manifest. It persists in present-day art. But at no time has it so dominated man's life, outlook and creative power as in the period discussed in this essay and represented by the pictures which follow.

1

RICHARD WILSON (1713/14–82)

Classical Landscape (1761)

Oil on canvas, 126.4 × 209.5 cm
Southampton City Art Gallery

Richard Wilson was born at Penegoes, Montgomeryshire. He was educated by his father, a parson, and in 1729 was sent to London to learn portrait painting under Thomas Wright, an obscure artist. After earning his living for a time from portraiture, he went in 1749 to Italy where, encouraged by Francesco Zuccarelli (1702–88) and the French painter Claude Joseph Vernet (1714–89), he took up landscape and soon made a name for himself. He remained in Italy until 1756, mixing with the cream of visiting English society. When he returned to England, he discovered that through these aquaintances, his reputation had preceded him, and he was soon considered the greatest contemporary landscapist. He was one of the first Royal Academicians and exhibited regularly until 1780. Nevertheless, he was increasingly neglected, and only his appointment as Librarian of the Academy in 1776 saved him from indigence in his last years.

Wilson's art, while in no way pastiche, is influenced by the examples of Gaspar Dughet, Salvator Rosa, Aelbert Cuyp, Claude Lorrain and especially Nicolas Poussin. Claude's influence is paramount in this *Classical Landscape*, a view of Lake Nemi (or, according to some, of the River Arno), with a serene sky, delectable landscape and pale golden light. It was painted after Wilson's return to England, though doubtless from sketches made on the spot, supplemented perhaps, in the manner of †Thomas Gainsborough, by studio models; he is said to have used a decayed cheese for a model in painting rock faces and cliffs. Some of his earlier landscapes were settings for mythological subjects – another resemblance to Dughet and Claude. †Sir Joshua Reynolds disapproved of this juxtaposition, claiming that Wilson's landscapes were too close to reality to admit such subjects. But the same objection might be made to Claude himself, and it may simply have been that Reynolds was attempting to score over Wilson, as the two rarely agreed. Once at a social gathering, Reynolds was proposing the health of Gainsborough, and referred to him as the best landscape painter; 'and the best portrait painter too', added Wilson audibly.

Wilson is one of the greatest landscape painters of the English school; he was also one of the first painters who consciously followed Burke's aesthetic ideas (see Introduction). His Italian subjects, like *Classical Landscape*, established his reputation, but he was equally assured in his portrayals of English landscape, which he transformed into arcadian or sublime visions, drawing on his experience of the clear Venetian light and the golden Roman atmosphere. By the same token he transformed the landscape effects of Claude, Dughet and Rosa into something essentially British, as in his famous portrayal of Cader Idris in the Tate Gallery (see Introduction).

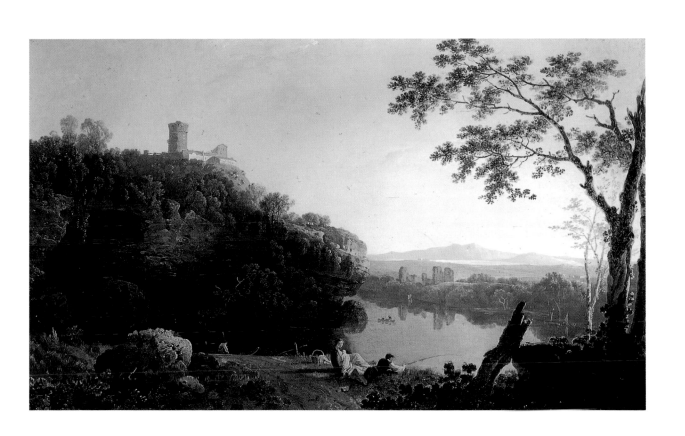

2

ALEXANDER COZENS (*c.* 1717–86)

Rocky Island (*c.* 1780)

Watercolour (monochrome), 463 × 622 mm
Whitworth Art Gallery, University of Manchester

The son of one of Peter the Great's English ship-builders, Alexander Cozens was born in Russia, probably at St Petersburg. (The old story that he was the illegitimate son of the Tsar is pure imagination.) Peter encouraged the arts, but there was no organised teaching available, and it seems that Alexander learned to draw by copying engravings. Later he travelled to Rome to study painting. From there, in about 1742, he came to England, returning to Italy again before finally settling in England in 1746.

Here he soon established himself and began to exhibit. In 1761 he was awarded a prize at an exhibition of the Society of Arts, and during the years 1772–81 he exhibited at the Royal Academy. He also practised at Bath, and taught drawing at Christ's Hospital and Eton College. It is likely that his private pupils included William Beckford of Fonthill, author of the exotic Romantic novel *Vathek* (1786).

Alexander Cozens's technique was original: it consisted of dashing blots (usually dark brown watercolour), not entirely at random, onto a sheet of paper and using them to stir his fancy so as to develop an imaginary landscape. He wrote: 'I scruple not to affirm, that too much time may be employed in copying the landscapes of nature herself' – despite which he did make some conventional watercolours.

Cozens set out the ideas behind his blot method in his illustrated treatise *A New Method of assisting the Invention in drawing Original Compositions of Landscape* (1785), in which he also described how he first alighted on the idea:

> Reflecting one day in company with a pupil of great natural capacity, on original composition of landscape, in contradistinction to copying, I lamented the want of a mechanical method sufficiently expeditious and extensive to draw forth the ideas of an ingenious mind disposed to the art of designing. At this instant happening to have a piece of soiled paper under my hand, and casting my eyes on it slightly, I sketched something like a landscape on it, with a pencil, in order to catch some hint which might be improved into a rule. The stains, though extremely faint, appeared upon revisal to have influenced me, insensibly, in expressing the general appearance of a landscape.

Rocky Island is a typical example of Cozens's blot drawings. The clouds are of a type he frequently used, and carry strong indications of their origin as blots. The imaginary island is convincing, as are the lights on the surface of the water. The tiny ships would have been added after the blots had been worked up into a final design. The emphasis of the composition lies in the series of horizontal planes, an effect reinforced by the dominating horizontal brush strokes.

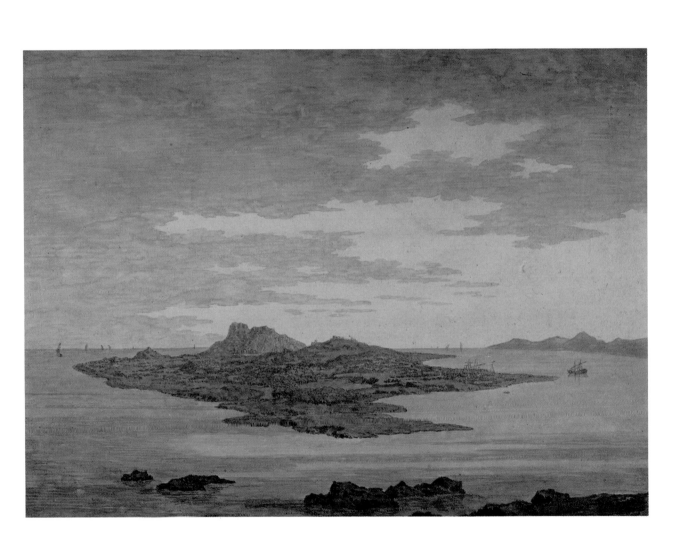

3

SIR JOSHUA REYNOLDS (1723–92)

Master Thomas Lister, later 1st Earl Ribblesdale,
also known as The Brown Boy (1764)

Oil on canvas, 231 × 139 cm
Bradford Art Galleries and Museums

Sir Josha Reynolds, first president of the Royal Academy, was the portrait painter *par excellence*; his rival, †Thomas Gainsborough, once remarked of him, 'Damn him! How various he is!' A glance at his portraits painted over a decade or so easily confirms this variety, ranging from the highly Romantic and sensitive portrait of Lady Chambers (1752, Iveagh Bequest, Kenwood) to the convincing portrayal, worthy of Chardin, of Master John Mudge (1758, private collection, England) and from the Thespian portrait of the actress Kitty Fisher as Cleopatra (*c.* 1759, Iveagh Bequest, Kenwood) to the sober, thoughtful delineation of Laurence Sterne (1761, private collection, England).

Reynolds was the son of a parson who was also master of the grammar school at Plympton in Devon. An early disposition for art was discouraged by his father, but Joshua persisted and was apprenticed to the fashionable portrait painter Thomas Hudson (1701–79). He worked up a successful practice as a portrait painter in Plymouth, but in 1749 he made the mandatory journey to Italy. Returning to England in 1752, he settled in London, and embarked on his career as the leading portrait painter of his age.

Reynolds's contemporary James Northcote R.A. (1746–1831) did not hesitate to speak of him in the same context as some of the greatest masters:

> If I was to compare him with Vandyke and Titian, I should say that Vandyke's portraits are like pictures (very perfect ones, no doubt), Sir Joshua's like the reflection in a looking-glass, and Titian's like the real people. There is an atmosphere of light and shade about Sir Joshua's, which neither of the others have in the same degree, together with a vagueness that gives them a visionary and romantic character, and makes them seem like dreams or vivid recollections of persons we have seen.

What Reynolds saw in Italy considerably influenced his own art. He often used the poses of ancient sculpture for those of his own sitters; several portraits were based on the Apollo Belvedere in the Vatican. The portrait of Master Thomas Lister is no exception for, apart from the boy's extended right arm, the pose reproduces exactly, even to the inclination of the head, that of a marble statue of Mercury in the Uffizi Gallery, Florence (see F. Haskell and N. Penny, *Taste and the Antique*, 1981, p. 266).

Reynolds's picture of dewy-eyed boyhood, still innocent, but on the threshold of puberty (Thomas Lister was twelve when it was painted), set in an idyllic Claudian landscape symbolically lit by the glow of dawn, is one of his most appealing portrayals of youth. The confident aristocrat may also be discerned in the boy's steady gaze. Like so many of Reynolds's portraits, this study combines the individuality of the sitter with a transcendent view of what he is – in this case a boy of noble birth.

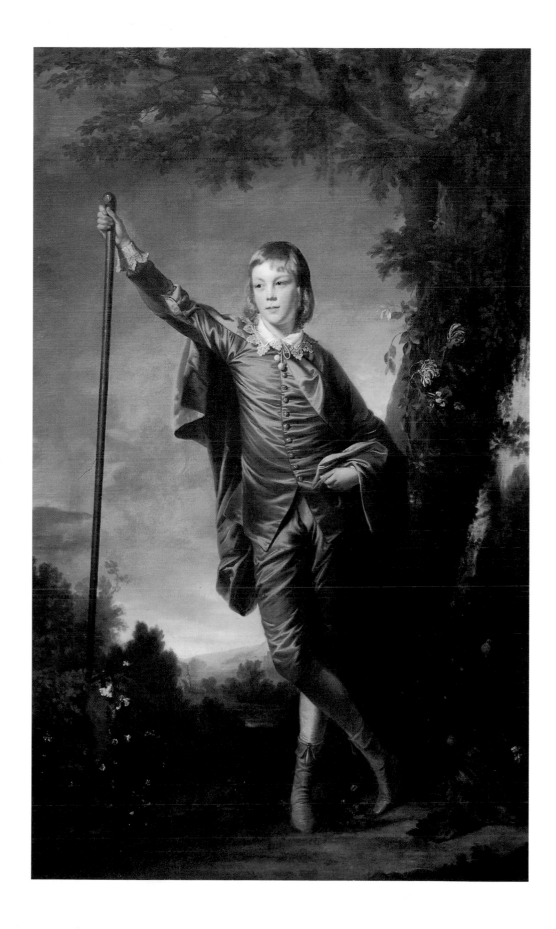

4

SIR JOSHUA REYNOLDS (1723–92)
Sarah Siddons as the Tragic Muse (1784)

Oil on canvas, 236 × 146 cm
The Henry E. Huntington Library and Art Gallery, San Marino, CA

This portrait shows Reynolds looking forward to the spirit of high Romanticism: the actress Mrs Siddons (1755–1831) poses as a mournful and brooding Melpomene, attended by the dark spirits of melancholy and despondency. Such moods were integral elements of Romanticism in all branches of art – for instance in Goethe's novel *The Sorrows of Young Werther* (1774) and in Gottfried August Bürger's poem *Leonora* (1796) – and they were to become everywhere more intense during the first half of the nineteenth century.

Despite his progressive deafness, Reynolds was much attracted to the theatre, and painted some noted actresses in addition to Mrs Siddons, including Kitty Fisher (*c.* 1759, Iveagh Bequest, Kenwood, and *c.* 1766, private collection, England), Mrs Abington (1771, Yale Center for British Art), and Miss Emily Pott as Thaïs (1781, National Trust, Waddesdon Manor). Especially, and on several occasions, he painted his friend David Garrick (1717–79), most notably in *David Garrick between Tragedy and Comedy* (1762, private collection, England), whose subject matter foreshadows the portrait reproduced here.

The pose of Mrs Siddons, like that of Thomas Lister (plate 3), was probably based on antique statuary, perhaps the marble known as the Cesi Juno in the Capitoline Museum, Rome; it also derives from Michelangelo's *Isaiah* on the Sistine Chapel ceiling. Here as elsewhere Reynolds's Romantic art is based on firm classical forms, showing the continuation of Neoclassical principles in certain phases of Romanticism.

The relative merits of derivation from early masters as against the pursuit of 'originality' – itself a much-discussed concept in this period – was the subject of keen contemporary debate. In his *Anecdotes of Painting in England* Horace Walpole defended Reynolds against the charge of plagiarism and proved a true prophet:

> Not only candour, but criticism must deny the *force* of the charge. When a single posture is imitated from an historic picture and applied to a portrait in a different dress and with new attributes, this is not plagiarism, but quotation: and a quotation from a great author, with a novel application of the sense, has always been allowed to be an instance of parts and taste; and may have more merit than the original ... One prophecy I will venture to make: Sir Joshua is not a plagiary, but will beget a thousand. The exuberance of his invention will be the grammar of future painters of portrait.

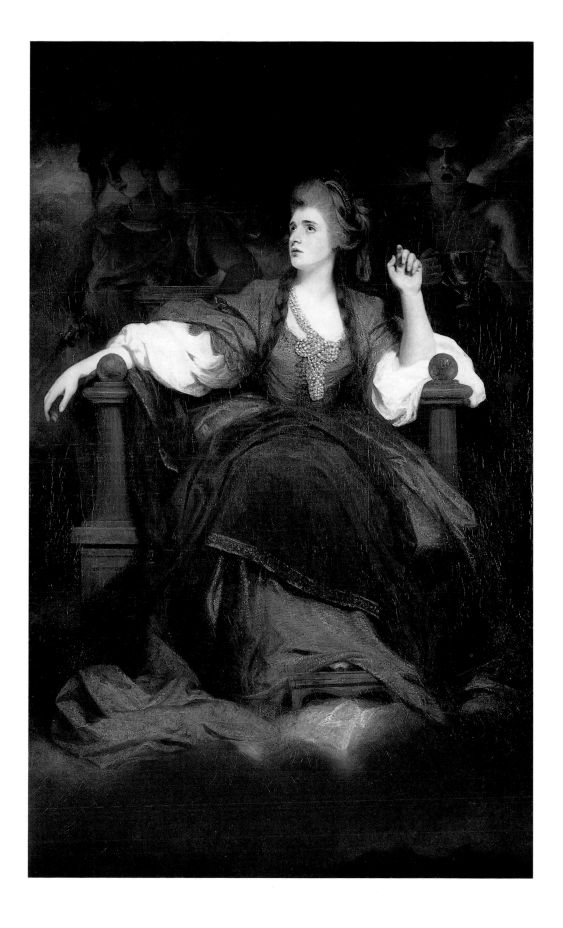

5

GEORGE STUBBS (1724–1806)
Horse attacked by a Lion (?1762)

Oil on canvas, 243.8 × 333 cm
Yale Center for British Art, Paul Mellon Collection

Stubbs is a key figure of the early Romantic period, for although he is known mainly as an animal painter, especially of the horse – itself a favourite Romantic subject – he was also sufficiently a man of his time to want to probe into hidden structures and discover the secrets of what Shelley later called 'Nature's unchanging harmony'. His curiosity extended to studying the anatomical structure of animals, even to dissecting and delineating their usually putrid carcasses; the summit of these enquiries was his great engraved collection of *écorché* (literally, flayed) studies, *The Anatomy of the Horse* (1766).

In studies of animals ranging from tigers and baboons to lemurs and hounds, he illuminated the very quintessence of their individual natures – powerful or timid, fleet or predatory. And in a number of works he demonstrated those essential attributes of the Sublime, violence and terror – Tennyson's 'Nature, red in tooth and claw'.

Usually Stubbs placed an animal in its actual or imagined habitat, but sometimes he used the setting to emphasise the nature of the subject by contrast, as here. The peaceful, Poussinesque landscape throws into greater relief the energy and savage brutality of the superb predator and the terrified panic of its victim. The subject was one to which Stubbs returned several times. In his *Horse frightened by a Lion* (1770, Walker Art Gallery, Liverpool), representing the moment before the attack, the setting is more threatening, the rugged Rosa-like landscape heightening the sense of menace.

The composition of *Horse attacked by a Lion* was based on a marble Roman copy of a Greek original of the same subject, then in the Palazzo Senatorio in Rome, which Stubbs probably saw on a visit to Italy during the 1750s; in that version the horse has collapsed. Stubbs painted a version with the horse collapsed in about 1762–5 (Tate Gallery, on loan). Altogether he painted at least seven versions of the subject in oil and one in enamel, and in 1788 he scraped a mezzotint of it; it was obviously a favourite subject not only of his own, but also of his patrons.

The painting illustrates Stubbs's strong sense of composition. The diagonal formed by the horse's near front leg continues through the lion's foreleg and body, and is paralleled by the horse's and lion's rear legs and tails. This is counterpointed by the positions of the horse's head and lifted front leg, which are in turn echoed by the angle of the tree at the right. All these lines combine to create a pattern of powerful vigour, emphasised by the contrast of the horizontals of the distant landscape.

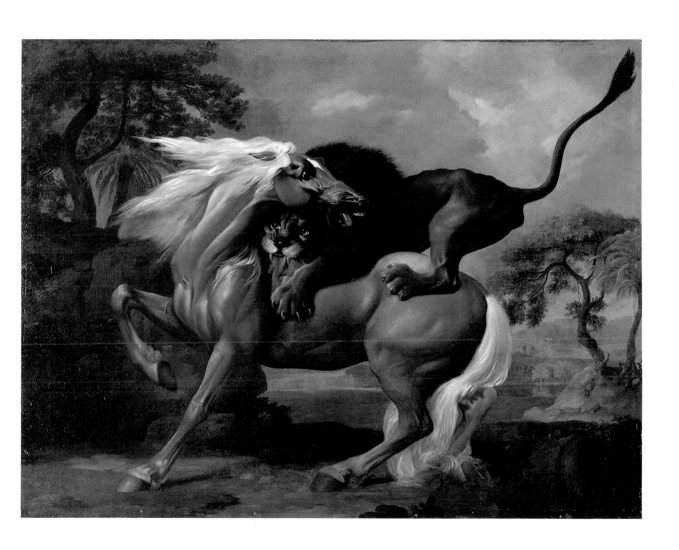

6

THOMAS GAINSBOROUGH (1727–88)

Johann Christian Fischer (1780)

Oil on canvas, 228.6 × 150.5 cm
Reproduced by gracious permission of Her Majesty the Queen

The rivals Gainsborough and †Reynolds were vastly different characters: Sir Joshua was rational, cool, courtly and methodical, while Gainsborough was intuitive, emotional, impulsive and tended to work only when the spirit moved him. Their work is marked by the same contrast – Reynolds's is more highly finished, more carefully painted, Gainsborough's is on the whole more impressionistic, more inimitable.

Gainsborough was born in Sudbury, the youngest of nine children. He attended Sudbury Grammar School, where his uncle was headmaster, but he was often given permission to stay away so that he could go out sketching. At the age of thirteen he was allowed to go to London to study under the French artist Hubert Gravelot (1699–1773).

After setting up his own studio in London for a brief period in 1745, Gainsborough returned to Suffolk, first to Sudbury and then (1752–9) to Ipswich. He began to paint highly accomplished portraits, some in landscape settings, such as *Mr and Mrs Robert Andrews* (*c.* 1748–9, National Gallery, London), others straightforward likenesses, such as *Mrs John Kirby née Alice Brown* (*c.* 1759, Fitzwilliam Museum, Cambridge).

From 1759 to 1774 he practised in Bath, and during this time his portraits reached full maturity, showing in their presentation, technique and colour the influence of Van Dyck and Rubens, yet bearing his own unmistakable stamp, as for example *Ann Ford, later Mrs Philip Thicknesse* (1760, Cincinnati Art Museum; see Introduction). In 1774 he returned to London, where he remained for the rest of his life. During these years he painted his most brilliant portraits, of which one is reproduced here. Fischer was the artist's son-in-law and the finest oboist of his period, and Gainsborough portrays him with sympathy and brilliance.

The composition is based on a play of straight and sloping lines. Fischer's stance against the harpsichord, the pile of music beneath, the open music book and his left leg contrast with the slope of the pen, the oboe and the fiddle on the chair. Further balance is achieved by the horizontals of the keyboard and the pile of music books on the floor, and the verticals of the chair, Fischer's right leg and the leg of the harpsichord. The painting of the coat and breeches of the sitter is beautifully handled, and his agreeable expression and the pearly tints of his skin enliven the portrait. The subtle colour combination of shades of crimson, green and brown completes the harmony of the composition.

Gainsborough was himself deeply interested in music, and often used its terms in discussions of painting. He fancied himself as a performer, and attempted to play several instruments, including the viola da gamba, violin and bassoon; probably not very successfully, for when J. C. Bach called on him one day and found him playing a bassoon, he likened him to a frog about to burst and told him to 'pote it away'.

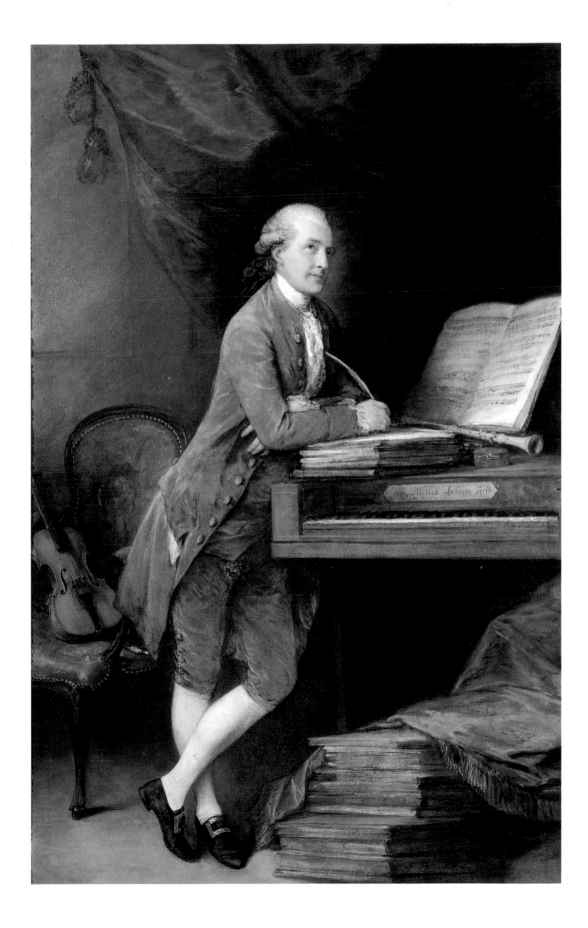

7

THOMAS GAINSBOROUGH (1727–88)

Diana and Actaeon (c. 1785)

Oil on canvas, 158 × 188 cm
Reproduced by gracious permission of Her Majesty the Queen

To many Thomas Gainsborough is pre-eminently a portrait painter, but he is equally important as a painter of landscape, which was in fact his own preference. His landscapes were not invariably based on actual scenery; sometimes he composed them from models he had made out of pieces of coal and cork, for the foregrounds, and of sand and clay, for more distant parts; and he used moss and lichen for bushes, and sprigs of broccoli for woodlands. He also possessed a box of his own devising, in which glass transparencies could be placed one behind another to build up scenery, as on a theatre stage, illuminated from behind by a candle, with a coloured translucent silk screen to diffuse and vary its tone. The box was fitted with an eyepiece and lens through which the effect could be viewed. It is now, with some of the original transparencies, in the Victoria and Albert Museum. It was inspired by Philippe Jacques de Loutherbourg's Eidophusikon (plate 28), which Gainsborough visited several times, and which delighted him so much that, in the words of a contemporary, 'he talked of nothing else'.

Diana and Actaeon, a Claudian conception in glistering colour harmony, is one of Gainsborough's most imaginative landscapes, and the only one of his works with a classical mythological subject. It depicts the moment when Actaeon, hunting in the valley of Gargaphe, comes upon Diana and her nymphs bathing in a stream. He has just received the handful of water Diana has thrown in his face, which has begun to transform him into a stag, and soon he will be slain by his own hounds.

The picture has more the character of a large sketch than of a completed work and is painted loosely, apparently with considerable rapidity and probably with a considerable amount of turpentine mixed in the pigments. This technique was much admired by Gainsborough's rival †Sir Joshua Reynolds, who referred to what he called its apparently fortuitous 'odd scratches and marks', which 'by a kind of magick, at a certain distance assumes form, and all the parts seem to drop into their proper places'.

This is particularly evident in the painting of the foliage of the two groups of trees, whose leaning and twisting movement seems to catch something of the imminent violence of the moment. Gainsborough would have painted these details with his brushes attached to 6-foot sticks, as recalled by the contemporary miniaturist Ozias Humphry.

The masterly qualities of *Diana and Actaeon* recall †John Constable's tribute to his great predecessor in landscape: 'The stillness of noon, the depths of twilight, and the dews and pearls of the morning, are all to be found on the canvases of this most benevolent and kind-hearted man. On looking at them, we find tears in our eyes, and know not what brings them.'

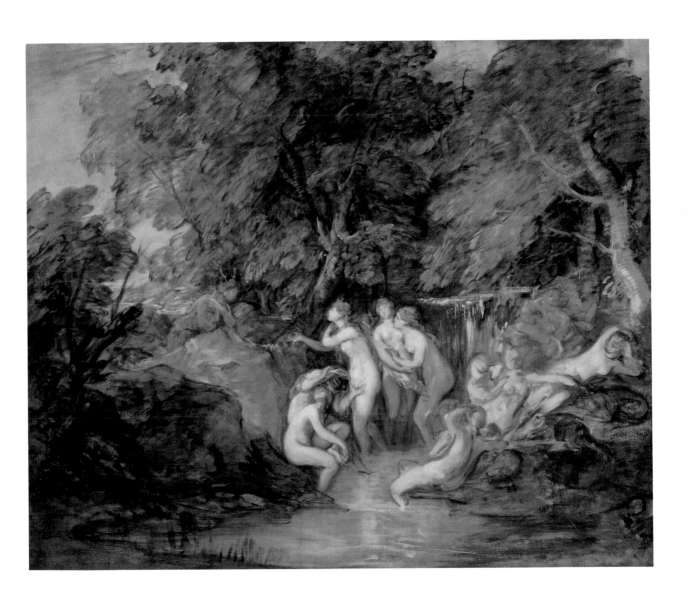

8

JOHANN ZOFFANY (1733–1810)
John Cuff with an Assistant (1772)

Oil on canvas, 89.5 × 69.2 cm
Reproduced by gracious permission of Her Majesty the Queen

Zoffany was born in Germany, of Bohemian descent on his father's side. By the time he was thirteen he had received some instruction in art, but at about this time he ran away from home, arriving eventually in Rome, where, befriended by a cardinal, he lived in a convent. Twelve years later he returned to Germany, and after an unhappy marriage, migrated to England. Here he was at first desperately poor, but obtained work painting clock faces and later became an assistant to †Richard Wilson, for whom he painted draperies at a wage of £40 a year.

In due course he attracted notice as a portrait painter; he was particularly successful in his portrayal of actors in their roles, as in *David Garrick and Mrs Pritchard in 'Macbeth'* (Garrick Club, London). In 1769 he was nominated for membership of the Royal Academy. From 1772 to 1779 Zoffany was again in Italy, where he was honoured by the academies of Bologna, Parma and Tuscany; and during a visit to Vienna (to deliver a portrait of the royal family of Tuscany to the Empress Maria Theresa) he was made a baron of the Austrian Empire. In 1783 he once more left England, this time for a visit to India, which lasted until 1790. His remaining years were spent in London.

Zoffany's portrait of John Cuff and his assistant is a brilliant piece of character painting. Cuff was an instrument maker, and was master of London's Worshipful Company of Spectacle Makers in 1748. He is depicted at his bench in his well-lit workshop, dressed in workaday attire, his spectacles pushed up on his forehead and looking good humouredly out of the picture, surrounded by the tools of his trade. His gaze is plain, direct and uncomplicated, and seems to indicate some amusement that anybody should want to paint him. One of the most important details, appropriately in a portrait of a craftsman, is the beautiful treatment of his capable and sensitive hands, one holding a lens and the other a polishing pad.

The portrayal of his unnamed assistant provides another aspect of character – the somewhat shy diffidence of a workman who is aware of the remarkable skill of his employer.

The conception of *John Cuff and his Assistant* owes much to the directness and accurate reporting of Dutch painting. It illustrates a viewpoint unconcerned with stately pomp and noble essence, but preoccupied with the presence of a simple craftsman at work. It partakes strongly of the Romantic attitude in having greater interest in the precise portrayal of the character of a plain man than in establishing his role as a symbol of a particular social class. To the Romantic, individual character was paramount, whatever the subject.

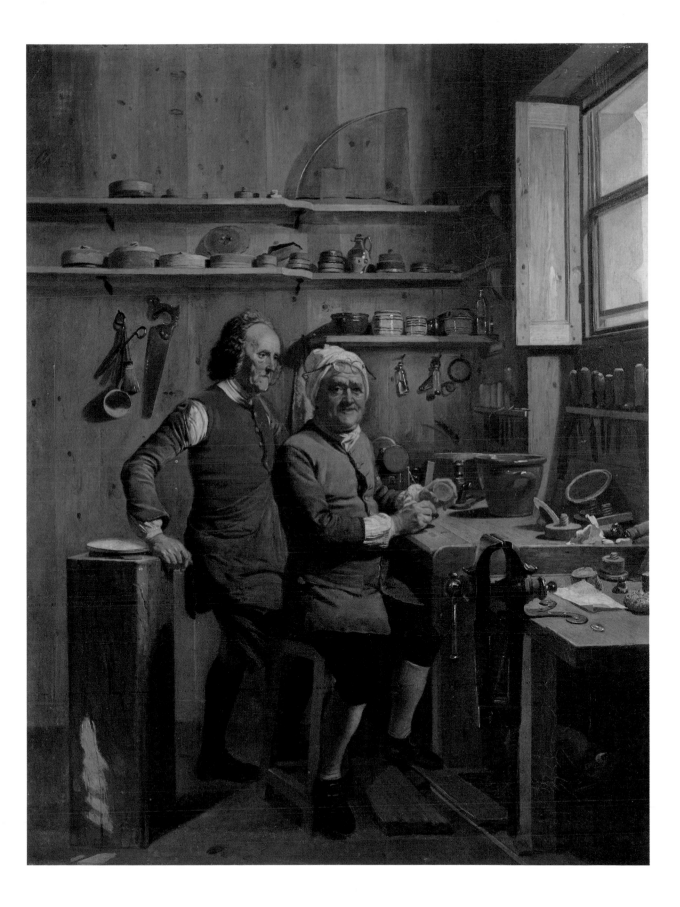

9

JOSEPH WRIGHT OF DERBY (1734–97)

An Experiment on a Bird in the Air Pump (c. 1767–8)

Oil on canvas, 182.9 × 243.8 cm
Reproduced by courtesy of the Trustees, The National Gallery, London

Joseph Wright, known as 'Wright of Derby' after his native town, was the youngest son of an attorney and was educated at the local grammar school. An early aptitude for portraiture was taken seriously by his father, who in 1751 sent him to London to study under the leading portrait painter Thomas Hudson (1701–79); he remained in London for two years, thereafter returning to Derby.

By 1760 Wright was earning his living as an itinerant portrait painter in the Midlands, with Derby as his base. During the early years of the decade he began to paint subjects illuminated by candlelight, an interest which he later developed in those subjects for which he is best known – set pieces bathed in artificial light, moonlight or firelight, many inspired by contemporary industrial scenes and scientific experiments. He was closely associated with men in the vanguard of the Industrial Revolution, including Sir Richard Arkwright (1732–92), and especially with members of the Midlands philosophical club known as the Lunar Society, such as Josiah Wedgwood, Joseph Priestley and Erasmus Darwin.

In 1773 Wright went to Italy, visiting Rome, Naples, Florence and Bologna. He was particularly impressed by an eruption of Vesuvius, which he subsequently painted several times (for example the version in Derby Museum and Art Gallery, painted in 1774). He also painted a *girandola* (firework display) at the Castel Sant'Angelo, Rome (*c.* 1774, Birmingham Museum and Art Gallery). Such experiences led to an enrichment of his art, and helped to strengthen his attention on dramatic lighting effects, as in *Cottage on Fire* (*c.* 1790, Yale Center for British Art, Paul Mellon Collection). He exhibited at the Royal Academy from 1778; he was made an associate in 1781 and was offered full membership in 1784, but declined for reasons which are not clear.

Wright's portraits are often highly Romantic, and that of Sir Brooke Boothby (1780–1, Tate Gallery) is especially brilliant: it shows the sitter reclining in a grove with a book in his left hand, a setting and attitude worthy of the poet he was. Besides portraits, Wright painted scenes from literature, allegorical subjects, genre pieces and landscapes.

One of Wright's most impressive scientific studies is the painting reproduced here, in which a young girl, her face buried in her hands, is reduced to tears by the fate of the bird in the glass globe, which will die when the air is pumped out. A young boy has hastened to the window, as if to open it and flood the room with air to relieve the claustrophobic feeling induced by the experiment. The artist has introduced the Romantic elements of suspense and terror, albeit in low key, and has intensified them by the dramatic artificial lighting, adding the no less Romantic light of the moon outside the window.

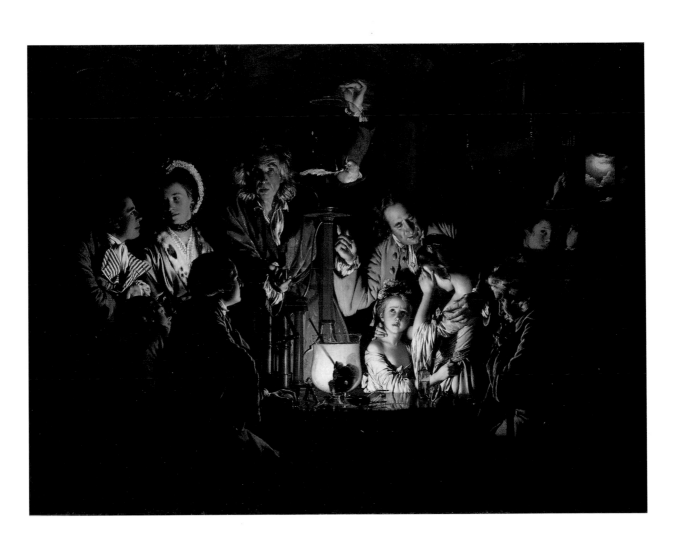

10

GEORGE ROMNEY (1734–1802)

Prince William Frederick, 2nd Duke of Gloucester (1791)

Oil on canvas, 236 × 167 cm
Reproduced by permission of the Master and Fellows of Trinity College, Cambridge

George Romney, the son of a cabinet maker, was born at Dalton-in-Furness, Lancashire. He was apprenticed to Christopher Steele (also known as Count Steele, *c.* 1730–*post* 1762), an itinerant portrait painter, and for a time earned his living in the same way, travelling from town to town, picking up portrait commissions where he could. Early in his apprenticeship, in 1756, he married a former servant girl, but after a time they separated, and when Romney went to London in 1762, he divided his sparse savings with her. He visited France in 1764 and Italy in 1773. He met [†]Fuseli in Rome and was much impressed by his work, particularly his pencil and pen, ink and wash drawings, which have a dramatic, excitable, and sometimes even wild quality.

He was on friendly terms with many contemporary Romantics, including the scholar, art patron and minor poet William Hayley (1745–1820), who wrote a *Life of George Romney, Esq.* (1809), and at whose residence, Eartham in Sussex, he met the poet William Cowper, who wrote a sonnet to him. He was acquainted with, among others, [†]William Blake, [†]John Flaxman and the dilettante George Cumberland (1754–184?). In his last years an already apparent tendency to morbidity developed into complete insanity. He returned to his wife and died at Kendal, aged sixty-eight.

Romney is best known for his portraits; the one reproduced here shows Prince William Frederick (1776–1834), a great-grandson of George II, in the academic robes of a nobleman. He entered Trinity College, Cambridge, in 1787 at the early age of twelve, the first member of the royal family to enter a Cambridge college. He was awarded the M.A. in 1790, and the LL.B. in 1796; in 1811 he became chancellor of the University. Primarily a soldier, William Frederick was nevertheless a man of liberal views who interested himself in many charitable and philanthropic causes, including the rights of negroes and Catholic emancipation.

Like Reynolds's portrayal of Thomas Lister (plate 3), Romney's portrait is a brilliant interpretation of the Romantic aspect of sexually ambiguous boyhood beauty. At the same time it accentuates the subject's pride, and his consciousness of his own regality. The pose is probably based on a classical model; it shares many features of the bronze (probably Greek) known as the *Idol*, but perhaps personifying Ganymede or Dionysus, in the Museo Archaeologico, Florence (see F. Haskell and N. Penny, *Taste and the Antique*, 1981, p. 241), plaster casts of which were freely available.

The portrait was probably presented to Trinity College soon after its completion. Romney's fee was £100, but as his bill was not promptly paid, an extra £30 for interest was added. It was engraved in 1793 by John Jones (*c.* 1745–97), engraver to the Prince of Wales and to the Duke of York and Albany.

Romney's portraits influenced those of [†]Sir Thomas Lawrence, who brought the type to perfection.

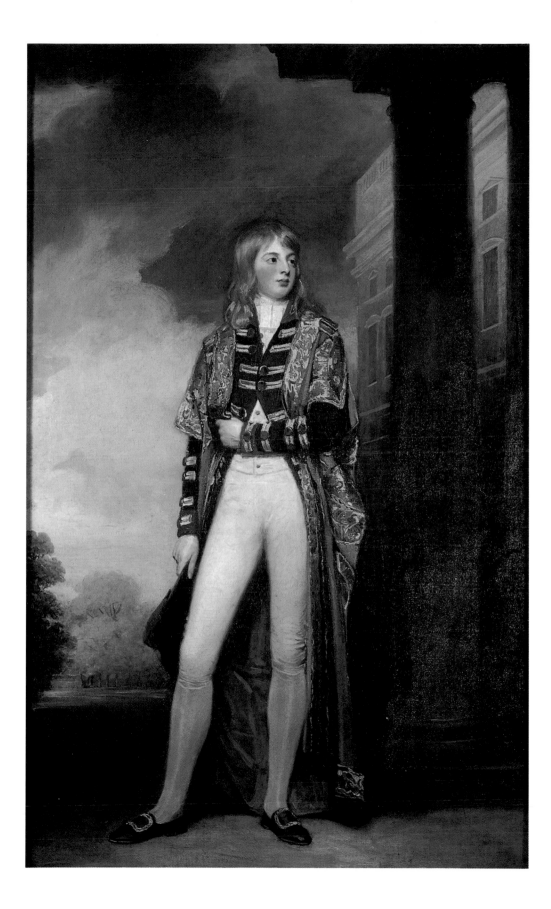

11

ALEXANDER RUNCIMAN (1736–85)

The Death of Oscar (*c*. 1770?)

Black lead, pen and wash, 500 × 350 mm
National Gallery of Scotland, Edinburgh

Alexander Runciman, a native of Edinburgh, was the son of a builder. When he was fourteen he was put with John Norris, an obscure landscape painter, as his assistant, and five years later he set up on his own, first as a landscape painter and then as an historical painter, but without success. He decided that he ought to study the works of the great masters and so, with his brother John (1744–68), also a painter, he travelled to Rome, assisted by the patronage of Sir James Clerk, Bt, of Penicuick.

In Rome, besides studying Italian art, Runciman met †Fuseli, and the two men deeply influenced one another; their work shares an exaggerated, excitable quality, and in later life Runciman's soubriquet in the Cape Club at Edinburgh was 'Sir Brimstone'. Fuseli, in a letter from Rome, said that in his opinion Runciman was 'the best *Painter* of *us* in Rome'.

Runciman returned to Edinburgh in 1771 and became one of the masters in the drawing school of the new Scottish Academy; his salary is said to have been £120 a year. In his forty-ninth year, he collapsed and died in the street outside his lodgings.

In Rome Runciman worked on a series of designs, based on the life of Achilles, to decorate ceilings at Penicuick House, but he put these aside and turned instead to subjects from Gaelic mythology, probably contrary to his patron's preference. However, he got his way, and one ceiling contained twelve subjects from the works of 'Ossian' – free arrangements of Gaelic poems made by James Macpherson but claimed by him to be literally translated from the work of a legendary third-century Gaelic warrior poet of that name. 'Ossian' was perfectly calculated to suit the Romantic taste for the Sublime in literature, having epic proportions and events, strikingly terse 'simplicity' of diction, a wild and misty northern setting, and a generous admixture of high pathos and sentiment; and it was immensely popular. Runciman's murals came to be known as 'the Sistine Chapel of the North'. They were destroyed by fire in 1899. Another ceiling, in a cupola over the staircase, contained paintings of events from the life of Queen Margaret of Scotland. Runciman reproduced some of the subjects of these murals in a series of etchings.

The Death of Oscar is a study for one of the Penicuick subjects, and is based on a passage from 'Ossian' (*Temora: An Epic Poem*, Book I): 'We saw Oscar on his shield. We saw the blood around. Silence darkened every face. Each turned his back and wept. The King strove to hide his tears. His grey beard whistled in the wind. He bends his head above the son. His words are mixed with sighs.'

Oscar, son of Ossian son of Fingal, is depicted writhing in agony on the ground, with Ossian blessing him. His figure is almost certainly derived from that of Michelangelo's Adam on the ceiling of the Sistine Chapel.

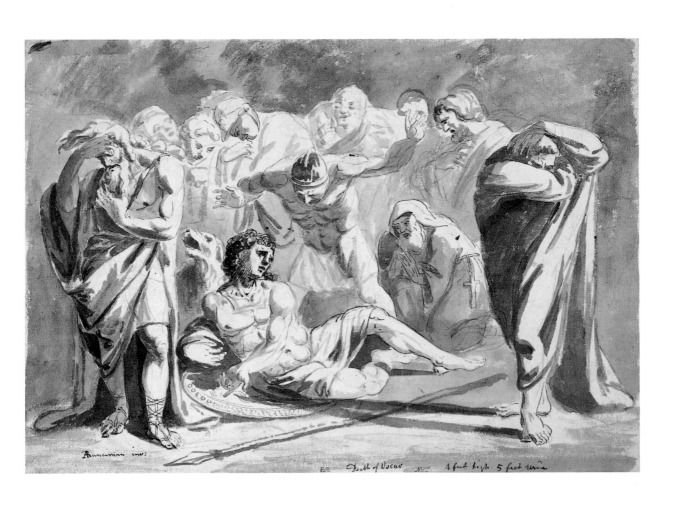

Runciman inv: Death of Oscar 4 feet high 5 feet wide

12

JOHN SINGLETON COPLEY (1737–1815)
Watson and the Shark (1778)

Oil on canvas, 91.4 × 77.5 cm
The Detroit Institute of Arts, Founders Society Purchase,
Dexter M. Ferry Jr Fund, 46.310

Of Anglo-Irish descent, John Singleton Copley was born at Boston, Massachusetts; his parents had emigrated to America in 1736. His father died in 1737 and Mrs Copley remarried. Her second husband, Peter Pelham of Boston, was a cultured man who attended to his stepson's education and encouraged his artistic inclinations, helping to prepare the foundations of his wide and prosperous practice as a portrait painter. In 1766 Copley sent one of his portraits to †Benjamin West, the American second president of the Royal Academy, requesting him, if he could, to get it exhibited in London, and seeking his advice about a visit to Europe.

This visit was delayed because in the meantime Copley married, and his wife presented him with three children. However, by June 1774, he was able to come to England, where West befriended him, showed him around and introduced him to †Sir Joshua Reynolds. Almost immediately he received numerous portrait commissions, but despite this initial success he decided to broaden his outlook by a trip to the continent, where he visited Italy, Austria, Germany and Holland. In 1776 he returned to England and settled here; he was elected an associate of the Royal Academy in the same year, and became an academician in 1779. At about this time he began to divide his work between fashionable portraiture and historical subjects, of which *Watson and the Shark* was the earliest. Towards the end of his life he became paralysed.

Watson and the Shark illustrates an incident in Havana harbour. The central subject is the fourteen-year-old Brook Watson (1735–1807), who later became Lord Mayor of London, Commissary-General to the forces, and a baronet. Swimming in the harbour, he was attacked by an enormous shark, and was lucky to escape with only the loss of a leg. The rescue was celebrated in a coat of arms later granted to Watson, showing Neptune striking with his trident at a shark about to seize its prey.

Commissioned by Watson himself, Copley's theatrically lit rendering is a powerfully Romantic evocation of the horrid and fearsome aspect of nature – another face of the appalling terror exemplified in Stubbs's *Horse attacked by a Lion* (plate 5). It has (justifiably) been seen as a precursor of *The Raft of the Medusa* by Théodore Géricault (Louvre, Paris), painted forty-one years later, although its composition is much simpler than the involved layout of that masterpiece.

For his composition Copley used a system of horizontal and vertical accents, held together by diagonals, emphasised by the T-shaped conjunction of the boat's oar lying parallel to Watson's body and the fishing spear aimed at the shark's head.

Several drawings of details exist, and there are other versions of the painting, including the large oil (182 × 230 cm) in the National Gallery of Art, Washington, DC.

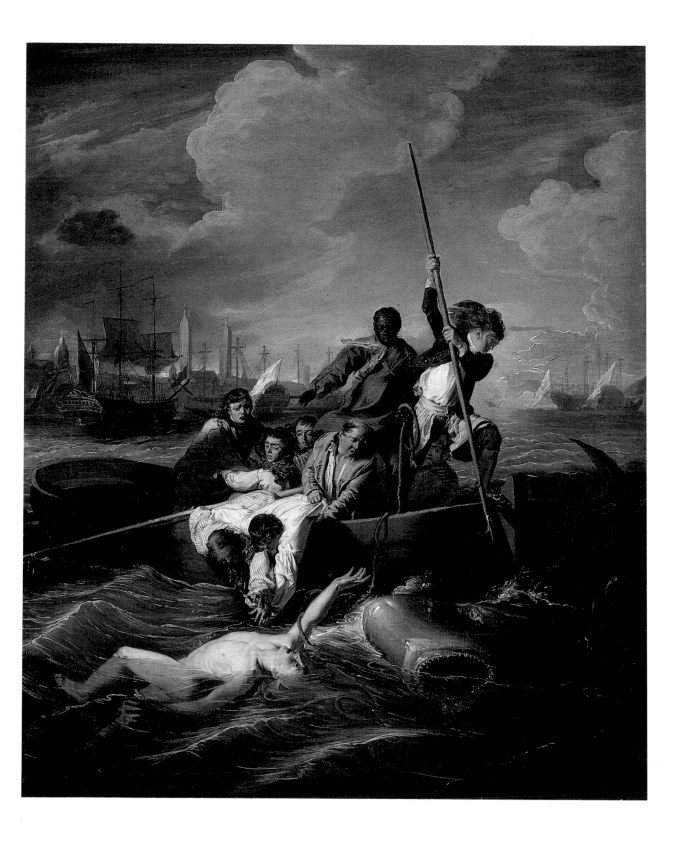

13

BENJAMIN WEST (1738–1820)

Saul and the Witch of Endor (1777)

Oil on canvas, 52 × 69 cm
Wadsworth Atheneum, Hartford, CT, Bequest of Clara Hinton Gould

Benjamin West, who was of English descent, was born at Springfield, Pennsylvania. As a child he declared his intention of becoming an artist, and, although his parents were Quakers, they were so impressed by his gifts that they allowed him to follow his inclinations. He set up as a portrait painter when he was eighteen, working especially at Philadelphia and New York. With the help of a gift of money from a merchant, he spent three years in Italy (1760–3). There he met the painters Anton Raphael Mengs (1728–79) and Gavin Hamilton (1723–98), and under their influence adopted many of the attributes of the Neoclassical style.

In 1763 West came to England, where he spent the greater part of his working life. He soon became a fashionable painter of biblical, historical and allegorical subjects, such as *Belshazzar's Feast* (1777, The Berkshire Museum, Pittsfield, MA), *William Penn's Treaty with the Indians* (1772, Pennsylvania Academy of Fine Arts, Philadelphia) and *The Triumph of Death* (begun 1783, Royal Academy, London). He was appointed historical painter to George III in 1772, and was twice president of the Royal Academy (1792–1805, 1806–20).

West's style, basically Neoclassical with a measure of realism, became more Romantic under the influence of †Fuseli and †Mortimer, as is evident in *Saul and the Witch of Endor*, a subject charged with sublime horror. It is taken from I Samuel XXVIII. 7–20, in which Saul asks the Witch to call up the spirit of Samuel, that he may seek his counsel, 'for the Philistines make war against me, and God is departed from me, and answereth me no more, neither by prophets, nor by dreams'. The spirit has no comfort to offer Saul, and predicts: 'tomorrow shalt thou and thy sons be with me: the Lord also shall deliver the host of Israel into the hand of the Philistines'.

The influence of Salvator Rosa's treatment of the same subject (Louvre, Paris), which West probably saw when he visited Paris in 1802, may be discovered in West's interpretation. It is a highly theatrical rendering – the bower of clouds from which Samuel's spirit is speaking could easily be taken for a stage property and its artificiality is emphasised by the contrasting realism of the figures: the Witch at the left, Saul's two attendants who appear to be about to run away in terror from the apparition, and the prostrate figure of Saul who, in the Bible episode, 'fell straightway all along on the earth, and was sore afraid, because of the words of Samuel: and there was no strength in him'.

A print of West's painting was engraved in 1788 by William Sharp (1749–1824).

14

FRANCIS TOWNE (1739/40–1816)

The Source of the Arveiron: Mont Blanc in the Background (1781)

Pen and watercolour, 425 × 311 mm (on four sheets of paper)
Victoria and Albert Museum, London

Little is known of the early years of Francis Towne. He was probably born in Exeter and began to paint in oils when he was fourteen, perhaps at W. Shipley's School, off the Strand in London. In 1759 he won a premium of the Society of Arts for 'an original design for Cabinet makers, Coachmakers, manufacturers in Metals, Chinas and Earthenware'. He exhibited, mostly landscapes, at the Society of Artists, the Free Society, the British Institution and the Royal Academy. By 1777 he had turned to watercolour, and in that year was living in Exeter, having set up as an artist and teacher.

Soon afterwards he set out on tour of Wales, and subsequently he visited Italy, where he made Rome his centre, and Switzerland; he returned to England in 1781, and in 1786 he toured the Lake District.

In 1807 he married an attractive young ballet dancer, Jeannette Hillinsberg, who was forty years his junior, but their happiness was short-lived, for she died in the following year. Nine years later Towne himself died; he was seventy-seven.

Towne's watercolours have an appealing simplicity and pellucidity, and consist usually of sensitive, nervous outlines in pen or pencil, reminiscent of etched lines, filled in with washes of lambent colour. In *The Source of the Arveiron*, and in many other compositions, such as *The Vale of St John looking towards Keswick* (1786, City Art Gallery, Leeds) and *Raven Crag with Part of Thirlmere* (1786, Fitzwilliam Museum, Cambridge), Towne reaches almost into the abstract. The features of the landscape are reduced to the simplest outlines, but the view still retains its topographical identity. He demonstrates, indeed, a new way of looking at landscape by reducing it to its basic elements, yet without loss of essential detail. In this he seems to anticipate Cézanne and his followers, and certainly resembles Japanese colour-print artists (cf commentary to plate 40).

Sometimes Towne's watercolours are nearer to the compositions of Claude and Rosa, but they still remain unmistakably his own – for example *St Peter's at Sunset, from above the Arco Oscuro* (1781, British Museum), which depicts the golden glow of a Roman sunset. Taken from a height, the view affords a contrast between dark but still translucent trees and rocks in the foreground, and the distant sunset-drenched Vatican and dome of St Peter's. It is a serene, restful composition, completely satisfying to the eye and reminiscent of Claude at his most genial.

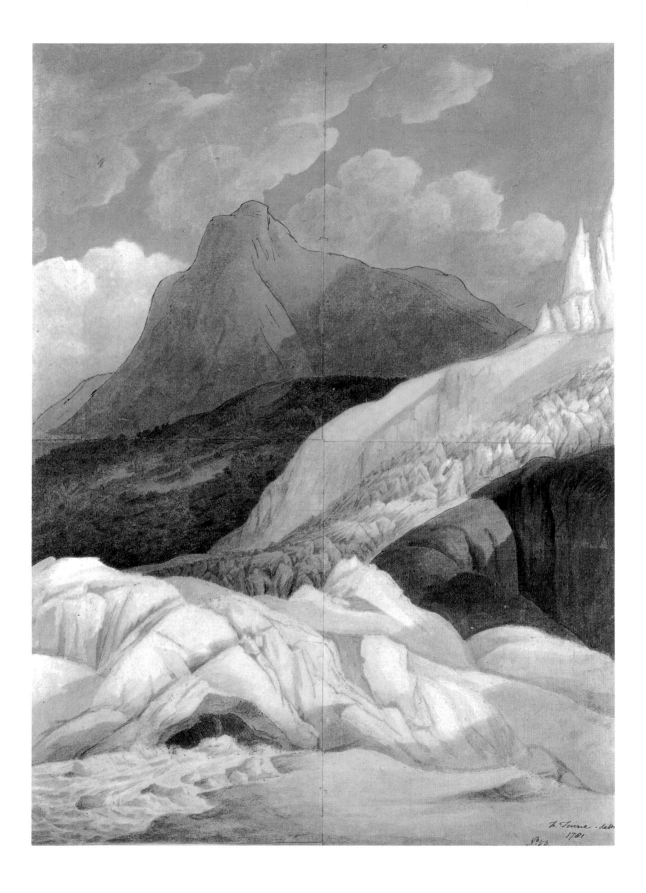

F. Tourne. del.
1781
N°53.

15

PHILIPPE JACQUES DE LOUTHERBOURG (1740–1812)
The Shipwreck (1793)

Oil on canvas, 109.8 × 160.5 cm
Southampton City Art Gallery

Loutherbourg was born at Strasbourg, the son of a miniaturist. He studied painting under Carle Van Loo (1705–65) and afterwards with Francesco Casanova (1727–1802). The philosophical writer Denys Diderot (1713–84) noticed him, and especially praised his rustic scenes; he was made a member of the Académie Royale at the early age of twenty-six.

After visiting Italy and Switzerland, Loutherbourg settled in England in 1771. Here he met the actor David Garrick, who engaged him to design scenery and costumes, and to oversee the stage machinery at Drury Lane Theatre at a salary of £500 a year. He worked for Garrick's successor Richard Brinsley Sheridan (1751–1816) until 1785.

Loutherbourg exhibited at the Royal Academy from 1772, becoming an associate in 1780 and an academician in the following year. At about this time he began to design his Eidophusikon (plate 28). He visited Switzerland again in 1783, and the Netherlands in 1793.

Loutherbourg temporarily abandoned painting for a period from 1789, in order to concentrate on his interest in the supernatural and alchemy. In this connection he met Alessandro di Cagliostro (1743–95), who instructed him in the occult sciences and faith-healing; this led to several watercolour studies with Masonic and Egyptian themes. A pamphlet issued in 1789 by Mary Pratt, a friend of Loutherbourg who described herself as 'a lover of the Lamb of God', claimed that he could cure 'all manner of diseases – deafness, lameness, cancer'.

During the last quarter of the eighteenth century, Loutherbourg was the principal exponent in England of the French tradition of landscape painting. His work was much influenced by that of Claude Joseph Vernet (1714–89) and Hubert Robert (1733–1808), but his conceptions also have more than a dash of the rugged style of Salvator Rosa.

This is evident in *The Shipwreck*, a subject full of the overbearing grandeur of nature beloved by the Romantics which Loutherbourg raises to the highest pitch. He introduces a narrative element to give an extra frisson to his scene of appalling storm and menace: a ship, whose hulk lies in the distance, has been lured on to rocks by wreckers. Local peasants, including a woman, some armed with pitchforks, are attacking the wreckers and attempting to rescue the shipwrecked sailors and passengers. Pathos is added to the tragedy by the family group on the rocks: the outstretched hand of the dying father fails to reach the little boy, who clings to the body of his mother. The colours are chilly and lurid, and the contrasts of lighting enhance the sense of terror.

Loutherbourg greatly admired English scenery, and a series of his drawings, reproduced by aquatint and entitled *Picturesque Scenery of Great Britain* was published in 1801; this was followed in 1805 by a second set. Loutherbourg's free execution much influenced the work of †Thomas Gainsborough and †John Martin.

Loutherbourg also painted allegorical, historical and symbolic works, and he contributed illustrations to the Bible published in 1800 by Thomas Macklin (*fl.* 1783–1800).

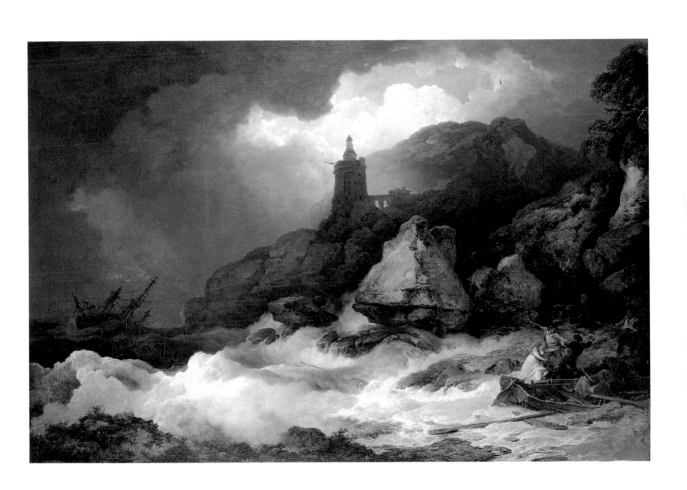

16

JOHN HAMILTON MORTIMER (1741–79)

Nebuchadnezzar recovering his Reason (*c.* 1771)

Pen and ink, 406 × 368 mm
Reproduced by courtesy of the Trustees of the British Museum

An Eastbourne miller's son, John Hamilton Mortimer was fortunate in having a percipient uncle who was a painter and recognised his artistic bent. He was sent to London, where he studied under Thomas Hudson (1701–79), the fashionable portraitist who had also taught †Joshua Reynolds and †Joseph Wright of Derby; at the St Martin's Lane Academy; and with Reynolds, Robert Edge Pine (1730–88) and Giovanni-Battista Cipriani (1727–85). In 1763 he gained first prize at the Society of Arts for a drawing from the antique, and in 1764, in competition with †George Romney, he won a premium of 100 guineas (£105) for the best historical picture. He was elected an associate of the Royal Academy in 1778; he was due, by special dispensation, to become an academician soon afterwards, but died before this could be achieved.

Besides historical subjects, Mortimer painted portraits and allegory, but he was especially gifted in the portrayal of horrific subjects, some probably partly based on what he had heard of opium dreams. For example in *Skeleton of a Sailor and Vultures on a Shore* (British Museum), the predatory birds which have devoured the flesh are an unpleasant reminder that to the wilder elements of nature humanity is not sacred. *Death on a Pale Horse* (from the Book of Revelation), now lost but known from an etching of it made in 1784 by his pupil Joseph Haynes (1760–1829), suggests one of Mortimer's sources, for it has affinities with Albrecht Dürer's woodcut *The Four Horsemen of the Apocalypse*.

In *Nebuchadnezzar recovering his Reason* Mortimer takes a subject also used by †William Blake, but his portrayal is less horrific than Blake's haunted study (Tate Gallery), which shows Nebuchadnezzar in the pit of his misery. Nevertheless, the king is drawn as he appeared when he was 'driven from men, and did eat grass as oxen, and his body was wet with the dew of heaven, till his hairs were grown like eagles' feathers, and his nails like birds' claws' (Daniel IV.33). Mortimer shows Nebuchadnezzar in the act of rising into the upright position of rational man, supporting himself on a rock as he does so; he is caught in a shaft of divine light into which he looks with thankful relief as he recovers from his bestiality. The narrative in the Book of Daniel continues: 'And at the end of the days I Nebuchadnezzar lifted up mine eyes unto heaven, and mine understanding returned unto me, and I blessed the most High, and I praised and honoured him that liveth for ever, whose dominion is an everlasting dominion, and his kingdom is from generation to generation.' It is a profound moment during which a soul is released from torment.

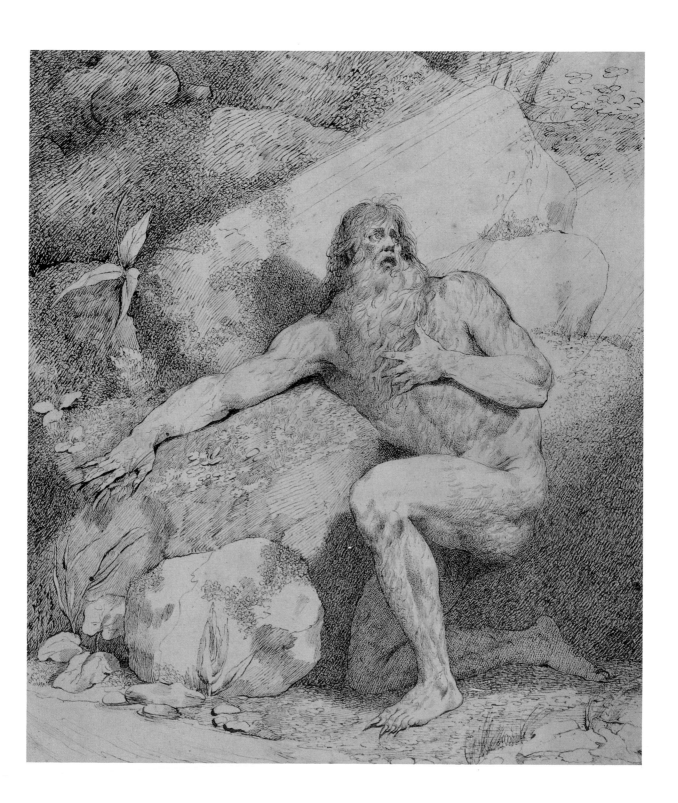

17

JOHN HENRY FUSELI (1741–1825)
The Nightmare (*c*. 1782–91)

Oil on canvas, 75.5 × 64 cm
Freies Deutsches Hochstift, Frankfurt am Main

Fuseli (the anglicised form of his name, Füssli) was born in Zurich in 1741; his father was a town clerk and an amateur of art. He studied art history under his father's guidance, but decided to become a minister of the Swiss reformed church founded by Huldreich Zwingli, and was ordained in 1761. After following this calling for a time and engaging in various literary pursuits, he was introduced in 1768 to †Sir Joshua Reynolds, who persuaded him to become a painter; to this end he visited Italy. In 1788 he settled in England and became an important figure in British contemporary art.

He was a complex character, full of psychological contradictions which are evident in his work, and nowhere more manifest than in his most famous subject, *The Nightmare*. He made several versions of it, notably one now in the Detroit Institute of Arts (*c*. 1782).

Like many Romantics, Fuseli was fascinated with dreams, both good and bad, and it is recorded that he ate raw pork chops in order to induce nightmares. But *The Nightmare* is no mere record of a bad dream, rather a well-ordered composition of symbols with strongly sexual connotations. The woman lies in an abandoned position, as she might be after intercourse, with an incubus sitting on the pit of her stomach; he has apparently ridden into the room on the back of the ghostly horse, a masculine symbol as old as history, and one associated with the devil (the *mare* in nightmare is not a female horse, but is derived from *mara*, a mythological spirit which tormented sleepers). The mirror at the right reflects nothing of horse or incubus: this emphasises that they exist only in the sleeper's imagination.

The composition is based on the double curve of the sleeper's body, which is continued in the neck of the horse. This curve is balanced by another, again double, formed by the woman's right arm and breast and continued in the back of the incubus.

The figure of the sleeper was probably derived from that of Dido in Reynolds's painting *The Death of Dido* (1781, collection of H.M. the Queen), and the head of the horse from that peeping from behind a curtain in Veronese's *Venus and Mars* (1575–84, Galleria Sabauda, Turin) or possibly from the horses in the statuary groups *The Horse Trainers* in the Piazza Quirinale, Rome.

There was probably also a more subjective influence on the work; some have seen in it a transfer of Fuseli's frustrated passion for a young Zurich girl, Anna Landolt. On the back of the version at Detroit is a portrait that possibly represents Anna.

The Nightmare was a popular work, and its composition was used by many contemporary political caricaturists, including Rowlandson, Robert Seymour and George Cruickshank.

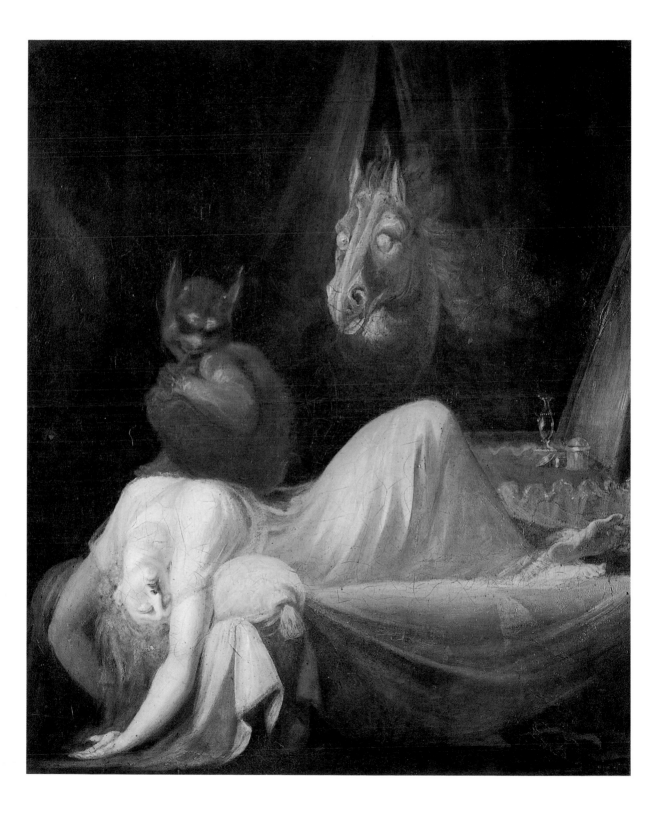

18

JOHN HENRY FUSELI (1741–1825)
A Nude reclining and a Woman playing the Piano (1799–1800)

Oil on canvas, 71 × 91 cm
Oeffentliche Kunstsammlung Basel, Kunstmuseum

This painting illustrates the perverse, wanton and sardonic aspects of Fuseli's work. The composition was based on Titian's *Venus and the Organ-Player* (Prado, Madrid): Fuseli's two figures reproduce almost exactly the pose of Titian's. But Fuseli supplanted Titian's heterosexual subject with one with strongly lesbian overtones. He gives to the beautiful nude girl, whose curvaceous, emphatically feminine figure recalls the Mannerist figures in the work of Parmigianino (Michele Rocca, *c.* 1670/5–1751), a female companion, who serenades her as she waits receptively. Her right hand resting on the back of the sofa appears to echo the left hand of the pianist, and her second finger is accentuated, as if in readiness to titillate her partner, whose own hands, as they roam over the keys, seem ready to explore the erogenic zones of her companion's luxuriant form.

The player is sinister, her hair-style giving her a predatory appearance – reminiscent of a fox perhaps, or a spider. Hair is a great fetish in Fuseli's work. On woman after woman, hair-styles are tortuous, knotted, tightly plaited, or loosely arranged in every imaginable and outlandish shape. In a portrait drawing of his wife seated by the fire, with a relief of the Medusa behind her, Mrs Fuseli has such an elaborate and piled-up *coiffure* that she might almost herself be a clone of the Medusa (Germanisches Nationalmuseum, Nuremberg). Some of these hair-styles have phallic overtones, while many others seem to indicate powerful female sexual aggression.

Fuseli's colouring is usually restrained, and here the combination of nacreous flesh tints, low-toned reds and blues suggests a tender light which prevents the subject from becoming too strident. Occasionally he heightens the key by placing a few spots of bright colour in the composition, but he was not really a brilliant colourist; his strength lies in line, in composition and most of all in the remarkable psychological content of his subjects. It was this latter, with all its implications of sexual perversity, fetishism and downright *diablerie*, that constituted his particular contribution to the spirit of Romanticism.

†Benjamin Robert Haydon wrote in his diary:

[Fuseli's] women are all whores, and men all banditti. They are whores not from a love of pleasure but from a hatred, a malignant spite against virtue, and his men are villains not from a daring desire of risk, but a licentious turbulence of moral restraint; with the look of demons, they have the actions of galvanised frogs, the dress of mountebanks, and the hue of pestilential disease. Such a monstrous imagination was never propagated on lovely women. No. Fuzeli [*sic*] was engendered by some hellish monster, on the dead body of a speckled hag, some hideous form, whose passions were excited & where lechery was fired at commingling with fiery rapture in the pulpy squashiness of a decaying corpse.

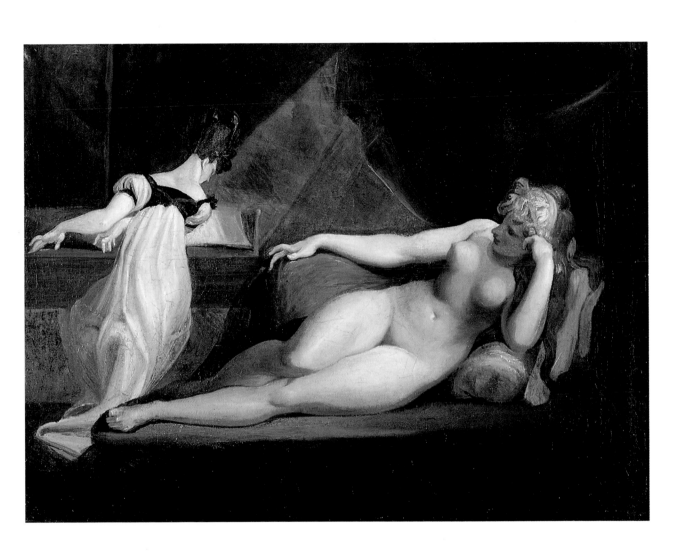

19

THOMAS JONES (1742–1803)
Buildings in Naples (1782)

Oil on paper, 14 × 21.5 cm
National Museum of Wales, Cardiff

Thomas Jones was born into a family of Radnorshire landowners. As a younger brother he was destined for the church, and was preparing to take his degree at Oxford, when the relation who had underwritten the cost of his education died, and left him without support; Jones thereupon decided to follow an old preference and become a painter instead. He went to London, where he studied drawing at the St Martin's Lane Academy and at Shipley's school in the Strand; thereafter for two years he studied landscape under †Richard Wilson. He worked in Italy, particularly in Naples and Rome, during 1776–83. Soon after his return to England he inherited the family lands, where he lived for the remainder of his life.

Jones painted landscapes in two distinct styles, one more conventional than the other. His conventional manner was much influenced by Wilson, but is less lyrical in feeling than Wilson's own work. In his other style, mainly in Italy but also in Wales and in the London area, he relied directly on nature, eschewing the contrived features of landscape composed and painted in the studio: these works were created in the open air, anticipating †John Constable, Pierre Henri Valenciennes (1750–1819) and Jean-Baptiste Camille Corot (1796–1875).

Among Jones's most sensitive achievements is a group of studies of buildings in Naples, of which this painting is an example. He arrived in Naples in 1780, and rented a second-floor apartment in a house facing the salt custom-house; it contained a studio and a room he could use as an exhibition gallery, and had a roof terrace. Nearly two years later, just before the lease terminated, Jones seems suddenly to have discovered the possibilities afforded by the views from the terrace and, in the few remaining weeks, made a series of sketches remarkable for their economy, intimacy, freshness and luminosity of colour. Composed of an assembly of simple forms, they almost prefigure twentieth-century abstract compositions, in such elements as, here, the balance of the window aperture, three-quarters darkened, with the small dark area in the ochre doorway; the surrounding, variously coloured bright wall; the rhomboid of the projecting building on the right; and the play of upright black rectangles with horizontal lines in the buildings on the left. Jones had discovered a new type of landscape in a group of urban buildings, and had realised the pleasure of viewing it at a transient instant of afternoon light.

JOHN ROBERT COZENS (1752–97)

View in the Canton of Unterwalden (*c.* 1776)

Watercolour, 340 × 500 mm
Courtauld Institute Galleries, London (Spooner Collection S.32)

John Robert Cozens was born in London, the son of [†]Alexander Cozens, who was almost certainly also his teacher: a book of studies Alexander made for his son still exists (now in the British Museum). John Robert exhibited at the Incorporated Society of Artists and at the Royal Academy between 1767 and 1776; he did not send anything to the Academy after 1776, when his application for associate membership was refused.

In that year he went to Switzerland and Italy, in the company of the art amateur and antiquary Richard Payne Knight (1750–1824), and he remained abroad until 1779. In Rome he met [†]Thomas Jones, who makes several passing references to him in his *Memoirs* (*Walpole Society*, vol. xxxii). He set off for the continent again in 1782, this time in the company of his father's former pupil, the author William Beckford (1759–1844), for whom he made several studies; he returned in the late summer of 1783.

Cozens's last years were miserable. According to Joseph Farington R.A. (1747–1821), his nervous system completely decayed; he finally lost his reason. Some financial support came to him in the form of an annual payment from the Academy, and from a private subscription organised by Sir George Beaumont (1753–1827), the connoisseur and art patron. He died at the age of forty-five in a Smithfield madhouse kept by the physician and connoisseur Dr Thomas Monro (1759–1833).

John Robert's art is based, not surprisingly, on his father's; but it is more refined, has the addition of colour, and represents actual landscapes. What he saw, he reproduced, but he looked at his subjects with the simplicity of his father's landscapes in mind. The result may be seen in landscapes like that reproduced here. *View in the Canton of Unterwalden*, with its towering alps and diminutive châlets, is a true exercise in the Sublime in its lofty, exalted guise. He does not dwell on the wild Swiss landscape in the manner of Salvator Rosa, as his father might had done, but brings to the scene subjective emotion which yields a contemplative and peaceful interpretation of the remote grandeur of the mountain peaks, while at the same time retaining their individuality.

[†]Constable said that 'Cozens is all poetry', a fair assessment. Like so many of his contemporaries he belongs to the tradition of Claude, as is evident in his watercolours of *The Lake of Nemi* (Whitworth Art Gallery, University of Manchester) and *Ariccia* (Birmingham Museum and Art Gallery).

Cozens influenced, among others, [†]Girtin and [†]Turner, who as students copied many of his drawings for Dr Monro. In such influence, and in the poetic outlook he brought to landscape, he must be considered a key figure in the development of English Romantic landscape art.

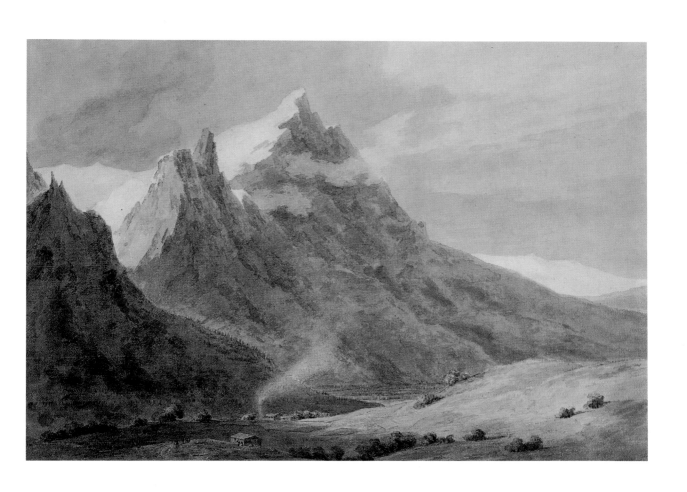

21

THOMAS BEWICK (1753–1828)

The Redbreast (c. 1795)

Pen and watercolour, 55 × 90 mm (design area)
Reproduced by courtesy of the Trustees of the British Museum

Thomas Bewick, who helped to revolutionise the craft of wood-engraving and to transform it into an art, was born of farming stock at Ovingham, Northumberland. After an undistinguished career at school, he was apprenticed in 1767 as a jobbing engraver to the Newcastle engraver Ralph Beilby. Having made a brief attempt to earn his living in London, he returned to Newcastle and in 1777 entered into partnership with his old master. He illustrated books, including Gay's *Fables* (1779), collections of *Select Fables* (1784) and *Fables of Aesop and Others* (1818), Beilby's *A General History of Quadrupeds* (1790) and the two-volume masterpiece *A History of British Birds* (*Land Birds* by Beilby, 1797, *Water Birds* by Bewick, 1804). Beilby's partnership with Bewick was dissolved in 1797.

Bewick had the loving attention to the particular of the true Romantic; this was realised by Wordsworth, who, according to William Hazlitt, 'greatly esteemed his engravings'. Like †Philip Henry Gosse, Bewick would not have dreamed of reconstructing what he saw; he loved nature as it was. In his own words in his *Memoir*:

> The painter need not roam very far from his home, in any part of our beautiful isles, to meet with plenty of charming scenes from which to copy nature . . . and in which he may give full scope to his genius and to his pencil, either in animate or inanimate subjects. His search will be crowned with success in the romantic ravine – the placid holme – the hollow dell – or amongst the pendant foliage of the richly ornamented dean; or by the sides of burns which roar or dash along, or run murmuring from pool to pool through their pebbly beds: all this bordered perhaps by a back-ground of ivy-covered, hollow oaks (thus clothed as if to hide their age), – of elms, willows, and birch.

Bewick did not compose his engravings on the wood, but made preliminary drawings from which the design was transferred to the block; so the engraving is a reversed image of the drawing. Bewick's engravings, despite their close attention to nature, or perhaps because of it, are full of insight; but his preliminary drawings have a vivid appeal of their own, as in this study of a robin in a winter landscape; one can almost feel the freezing air and sense the bird's imminent darting run. Writing to his friend J. F. M. Dovaston, Bewick describes how this drawing

> was done from an old bird, on which acct the bill might be a little enlarged, & by being a little foreshortened, would add something to its apparent thickness – but there is, I think, no difference otherwise, between him & his blue throated, distant & foreign relation – my Red breast was done in his winter dress – & my bluebreast in his summer vestments & this always makes a difference in the contour of the figures of all birds.

22

After THOMAS BEWICK (1753–1828)

An Early Morning Thief surprised (*c.* 1795)

Pencil and watercolour, 50 × 93 mm (design area)
The Natural History Society of Northumbria

In addition to the figures of birds, each depicted in its appropriate surroundings, Bewick decorated his *British Birds* (see commentary to plate 21) with tail-piece vignettes which afford a vivid series of insights into the comments on British country life during the late eighteenth century. There is no sentimentality in these little pictorial anecdotes; on the contrary, they depict the often rough life in a countryside dominated by hard work and conditions, by bloodsports and games, and often by poverty. Sometimes a subject revolves around a cynical or moral anecdote – a fat man, having over-eaten, vomits on to the floor; an old woman is confronted by a bull at a stile – but it is always presented with tolerant good humour.

Bewick did not always prepare his transfer drawings; they were often left to apprentices and others, like the present one, which was made, after a pencil study of his own (Newberry Library, Chicago), by his former apprentice Robert Johnson (1770–96). It was described by Bewick's daughter, Jane (1787–1881), in some notes she made on his tail-pieces: '...the Thief is prowling about the Yard, the mastiff is loose and is making a spring at him – which he parries by holding his stick by each end across his chest – if he stoops to pick up his booty – the dog has him at once'.

Johnson evidently added his own interpretation to parts of the design, for the perspective and shape of the buildings are considerably altered (for the better) from Bewick's original pencil sketch. The delicate bluish-green colour key is very pleasing.

Robert Johnson was rather a sad figure, born at Shotley, Northumberland, not far from Bewick's birthplace. His father was a carpenter and joiner, and the family moved to Gateshead soon after Robert's birth. In 1788 he was apprenticed as a copperplate engraver to Bewick and his partner Beilby, but at the end of his apprenticeship he abandoned engraving to devote himself to painting. He was commissioned to copy portraits at the seat of the Earl of Breadalbane, Taymouth Castle, intended for eventual reproduction in John Pinkerton's *Iconographia Scotia*; he had finished fifteen and four remained to be done when he died. The climax of Johnson's brief life is told in Eneas Mackenzie's *History of Northumberland* (Newcastle-on-Tyne, 1825):

> In his anxiety to complete his task, he would sit, though of a delicate constitution, all day in a room without fire. A violent cold was the consequence, which, neglected, increased to a fever. 'It flew to his brain; and, terrible to relate! he was bound with ropes, beaten, and treated like a madman.' This improper treatment was discontinued by the orders of a physician who accidentally arrived. By the application of blisters, reason returned: and poor Johnson died in peace on October 29, 1796, in the twenty-sixth year of his age. His friend and fellow-prentice, [Charlton] Nesbit [1775–1838], engraved a memorial to his memory; and a stone was erected in Ovingham Churchyard to record the early fate of this ingenious and promising artist.

23

JOHN FLAXMAN (1755–1826)

Chatterton receiving Poison from the Spirit of Despair (*c.* 1775–80)

Pen and brown wash, 320 × 270 mm
Reproduced by courtesy of the Trustees of the British Museum

John Flaxman was taught modelling and drawing by his father, a plaster-cast maker of York. Though now known primarily as a sculptor, he was a draughtsman of no mean ability, as is evident in his series of outline illustrations, inspired by red and black figure designs on Greek pottery, to the works of Homer, Hesiod, Aeschylus and Dante, which were engraved by Tommaso Piroli (1752–1824) and †William Blake.

After studying at the Royal Academy, Flaxman spent several years (1775–87) designing pottery for Josiah Wedgwood, who then helped him to finance a seven-year visit to Italy. Here he reinforced his already great enthusiasm for classical art. He returned to England in 1795, and soon found fame as a sculptor and as a designer of memorials and monuments. He was elected an academician in 1800, and became the Academy's professor of sculpture in 1810.

In 1820, Flaxman's wife, Ann, whom he had married in 1782, died. The couple had been very close, with shared interests and studies, and her death was a bitter blow from which he never really recovered. He died in London, after catching cold in a church.

Flaxman was one of the chief exponents of Neoclassicism in Britain, but he is represented here by a more quintessentially Romantic subject, the suicide of the poet Thomas Chatterton (1752–70) at the age of seventeen. The posthumous son of an impecunious schoolmaster, Chatterton was brought up by his uncle, sexton of St Mary Redcliffe Church, Bristol. Thomas spent all his spare time in the muniment room of the church, reading old documents, which inspired him to write poems of his own in medieval style and spelling; these he claimed were by Thomas Rowley, a medieval monk (named on one of the fragments scattered at his feet in this picture). Some were deceived by them, but they were recognised as forgeries soon after his death.

Chatterton was apprenticed to a Bristol attorney but, full of Romantic aspirations, he set out for London, determined to earn his living as a writer. After some initial success, within a few months he came near to starvation, and poisoned himself with arsenic.

Flaxman claimed to have used his self-portrait (Halesowen Grammar School) for the representation of Chatterton, and there does seem to be a resemblance in the face of the tragic youth who eagerly reaches out for the dish of poison handed to him by the gaunt and ugly Spirit of Despair, or perhaps encourages Despair to pour the fatal brew down his throat. In the background a spiritual chariot awaits to bear the poet's soul heavenwards. The figure of Chatterton has affinities with that in *Philoctetes on the Island of Lemnos* by another leading Neoclassicist, James Barry (1741–1806), painted in 1770 (Pinacoteca Nazionale, Bologna): Flaxman may have known this from an engraving of 1777.

Chatterton's humble origins, genuine talent, thwarted aspirations and early death made him something of an icon for the Romantics. Keats dedicated his romance *Endymion* (1818) to Chatterton's memory, and the Preraphaelite Henry Wallis (1830–1916) portrayed his death in a well-known painting of 1856 (Tate Gallery).

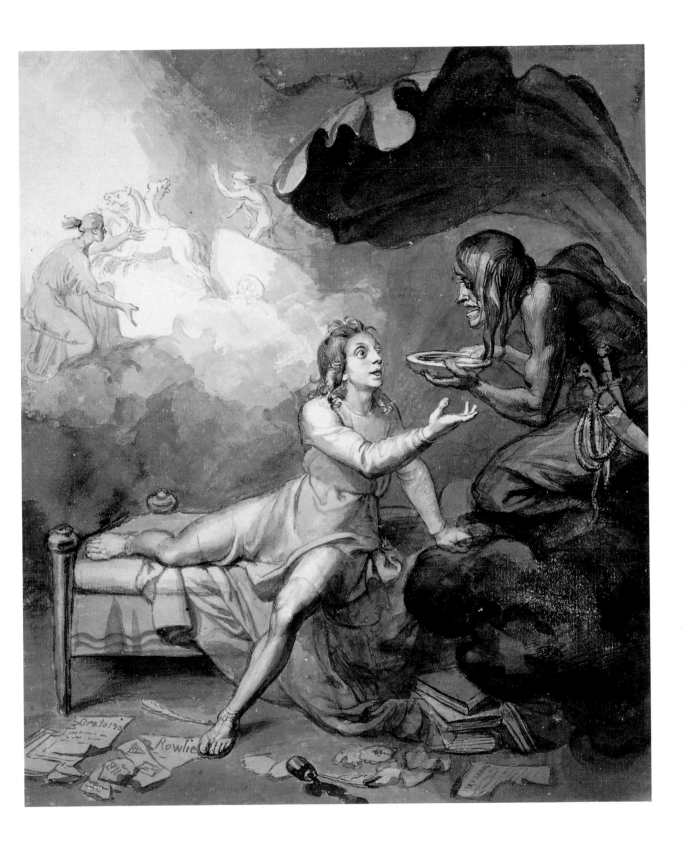

24

THOMAS STOTHARD (1755–1834)

Intemperance (*c.* 1799)

Oil on canvas, 49 × 74 cm
The Tate Gallery, London

Thomas Stothard, an inkeeper's son, was born in London, but, being delicate, he lived for much of his childhood with relatives in Yorkshire. After returning to London at the age of thirteen and spending a short time at a boarding school, he was apprenticed to a pattern-designer for flowered silks. He gave this up in 1777 in order to become a pupil at the schools of the Royal Academy; soon afterwards he began his triumphant career as an illustrator and painter. He was elected an academician in 1794. Possessing an attractive character, he became in time, in the words of the painter †James Smetham, a 'calm, seedy, philosopher-looking old man, walking for hours with his sketch-book, and getting life from the fresh air, and knowledge from the hedges and from the passing incidents of being, and then he plants himself with one foot on the rail of his easel till it is worn through'.

In 1799 Stothard was commissioned, for a fee of £1300, to decorate the grand staircase in the Marquess of Exeter's palace, Stamford House. The diverse subjects of these more than life-size murals are *War*, *Intemperance* and *The Descent of Orpheus into Hades*; they are still extant. He was occupied on the work during four summers. A sketch was prepared for each subject, and these were exhibited at the Royal Academy in 1806 and 1810.

The sketch for *Intemperance*, reproduced here, draws on the story of Mark Antony and Cleopatra and illustrates the moment when Cleopatra casts the pearl into the cup to be dissolved. The Egyptian queen is surrounded by the Graces and other allegorical figures, some in tipsy abandon, others symbolising love; the effect is rich, ripe and florid.

In several places the influence of earlier masters is apparent: for instance the figure drawing is everywhere redolent of Rubens, and the central group of Antony and Cleopatra is clearly based on Titian's *Venus and Adonis* (1553, Prado, Madrid), which Stothard probably knew from a copy or an engraving. Other figures recall Titian's *The Andrians* (*c.* 1523–5, Prado, Madrid), whose bacchanalian subject is closely paralleled by Stothard's theme of intemperance; the figure of the Grace standing above Antony with arm outstretched strongly recalls a figure at the left of a group of revellers in Titian's painting. And the seated figure leaning on her right arm, at the lower right of the centre panel, recalls the figure of the attendant holding Diana's arrows in Titian's *Diana and Callisto* (1536–9, National Gallery of Scotland, on loan from the Duke of Sutherland).

The Romantic element in this work, the abandonment of restraint, in which drunken revelry is about to develop into unrestrained sexual indulgence, is remote from the lyrically Romantic content of much of Stothard's work.

SIR HENRY RAEBURN (1756–1823)

Sir John Sinclair (*c*. 1794–5)

Oil on canvas, 238 × 154 cm
National Gallery of Scotland, Edinburgh

Sir Henry Raeburn, nicknamed 'the Scottish Reynolds', was born at Stockbridge, Edinburgh; his father was a manufacturer. He was apprenticed to a local goldsmith and jeweller and, probably as a development of this work, began in about 1762 to paint miniatures. From the fashionable portrait painter David Martin (1736–98) he gathered many details of technique, but he was never actually Martin's pupil and remained largely self-taught.

It was not long before Raeburn began to paint portraits in oil. He made two short visits to London; the first, during which he met †Sir Joshua Reynolds, was followed by a visit to Rome (1785–7), which had little effect on his style; the second was in 1810. He first sent work to the Royal Academy exhibitions in 1814, and this prompted his election as an associate; in the following year he was made an academician. When George IV visited Edinburgh in 1822 (dressed in Highland costume and pink tights) he knighted Raeburn, and in 1823, not long before the painter's death, he appointed him 'his Majesty's first limner and painter in Scotland'.

The portrait of Sir John Sinclair (1754–1835) is conceived in the spirit of exotic Romanticism. The Romantics were fascinated by Scotland; it was the setting for many novels, tales, poems and even ballets – Filippo Taglioni's and Schneitzhoeffer's *La Sylphide* (1832) was set in the Highlands and its hero was a Scottish peasant, James Reuben. For the Romantics, the then remote Highland landscape, with its floods, mists, woods and mountains, provided a perfect setting for stories of drama and suspense such as Mrs Ann Radcliffe's *The Castles of Athlyn and Dunbane* (1789).

In this portrait the Romantic spirit and its Scottish manifestation are personified by Sir John Sinclair, a Scottish aristocrat whose ancestors included the ancient earls of Caithness and Orkney. His confident gaze, firm stance and colourful Highland uniform of a colonel of a regiment of volunteers, against a background of mountains and overcast sky, at once implies a commanding personality, a high-born patrician and leader. It is one of the first of Raeburn's mature portraits, a foretaste of what he was to achieve during the remainder of his life, despite his lack of formal training.

The colouring is vivacious, the execution positive and assured. The classic pose may have been suggested by ancient statuary Raeburn probably saw in Rome, for instance the marble *Meleager* in the Vatican Museum (Sala degli Animali). (For similar probable derivations see plates 3, 4, 5, 10, 17, 62.)

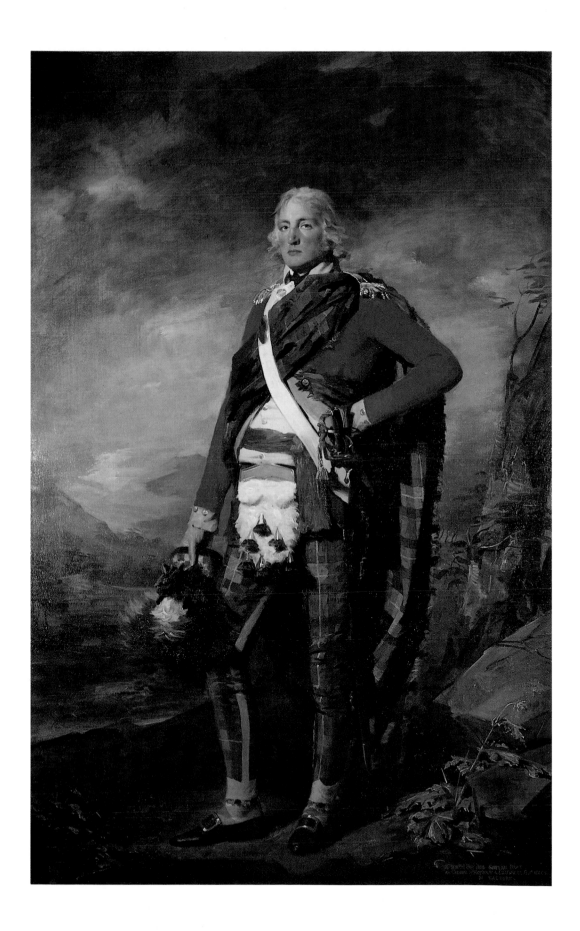

26

WILLIAM BLAKE (1757–1827)

Christ blessing Little Children (1799)

Tempera on canvas, 26 × 37.5 cm
The Tate Gallery, London

More than any other artist, Blake embodied the whole range of Romanticism, every facet of the mind and character of man, from the gentle pastoralism embodied in this work and in his small wood-engravings for Robert John Thornton's edition of *The Pastorals of Virgil*, to the *terribilità* of the illustrations in his 'prophetic' books, such as *America, Europe, The Book of Urizen* and *Jerusalem*, and of his interpretations of the Book of Job (plate 27).

A hosier's son, he was born in Broad Street, Golden Square, London. He was apprenticed to the engraver James Basire (1730–1802), but as a painter was largely self-taught, though he attended some classes at the Royal Academy. Besides being an artist, Blake was also a great poet. Often neglected for long periods, he was, like Prometheus, defiant, always fearless in proclaiming his beliefs. He died disregarded by the worldly great, but singing hymns of praise.

The viewer of the otherworldly scene depicted in *Christ blessing Little Children*, which Blake painted for his patron, Thomas Butts (1757–1845), is bound to be struck by the enormous difference in scale between the children – some little bigger than dolls – and the adults. This difference was probably intended by Blake (who rarely did anything without good reason) to emphasise the innocence and vulnerability of the children. The subject is based on Mark X.14 and Luke XVIII.16: 'Suffer the little children to come unto me, and forbid them not: for of such is the Kingdom of God.' Here was something with which Blake could wholeheartedly agree, the Innocence of childhood being a spiritual state which the adult individual, arrived at the state of Experience, has lost but should strive to regain, so as to partake of a fuller spiritual life.

The central, icon-like figure of Christ, holding to his breast two children, his arms and hands in hieratic pose, sits beneath a tree (which divides the composition vertically and symmetrically) on a stone altar-like seat. This seat is probably a reference to what in his emblem book, *For the Sexes: The Gates of Paradise*, Blake calls Jehovah's 'Mercy Seat'. Under this were hidden the Tables of Stone (the Decalogue, whose laws, Blake held, were made to entrap man in sin), so that, in their absence, Paradise might be attained through the 'forgiveness of each Vice', allowing the sinner to become once more as a little child.

At either side adults (whose figures form with that of Jesus a triangular composition) bring more children forward. Close to Christ's seat, forming with him a smaller triangle, stand two children, a girl on one side, a boy on the other, their hands held together in prayer. Another child, also at prayer, kneels in the foreground, and yet another stands before him, completely naked, symbolising Innocence. Beyond is a pleasant pastoral landscape containing a river (probably the River of Life), a flock of sheep (an allusion to Christ's flock), and distant mountains.

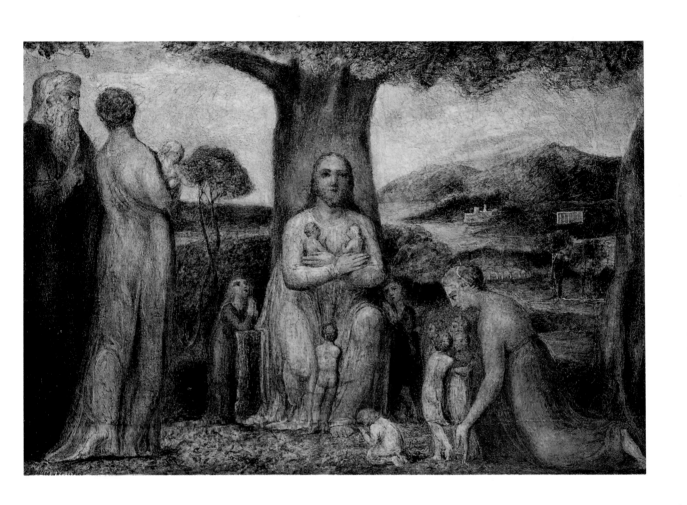

27

WILLIAM BLAKE (1757–1827)

Satan smiting Job with Sore Boils (*c.* 1826)

Pen and tempera on mahogany panel, 32.5 × 43.3 cm
The Tate Gallery, London

Plate 26 illustrates Blake's interpretation of an agreeable pastoral subject. Here, at the opposite end of the scale, he portrays the fearsome.

In his old age, Blake was commissioned by his friend †John Linnell to engrave a series of *Illustrations of the Book of Job*; they were published in 1826. The pen and tempera painting of *Satan smiting Job with Sore Boils*, which was painted not long afterwards, repeats the subject of one of the engravings, based on Job II.7: 'So went Satan forth from the presence of the Lord, and smote Job with sore boils from the sole of his foot unto his crown.'

But Blake's interpretation is far from a literal representation of the biblical text, for he saw Job as a symbol of man, with Jehovah (conventional religion) and Satan (error) as states of man's psyche. The series of engravings depicts the progress of Job from material prosperity and purely formal religion, through bitter adversity and sexual shame, to final delivery into spiritual regeneration in which error (Satan) cannot dwell.

This painting shows Job in the depth of his despair, his body covered with boils representing real or imagined sin, as expressed by Blake in his poem *Jerusalem*:

> The disease of Shame covers me from head to feet. I have no hope.
> Every boil upon my body is a separate & deadly Sin.
> Doubt first assail'd me, then Shame took possession of me.
> Shame divides Families, Shame hath divided Albion in sunder.

The conception of the design is superb. An angry sun sets beneath banks of lowering clouds and the figure of Satan stands on Job, exulting, pouring disease from a flask held in his left hand, while flames burst from his right; his outstretched arms are backed by great bat-like wings; his loins and genitals, as befits his hermaphrodite nature, are covered in saurian scales. Job, his body extended in terror, naked but for a mat across his loins (symbolising his shame), lies on his dung heap; his wife is crouched in torment, in a typically Blakean attitude, induced by Job's view of what he imagines to be the sin of bodily lust.

It is a most imaginative conception, yet it is strongly reminiscent of a theatrical presentation in some of its details. The rendering of the clouds gives the impression of borders hung from the flies above a stage, and the sun, about to disappear behind the sea, has the strangely artificial look of a stage property. This impression is completed by the figure of Satan, in a pose like that of a ballet dancer. This balletic element is a factor that appears so often in Blake's work as to suggest that he must have seen ballet performances, perhaps with his great contemporary Auguste Vestris (1760–1842) among the performers. The balletic aspect of his interpretations of Job's story was realised in 1931 in Vaughan Williams's *Job: A Masque for Dancing*, initiated by Geoffrey Keynes, with choreography by Ninette de Valois and designs by Gwen Raverat, first produced at the Cambridge Theatre, London.

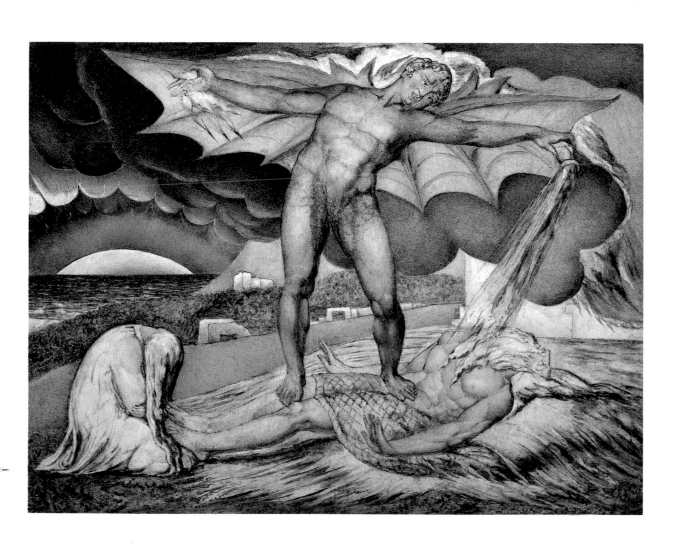

28

EDWARD FRANCIS BURNEY (1760–1848)
Loutherbourg's Eidophusikon (c. 1781)

Watercolour, 200 × 270 mm
Reproduced by courtesy of the Trustees of the British Museum

Burney was born at Worcester and attended the Royal Academy schools, where he was befriended by †Sir Joshua Reynolds. He set out as a portraitist, but after 1803 devoted himself principally to book illustration and satirical drawing.

This watercolour depicts the Eidophusikon or Spectacle of Nature, invented by †P. J. de Loutherbourg and first demonstrated in London in 1781. Presumably the name is derived from the Greek words *eidos*, form, and *physikon*, natural. For David Garrick, Loutherbourg had perfected the application of mobile scenery and lighting effects, and the Eidophusikon grew out of these experiments. Exhibited within a proscenium, to the accompaniment of music and sound effects, it used articulated pictures, coloured gauzes, and lighting and atmospheric effects to impart an impression of actual landscapes and scenes in all kinds of weather.

It fascinated Reynolds, who recommended it to his friends as suitable entertainment for their daughters. †Gainsborough, who sometimes helped Loutherbourg to work the effects, was 'so wrapt in delight with [it], that for a time he thought of nothing else – he talked of nothing else – and passed his evenings at that exhibition in long succession'. He had a model of the contraption, which was exhibited in 1885; its present whereabouts are untraced.

An idea of some of the Eidophusikon's effects may be gleaned from a description by William Henry Pyne ('Ephraim Hardcastle'; 1769–1843) in *Wine and Walnuts* (1823), which is also the source for the account of Gainsborough's interest:

> I can never forget the awful impression that was excited by his ingenious contrivance to produce the effect of the firing of a signal of distress, in his sea-storm. That appalling sound, which he that had been exposed to the terrors of a raging tempest could not listen to, even in this mimic scene, without being reminded of the heart-sickening answer, which sympathetic danger had reluctantly poured forth from his own loud gun – a hoarse sound to the howling wind. . .
>
> De Loutherbourg had tried many schemes to effect this; but none were satisfactory to his nice ear, until he caused a large skin to be dressed into parchment, which was fastened by screws to a circular frame, forming a vast tambourine; to this was attached a compact sponge that went upon a whalebone spring; which, struck with violence, gave the effect of a near explosion; a more gentle blow, that of a far-off gun; and the reverberation of the sponge produced a marvellous imitation of the echo from [cloud] to cloud, dying away into silence.
>
> The thunder was no less natural, and infinitely grand: a spacious sheet of thin copper was suspended by a chain, which, shaken by one of the lower corners, produced the distant rumbling, seemingly below the horizon; and as the clouds rolled on, approached nearer and nearer, increasing peal by peal, until, following rapidly the lightning's zig-zag flash, which was admirably vivid and sudden, it burst in a tremendous crash immediately over-head.

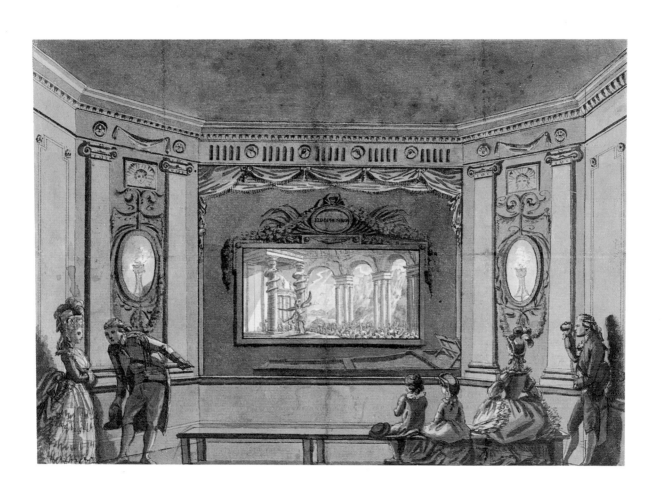

29

GEORGE MORLAND (1763–1804)
The Cottage Door (1790)

Oil on panel, 34 × 44 cm
Royal Holloway and Bedford New College, University of London, Egham

George Morland was taught painting and drawing by his father, Henry Robert Morland (*c.* 1730–97), known as 'Old Morland' or 'Morland the Elder', a painter of portraits and genre scenes. George was a receptive pupil, already exhibiting at the Royal Academy at the age of ten. At first he worked for his father, restoring works by Dutch and Flemish masters, and copying pictures, including, it has been said, Fuseli's *Nightmare* (plate 17). Henry Morland was a strict disciplinarian, and in reaction against this, George adopted a bohemian lifestyle, carousing in taverns with his cronies, always in debt and often drunk. He was several times imprisoned for debt, each time becoming more dissolute than before; he was often dead drunk for days on end during these incarcerations. He died in a sponging house in 1804, after again being arrested for debt.

Morland's style of painting owed much to †Gainsborough, to Jean-Baptiste Greuze (1725–1805), and to the Dutch masters whose work he had copied and restored. Although sometimes vitiated by facile sentimentality, his subject matter was picturesque, based on rural motifs, particularly on the poverty of contemporary English peasantry and on their cottages and animals – donkeys, farm horses, and especially pigs – all set in the verdant English countryside.

The Cottage Door (formerly called *The Contented Waterman*) is a typical example, with cottagers seated outside their dwelling on a balmy evening in summer. A boatman, his craft chained to the quay at the left, leans on a chair, enjoying a respite from work and smoking his clay pipe; his wife is mending clothes and their little daughter plays with her doll, while another man – perhaps his brother-in-law – sits on a half barrel with a little brown jug in his hand, a small barrel of liquor beside him, and his tobacco pipe propped against it. Their dog lies nearby eyeing the family pig, which reaches out of its sty and feeds on swill. The figures, especially that of the boatman, owe much to those of Greuze.

The handling, while loose, as in much of Morland's work, is nevertheless more careful than usual. Despite being painted quickly (Morland sometimes painted as many as three pictures in a day), *The Cottage Door* is well composed. It is based on double triangles, one formed by the figures of the wife and little girl and the corner of river beneath the prow of the boat, the other by the figures of the boatman, the child and the seated man. These are further accentuated by other triangular constructions, for example those of the eaves of the cottage roof, the thatched lintel, and the roof of the pigsty.

The Cottage Door was engraved three times: in 1790 and 1806 by William Ward (1766–1826), elder brother of †James Ward, Morland's brother-in-law; and by the obscure engraver R. Clamp in 1797.

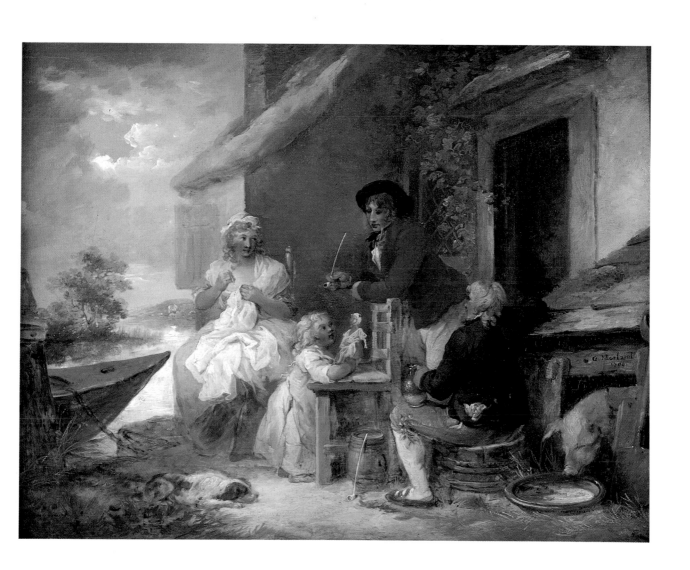

SIR THOMAS LAWRENCE (1769–1830)
Charles William Bell (1798)

Oil on canvas, 76 × 63 cm
Musée du Louvre, Paris

Sir Thomas Lawrence is one of the most essentially Romantic of all portrait painters, imparting a Byronic, or at any rate a histrionic, attitude to his sitters, surrounding them with an atmosphere of glowing light and intense shade, and investing them with emotional resonance.

He was born in Bristol, the son of an innkeeper of idle habits who, coming from a genteel background (his father was a Presbyterian minister), had tried various trades and professions without making a success of any. He taught Thomas to recite poetry by Milton, Pope and others, and very early on the boy also showed considerable talent in drawing likenesses. When Thomas was only five, his father would introduce him to visitors to his inn, saying, 'Gentlemen, here's my son. Will you have him recite from the poets or take your portraits?' Thus he was able to contribute to his parents' income; he continued to make this supplement in more mature years, when he practised his art at Oxford, Bath and elsewhere in the West Country.

In 1786 he went to London and studied at the Royal Academy schools; in 1790 he exhibited his first full-length portrait (of Queen Charlotte), and from that time his reputation and success were assured. He was elected an academician in 1794, in 1815 he was knighted by the Prince Regent, and in 1820 he was elected president of the Royal Academy.

From 1818 to 1820 Lawrence was on the continent, at Aix-la-Chapelle (where a congress of the European powers was taking place), Vienna and Rome. During these three years he painted portraits of the Pope, the Emperors of Austria and Russia, and other kings, princes and statesmen. He was presented with diamond rings by the Emperor of Austria and the King of Prussia, and was considered the premier portrait painter in Europe. Such success can hardly have surprised Lawrence himself, for he never doubted his abilities, and once said, 'excepting Sir Joshua [Reynolds], for the painting of a head, I would risk my reputation with any painter in London'.

This portrait of Charles William Bell is a comparatively early work, but it bears Lawrence's unmistakable cachet: the Byronic attitude of the head (he once sketched Byron in pen and ink), turned slightly to one side, with chin held high and further accentuated by the high neckerchief; the radiant and proud eyes, riveted on some distant object; the negligently arranged hair; the jacket widely and dashingly unbuttoned. Add to these the suggestion of turbulence in the background and there is the essential Romantic portrait. Such elements in Lawrence's work were later much admired by Eugène Delacroix.

The portrait of Charles William Bell was engraved in 1805 by William Whiston Barney (*fl.* 1790–1810), a pupil of Reynolds.

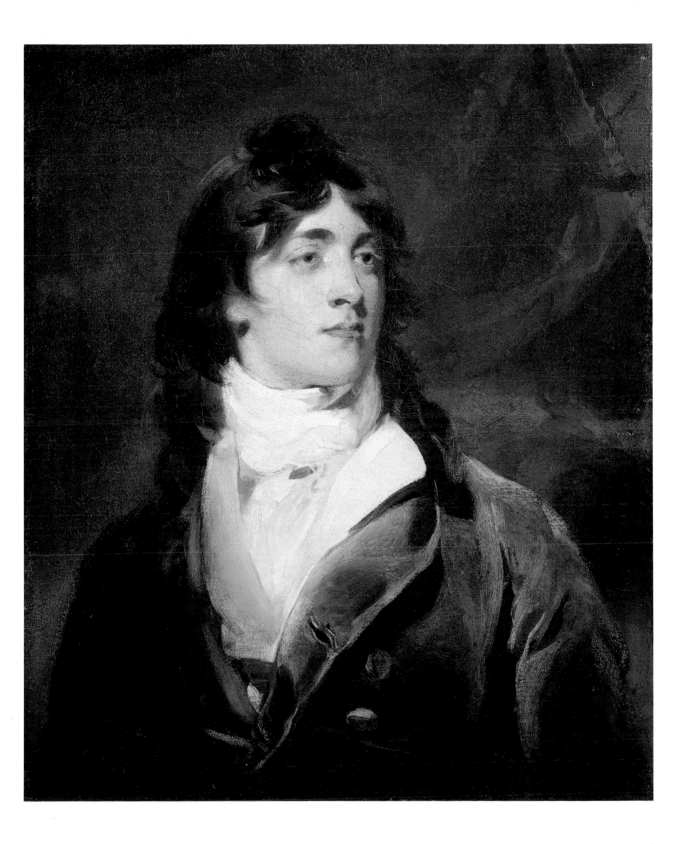

31

JAMES WARD (1769–1859)

Bulls fighting, with the Castle of St Donat in the distance (1803)

Oil on canvas, 131 × 227 cm
Victoria and Albert Museum, London

James Ward was the son of a hard-drinking London greengrocer. At the age of thirteen he took up painting, studying under John Raphael Smith (1752–1812), and about twelve months later he was apprenticed for nine years as a mezzotint engraver to his brother William Ward (1766–1826). James continued to work in mezzotint until 1817, after which he gave his whole attention to painting. Earlier, alongside his mezzotints, he had painted sentimental rustic and domestic scenes in the style of †George Morland, who was married to his sister Anne. But he had also begun to paint the animal subjects for which he later became famous, such as the one entitled *Bull Baiting* which he exhibited at the Royal Academy in 1797.

He was much influenced by Dutch and Flemish painters, for example Paul Potter (1625–54), and especially by Rubens, notwithstanding an early aversion after a visit to Italy. 'I remember,' he told the painter James Northcote, 'that when I returned from Italy, I couldn't bear Rubens' pictures; they appeared to me what they have frequently been called – *the shambles* – but I can now admire Rubens as much as any man. He is a dangerous model to imitate, however, and I have known painters ruined by him; it requires a strong mind to study Rubens with safety.' Evidently Ward's mind was sufficiently strong, for not only did he study Rubens closely, but the influence of the great Flemish painter helped him to achieve a sublime and terrific originality in works like his huge *Gordale Scar* (1811–15, Tate Gallery), without cheapening his conceptions by over-exaggeration.

Rubens's influence is strongly evident also in the painting reproduced here. The landscape was inspired by Rubens's *Château de Steen* (National Gallery, London), and its colour and vigour owe much to that work. The presentation of the mighty primaeval energy of the bulls – the grandest of domestic animals – locked in combat, suggests Romantic terror. Further, the great contorted dead tree trunk across which the bulls are fighting, an essential element in the composition, indicates impermanence and decay, in contrast to the splendour of the animals' physique. The flock of sheep at the left, the group of rustic travellers with horses at the right, and the distant castle by a still sea provide reassuring notes in contrast to the stormy sky and the turmoil of the central incident.

The tortured shape of the tree trunk prefigures some of the work of the twentieth-century neo-Romantic artist Graham Sutherland (1903–80); compare for example his *Green Tree Form: Interior of Woods* (Tate Gallery).

St Donat's Castle still stands, a restored fifteenth- and sixteenth-century baronial mansion in Glamorgan.

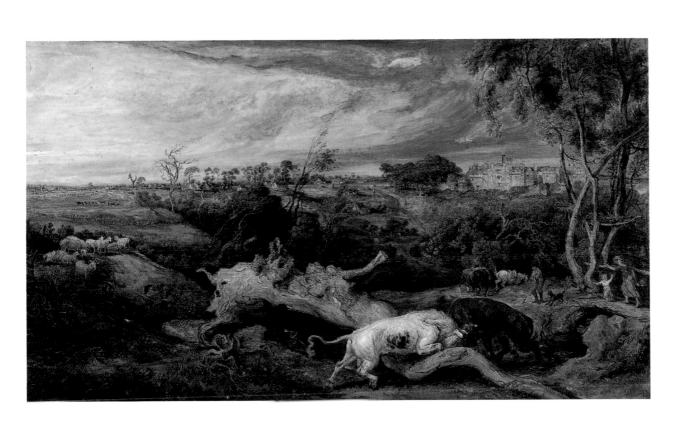

THOMAS PHILLIPS (1770–1845)

Lady Caroline Lamb in the Costume of a Page (1813)

Oil on canvas, 91 × 70 cm
The Trustees of the Chatsworth Settlement

Thomas Phillips was born at Dudley in Warwickshire, and began his artistic career at Birmingham as a glass-painter. In 1791 he went to London, carrying an introduction to †Benjamin West, who procured him a job painting windows in St George's Chapel, Windsor. During the following year he entered the Royal Academy schools and was soon contributing landscape, historical and mythological paintings to the Academy exhibitions. Before long, however, he discovered his true *métier* in portraiture, and by 1804 his reputation as a portraitist was established by his election as an associate of the Royal Academy; he became an academician in 1808.

His sitters include Lord Byron (painted in Near Eastern costume), Sir Walter Scott, Robert Southey, Samuel Taylor Coleridge and †William Blake. His portrait of Blake (National Portrait Gallery) is probably the best-known likeness of the artist–poet; it was reproduced as a frontispiece to Robert Blair's *The Grave*, illustrated by Blake in 1808.

This transvestite portrait of Lady Caroline Lamb (1785–1828) was painted when she was twenty-eight. She was born Lady Caroline Ponsonby, daughter of the third Earl of Bessborough, and in 1805 married the Hon. William Lamb (later second Lord Melbourne and Queen Victoria's first prime minister), but soon succumbed to the charms of Byron. Perhaps her page's costume here was an invitation to his pederastic preferences; it was she who coined the famous description of him, 'mad, bad, and dangerous to know'.

Lady Caroline was a woman of considerable intelligence, an original if somewhat wild conversationalist, and was capable of great generosity, but she was also intensely vain and dangerously over-excitable. She and Byron fell out at about the time this portrait was painted, and so violent did Lady Caroline's temper become thereafter that her husband sought and in 1825 obtained a divorce. She caricatured Byron in her novel *Glenarvon* (1816), and when she learnt that he had laughed at it, made a pyre of copies of his letters and a miniature of himself which he had given her. As she set fire to it she got several girls dressed in white to dance around it, while she sang a song she had written for the occasion.

Phillips has caught something of Lady Caroline's contradictory character in this portrait, accentuating it by the travesty costume, boyish hairstyle and backward glance. The pose is a reversed version of that in Titian's portrait *Lavinia with a Tray of Fruit* (*c.* 1555, Berlin–Dahlem, Staatliche Gemäldegalerie) in which Titian's daughter, probably representing Pomona, the fruit goddess, is depicted holding a basket of fruit. Whether Phillips had seen the original, one of its several variants or copies, or a print is not known.

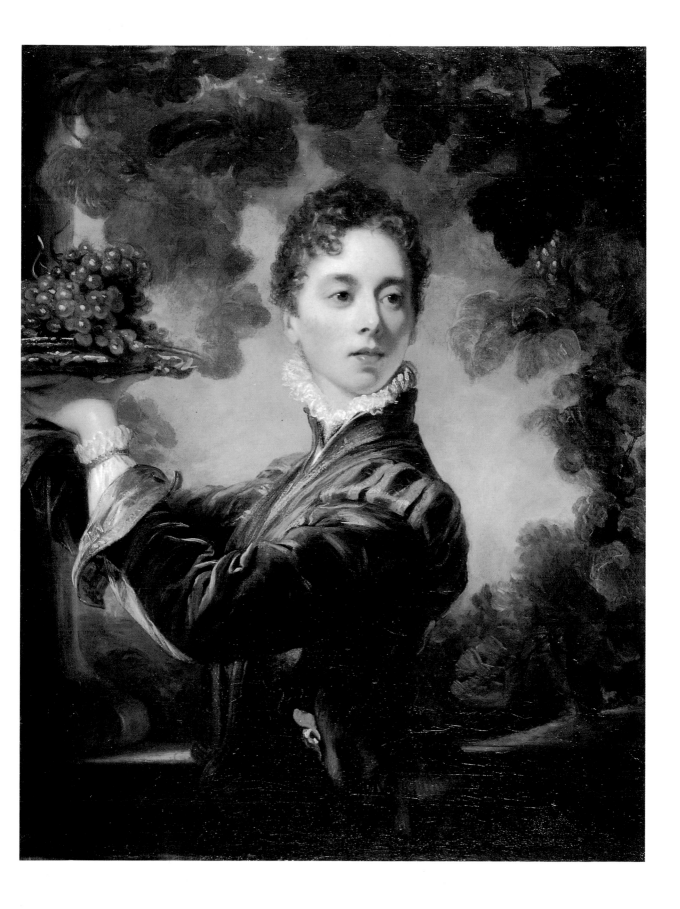

33

JOSEPH MALLORD WILLIAM TURNER (1775–1851)
The Great Falls of Reichenbach (1802)

Watercolour, 1022 × 689 mm
The Trustees, The Cecil Higgins Art Gallery, Bedford, England

Turner, the greatest landscape artist of England and one of the greatest in the world, was the son of a London barber. His mother, the daughter of a butcher, became insane, and Turner may have feared that the same fate awaited him, for he always resented any talk of morbidity or eccentricity in his paintings. He was preoccupied with art from his earliest years, but the surroundings of his early life were unpropitious. †John Ruskin once contrasted his upbringing with Giorgione's – Giorgione's in Venice with its vivid colouring and golden vistas, Turner's in grimy London with the muted tones of its markets, riverside and docks. Turner's father encouraged him to paint watercolours of picturesque subjects, which he was able to sell. But beneath the surface, Turner always longed for wild, violent, even apocalyptic subjects.

The dramatic Alpine watercolour reproduced here is characteristic of watercolours Turner executed during a visit to Switzerland in 1802. It illustrates the qualities of immensity called for by Burke as one of the essentials of the Sublime. There is also, in this immensity, something of the horrific character Burke also demanded: the puny size of the figures near the smoke at the left and of the flock of sheep at the right, contrasted with the immensity of the falls, rushing furiously from a cleft between the lofty and distant mountains, their summits partly obscured by clouds, underlines the majesty of nature and the frailty of man. Turner aptly illustrates Burke's dictum that 'Greatness of dimension is a powerful cause of the sublime'.

Here Turner conveys the power of nature that stirred the imagination of Romantic artists of Northern Europe, an imagination that had for long been rendered inert by Mediterranean amplitude. It was something that entered his art in the late 1790s, when he began to turn from conventional topographical and picturesque views to more dramatic works, partly under the influence of Romantic poets such as James Thomson, Wordsworth, Byron and Shelley, whom he read with avidity.

But even his earlier works are not free of tension. He had set out with Claude and Poussin as his mentors, and their influence may be discerned everywhere, but his subjects are usually far removed from the agreeable idylls of the one and the classic calm of the other. Instead, as here, he concentrated on the overwhelming forces of nature which would, in time, dissolve his landscapes into almost abstract patterns of light, colour, mists and mirages (see plate 34). In *The Great Falls of Reichenbach* his approach is more formal, being based on a series of V-shapes in the landscape, while the foreground and middle distances are linked by a diagonal formed by dead trees. Turner doubtless chose this view and the elements of the composition from what he actually saw, but he used and arranged them creatively, with what Kenneth Clark once called 'the rhetoric of romanticism'.

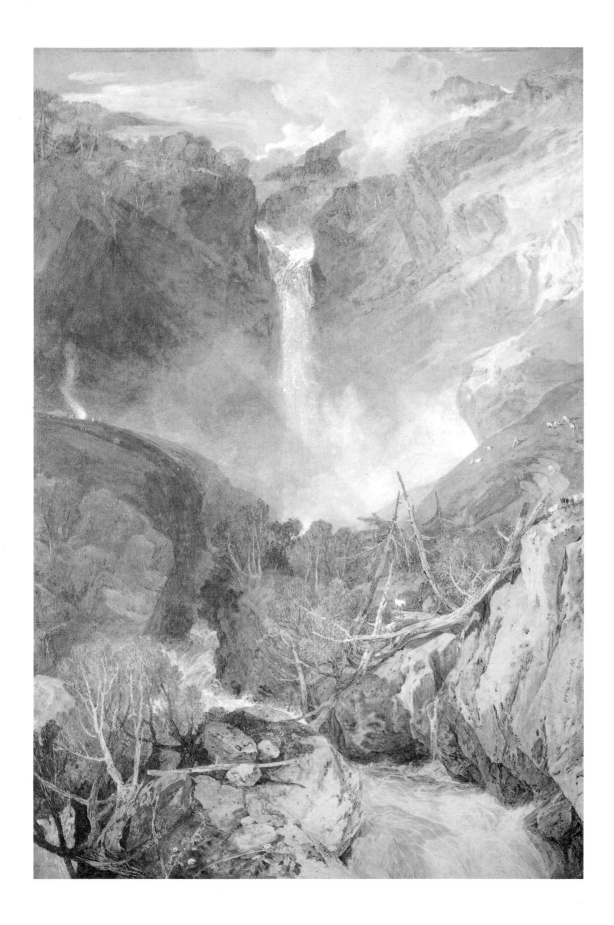

34

JOSEPH MALLORD WILLIAM TURNER (1775–1851)

Snow Storm: Hannibal and his Army crossing the Alps (1812)

Oil on canvas, 145 × 237.5 cm
The Turner Collection, Tate Gallery, London

Turner once described how, in a storm at sea, he got the sailors to lash him to the mast for four hours so that he could observe and record the atmospheric effects. This was the foundation of his oil painting *Snow Storm – Steam-Boat off a Harbour's Mouth* (1842, Turner Collection, Tate Gallery). Similarly, *Hannibal and his Army crossing the Alps* originated in studies made in Yorkshire during a thunderstorm. Hawkesworth, the son of Turner's friend Walter Fawkes, recalled how one day in 1810 at Farnley, Turner, standing in a doorway, called to him loudly: 'Hawkey – Hawkey! – come here – come here! Look at this thunder storm! Isn't it grand? – isn't it wonderful? – isn't it sublime?' Fawkes continues:

> All this time he was making notes of its form and colour on the back of a letter. I proposed some better drawing-block, but he said it did very well. He was absorbed – he was entranced. There was the storm rolling and sweeping and shafting out its lightning over the Yorkshire hills. Presently the storm passed, and he finished. 'There', said he, 'Hawkey; in two years you will see this again, and call it "Hannibal crossing the Alps".'

When the diarist Henry Crabb Robinson saw *Hannibal* in the Royal Academy in 1812, he wrote: 'It seemed to me the most marvellous landscape I had ever seen ... I can never forget it.' An extract from Turner's ambitious but amorphous poem *The Fallacies of Hope* appeared in the catalogue:

> Craft, treachery, and fraud – Salassian force,
> Hung on the fainting rear! then plunder seiz'd
> The victor and the captive, – Saguntum's spoil,
> Alike became their prey; still the chief advanc'd,
> Look'd on the sun with hope; – low, broad, and wan;
> While the fierce archer of the downward year
> Stains Italy's blanch'd barrier with storms.
> In vain each pass, ensanguin'd deep with dead,
> Or rocky fragments, wide destruction roll'd.
> Still on Campania's fertile plains – he thought,
> But the loud breeze sob'd, 'Capua's joys beware!'

Turner's thirst for first-hand experience of atmospherics and his interest in historical perspectives, united in *Hannibal*, combine two important aspects of Romanticism. The painting also bears a hallmark of much of Turner's work: the transformation of the atmosphere into great hyperbolas of light and cloud around a vortex, providing an impression of almost cosmic expanse and generating the terror of the Sublime. So strong is this impression that his contemporary, Elizabeth Rigby (later Lady Eastlake) asked Turner on seeing it: 'The End of the World, Mr Turner?' 'No ma'am', he replied, '*Hannibal crossing the Alps*'.

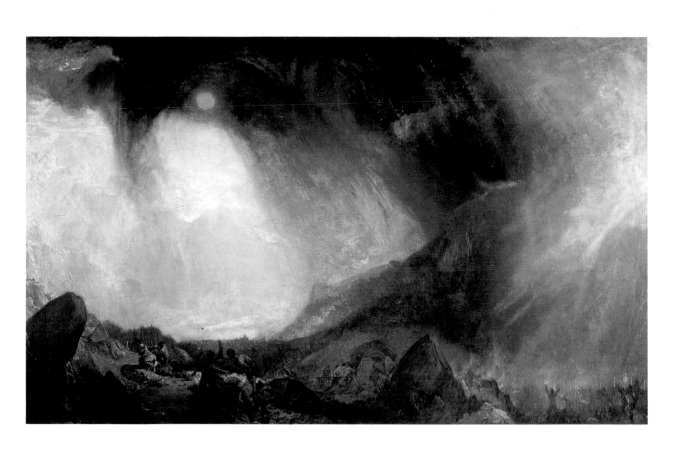

THOMAS GIRTIN (1775–1802)
Durham Cathedral (*c.* 1796)

Watercolour, 410 × 530 mm
Whitworth Art Gallery, University of Manchester

Girtin was only twenty-seven when he died, but he has an almost unrivalled reputation as a watercolour painter; he is as important as †Turner in the development of Romantic landscape art, and in the enrichment of watercolour technique. Richard Redgrave (1804–88) stated that 'to the poetry of the art, as practised by [†J. R.] Cozens, Girtin added power – power of effect, power of colour and tone, power of execution'. Alongside Turner, Girtin transformed watercolour from what was usually little more than the art of tinting drawings, into true painting comparable with work in oil. As the writer W. H. Pyne expressed it, he achieved this by 'laying in the object upon his paper, with the local colour, and shadowing the same with the individual tint of its own shadow'. That is an over-simplification, and Pyne goes into much greater detail, but it does indicate how Girtin worked.

He was born at Southwark, where his father was a dealer in ropes and brushes. After some initial drawing lessons from an obscure teacher, he was from 1789 to 1791 or 1792 apprenticed to the watercolourist and engraver Edward Dayes (1763–1804). His apprenticeship at an end, Girtin toured the Midlands and Wales, making watercolours in the style of Dayes. In 1795 he was noticed by the connoisseur Dr Thomas Monro (see commentary to plate 20), who gave him both encouragement and commissions and tried, apparently unsuccessfully, to get him into the Royal Academy schools.

During the following year, Girtin's art entered a new phase, and from producing conventional, though excellent, topographical studies, he began to transform his subjects into visual poetry. In the same year he toured the north of England and part of Scotland, during which he made the study of Durham Cathedral (private collection, England) from which this watercolour was developed. In 1801 a visit to Paris prompted a number of excellent watercolours; a book of etchings of some of them was published posthumously as *A Selection of Twenty of the most Picturesque Views in Paris*. Girtin died suddenly, probably from consumption.

Durham Cathedral belongs to a group of what Turner called Girtin's 'golden drawings', of which he is said to have remarked, 'I never in my whole life could make a drawing like that: I would at any time have given one of my little fingers to have made such a one.'

The vertical massing of the architecture of the cathedral and the castle of the prince-bishops raised on a rocky eminence – still an unrivalled sight – and the smaller buildings at the end of the bridge, underlined by the horizontal of the bridge reaching from side to side, constitutes a masterly combination. The artist quickly transforms the viewer's topographical interest in the subject into a contemplation of the contrasting verticals, diagonals and horizontals; the complex structure evokes an emotive response, and the spirit is lifted as if by music.

36

JOHN CONSTABLE (1776–1837)

The Lock (*c.* 1831–4)

Indian ink and brown wash, with some scraping, 114 × 147 mm
Fitzwilliam Museum, Cambridge

It has been said that, in terms of their art, Turner was Byronic, while Constable was Wordsworthian. While too much should not be read into such thumbnail definitions, it is a fact that Constable's work contains something of the same preoccupation with nature that pervades Wordworth's poetry. 'My art', he said, 'can be found under every hedge.'

Born in 1776 in East Bergholt in Suffolk, where his father owned a mill, John Constable had much of the countryman's earthy outlook: when †William Blake was shown a sketch by Constable of an avenue of fir trees, he said with enthusiasm, 'Why, this is not drawing, but *inspiration*', at which Constable made the mordant comment, 'I never knew it before; I meant it for drawing.' Yet he also said, 'Painting is with me but another word for feeling', acknowledging that he was not so far removed from inspiration, which on his own admission he gained from the most unpromising subjects – 'old rotten planks, slimy posts and brickwork'. In this he was not unlike Blake himself, who once told †George Richmond: 'I could look at a knot in a piece of wood until I am frightened at it.'

At the same time Constable was a true Romantic in his adherence to the scientific spirit of the age, exemplified in, for example, Erasmus Darwin's *The Botanic Garden* (1789–91), in the natural history illustrations of †Thomas Bewick, and in the paintings of †Joseph Wright of Derby. 'Painting is a science', he said, 'and should be pursued as an inquiry into the laws of nature. Why, then, may not landscape painting be considered as a branch of natural philosophy, of which the pictures are but the experiments?'

It would be wrong, though, to think of Constable as a quiet and contemplative painter, for there is often an agitation in his art, with its dancing lights and excitedly worked textures, that suggests considerable spiritual conflict. In this respect his work bears comparison with that of his near contemporary Eugène Delacroix, who, however, was less concerned with landscape than with humanity.

To modern tastes Constable is often at his best in quickly executed sketches like the river scene reproduced here. By concentrating on the essential, they have an immediacy often lacking from his more highly finished and more formal set-pieces. The finished work, also entitled *The Lock* (1826, Royal Society of Arts, London), which was Constable's diploma picture, is a splendid achievement. But this sketch (one of two of the same subject in the Fitzwilliam Museum) has greater vitality, especially in the attitude of the lock-keeper working the wrench, with his leg pressed against it to give greater leverage.

The scene is set in Constable's native Suffolk at Flatford Lock; topographical detail is more evident in the finished painting, but details in the drawing also confirm the location.

JOHN CONSTABLE (1776–1837)

Stonehenge (1836)

Watercolour, 387 × 591 mm
Victoria and Albert Museum, London

The essentially Romantic nature of this watercolour is set out in an inscription on its original mount: 'Stonehenge. "The mysterious monument of Stonehenge, standing remote on a bare and boundless heath, as much unconnected with the events of past ages as it is with the uses of the present, carries you back beyond all historical records into the obscurity of a totally unknown period".'

Mystery and remoteness in distance and in time, in a setting dominated by atmospheric effects (including the hopeful rainbow) all contribute to the drama of this supreme example of Constable's skill as a watercolourist, as does the contrast between the transient effects of nature – the quickly changing clouds, the fugitive rainbow, even the hare bolting at the lower left of the composition – and the ageless permanence of the monument. As Constable himself wrote to his friend C. R. Leslie R.A., on 14 September 1836: 'I have made a beautiful drawing of Stonehenge.'

Yet it is not a spontaneous work; in contrast with the sketch of *The Lock* (plate 36), it is highly wrought and painstakingly developed, the effect of much preparation and study. Constable probably first visited the site in July 1820, when he made a pencil drawing, a much more restrained version, from the same viewpoint (also in the Victoria and Albert Museum); he made several other studies (examples are in the Witt Collection in the Courtauld Institute Galleries, and in the British Museum), which marked stages in the development of the design of the composition and in his preoccupation with the subject.

In a lecture on landscape painting, delivered at the Hampstead Assembly Rooms in June 1833, Constable spoke of Raphael, praising the 'extreme beauty' of the landscape backgrounds in the Vatican Logge, and the 'lovely pastoral scenery' of the cartoon of the *Charge to Peter* (on loan to the Victoria and Albert Museum), remarking, 'Thus was landscape cradled in the lap of history.' It is a sentiment that could be adapted to *Stonehenge*, in which prehistory is cradled in the lap of landscape.

Although Constable's work was influenced by Italian art, and by (among others) Claude, Poussin, Hobbema and Cuyp, he was well aware that such influences must be tightly reined: 'The absurdity of imitation', he said, 'is nowhere so striking as in the landscapes of the English [John] Woot[t]on [*c.* 1686–1765], who painted country gentlemen in their wigs and jockey caps, and top-boots, with packs of hounds, and placed them in Italian landscapes resembling those of Gaspar Poussin [Dughet], except in truth and force.' He always kept the influence of earlier masters on his own work under close control, and though *Stonehenge*, for instance, contains a suggestion of Meindert Hobbema in the *plein air* rendering, it remains Constable's conception and could not have been painted by any other artist.

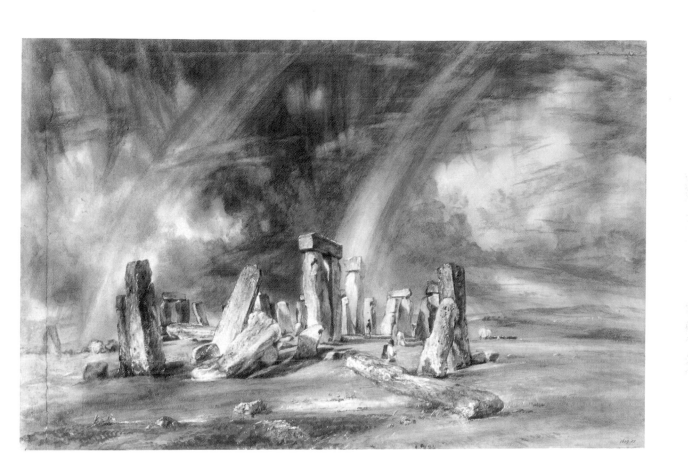

JOHN VARLEY (1778–1842)

Snowdon from Capel Curig (*c.* 1810)

Watercolour, 368 × 476 mm
Birmingham Museum and Art Gallery

John Varley was not only a noted watercolourist, he was also an astrologer and an especially gifted teacher; his pupils included [†]David Cox, [†]William Mulready and [†]John Linnell. Among his friends was [†]William Blake, who drew for him his well-known 'visionary heads' – imaginative portraits of historical and mythological personages from Wat Tyler to the Ghost of a Flea. He was a founder-member of the Watercolour Society in 1804–5.

Varley was born in Hackney. Little is known of his father beyond the fact that he forbade John to take up art – vainly, for at the age of fifteen or sixteen the young Varley became a pupil and assistant of the Holborn drawing master and landscape painter Joseph Charles Barrow (*fl.* 1789–1802). He began to exhibit at the Royal Academy in 1798 and within a few years had become a noted landscape painter; concurrently he had achieved recognition as an unrivalled art teacher, his practice leading in 1816–21 to the publication, in parts, of his *Treatise on the Principles of Landscape Design*.

His pupils boarded at his house, where their experiences were seldom unexciting. Varley weighed seventeen stone and possessed prodigious energy. For forty years he worked for fourteen hours a day, and when in need of respite would put on boxing gloves and fight a bout with one of his pupils. If that did not tire him, he divided his pupils into two teams and, himself taking part, threw his screaming wife from one to the other across the table. He was perpetually in debt and whenever the tipstaff came to arrest him, would beg him to wait while he collected his paintbox, so that he could paint one or two works in prison, to sell to pay off his debt.

The Snowdon massif, which dominates the view in this watercolour, is full of historical and pastoral resonances. It was portrayed by many artists; for example [†]Samuel Palmer drew it at different times from several viewpoints. Varley's watercolour is an elegant composition which exploits verticals and horizontals in the landscape in order to achieve a broad, serene, Claude-like prospect. The harmonious colouring is bright and limpid, but restful, and imparts a soothing note – unlike the wild scenery of much other Romantic work, for example by Loutherbourg and Turner (plates 15 and 34).

The close, somewhat hard texture of the foreground of this work resembles that used frequently by Varley's pupil [†]Francis Oliver Finch; indeed Varley's influence is clear throughout Finch's *oeuvre*.

39

ALFRED EDWARD CHALON (1780–1860)

The Opera Box (1838)

Watercolour, 469 × 346 mm
Reproduced by courtesy of the Trustees of the British Museum

The brothers Alfred Edward and John James Chalon (1778–1854), both artists, were of French descent but Swiss nationality, born in Geneva. Their father settled in England while they were still children, having obtained the post of Professor of French at the Royal Military College, Sandhurst. Chalon *père* wanted Alfred to take up a commercial career, but the boy showed an early disposition for art, and entered the Royal Academy schools in 1797; he began to show his work at the Academy exhibitions in 1801. He was elected an associate in 1812 and an academician in 1816.

He soon established himself as a premier portrait painter in watercolour, and was appointed watercolourist to Queen Victoria. His brilliant and colourful portrait of her (Royal Collection of Belgium), painted soon after her accession, in the rich robes worn at the dissolution of Parliament, is among his most famous works; the head from it was used most effectively as the central motif on many British colonial postage stamps issued during the period 1850–90 for the Bahamas, Grenada, New Zealand, Nova Scotia, Queensland and Tasmania.

Chalon also painted miniatures and oils. Among his most pleasing works are studies of the ballerinas of the Romantic ballet in performance, many of which were accorded wide circulation by lithographed reproductions. The most famous of these include *The Celebrated Pas de Quatre composed by Jules Perrot*, which depicts the great dancers Carlotta Grisi (1819–99), Marie Taglioni (1804–84), Lucile Grahn (1819–1907) and Fanny Cerrito (1817–1909) lithographed by Thomas Herbert Maguire (1821–95); and *The Three Graces* (Fanny Elssler (1810–84), Taglioni and Cerrito) by an unidentified lithographer.

The Opera Box depicts a moment during the performance of a ballet, as seen from the interior of a box from which two stately ladies and a gentleman watch a dancer performing on the apron of the stage, a form of presentation that must often have destroyed some at least of the illusion of the *mise en scène*. To judge by the attitudes of the people in the boxes opposite this would seem to have mattered little, as one lady has completely turned her back on the performer, while her companion in the same box is leaning round the edge to talk to a woman in the next box.

The dress of the lady at the left savouring a nosegay is almost like the costume of a dancer, with overtones from *Giselle* or *La Sylphide*. Her companion, drawing a paisley shawl around her shoulders and glancing slyly at their escort, is reminiscent of a Spanish duenna, in keeping with the Romantic taste for the exotic. The somewhat Byronic profile and hairstyle of the young man adds yet another gloss. It is as if the box contains its own little dramatic episode.

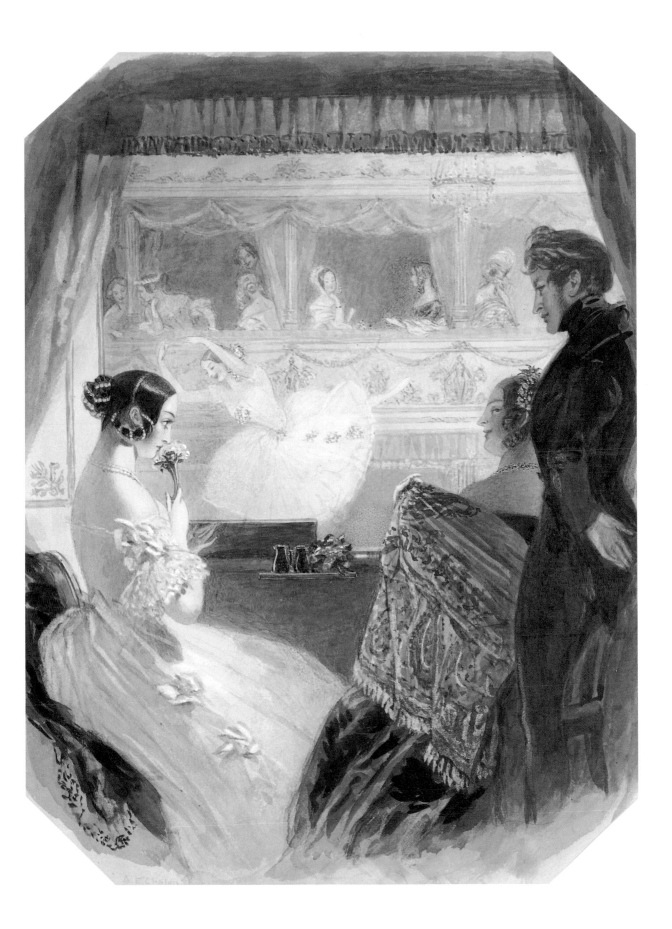

JOHN SELL COTMAN (1782–1842)

Chirk Aqueduct (*c.* 1804)

Watercolour, 318 × 231 mm
Victoria and Albert Museum, London

John Sell Cotman, one of the finest of all painters in watercolour, was, like †J.M.W. Turner, the son of a barber. While attending the Grammar School in his home town, Norwich, John Sell showed a marked inclination to painting. His father, Edmund Cotman, had become acquainted with the portrait painter John Opie (1761–1807), who was visiting Norwich, and sought his advice about the possibility of the boy becoming an artist. 'Let him rather black boots', was Opie's discouraging reply. Despite this John Sell went to London in the late 1790s, where he was engaged by Ackermann to colour prints.

In 1801 he joined a society of young artists founded in 1799 with †Thomas Girtin as its head. Calling themselves 'The Brothers', their *raison d'être* was the study of Romantic landscape. Cotman became its president in 1802.

He returned to Norwich in 1807, after visiting many other parts of Britain, including Wales, Devon, Yorkshire, Somerset, Durham and Lincolnshire. In addition to painting, he took in pupils; he became president of the Norwich Society of Artists in 1811. In 1825 he was elected an associate member of the Old Water-Colour Society, and in 1833 was appointed drawing master at King's College, London. From then on he lived in London. His mental health was unstable, and alternate bouts of melancholia and euphoria seem to point to manic-depression. His sons, Miles Edmund (1810–58) and John Joseph (1814–78) were also watercolourists.

Like that of †Francis Towne, Cotman's work tended to the abstract; his principle was 'to leave out but add nothing'. This led, as in *Chirk Aqueduct*, to compositions combining glittering patterns of light, rhythms and shapes. Like Towne's, Cotman's views are topographically convincing, but they heighten the structural dimension of landscape, raising it (somewhat in the manner of the Japanese artists Hiroshige and Utamaro) to the level of music, arranging the subject into a coherent artistic whole (cf commentary to plate 14).

This is especially evident in the present composition. The great arcade of the aqueduct, one of Thomas Telford's masterpieces of industrial architecture, carries the Shropshire Union Canal across the Vale of Ceiriog. The sharply drawn arches, two of them diagonally bisected on one wall by shadows as sharply divided as heraldic charges, are each reflected in the water below, as if in a nacreous mirror. Their mass and distinctness are contrasted by the soft greens, yellows and browns of the farther landscape and the foreground. The light fencing seen through the left and centre arches helps, by supplying a slight but sufficient horizontal accent, to tie the composition together, as does the slope at the left; while the stray tree branches just above the slope and across the inner wall of the arch at the left ensure that no monotony attaches to the repeated arches of the aqueduct.

DAVID COX (1783–1859)

Carting Timber (1851)

Watercolour, 241 × 324 mm
Southampton City Art Gallery

David Cox, one of the most influential English watercolourists, was the son of a blacksmith and whitesmith of Birmingham. After studying under the landscape painter Joseph Barber (1757–1811), so as to qualify for work in the Birmingham fancy-goods trade, painting snuffboxes, lockets and other trinkets, he was briefly apprenticed to a miniature painter, who however committed suicide eighteen months later. He then found employment painting theatre scenery, which shortly took him to London – where he had lessons from †John Varley – and to various other towns including Swansea and Wolverhampton.

By about 1808 Cox had begun his career as a watercolour painter. To collect subject matter he travelled to Wales, northern England, Holland, Belgium and France. Until 1841 he made London his base, but he returned to the Birmingham area (Harbourne) in 1841, and settled there.

Cox was a noted teacher, and in 1811 published *A Series of Progressive Lessons intended to Elucidate the Art of Painting in Water-Colours*, which was followed in 1813–14 by his important *Treatise on Landscape Painting and Effect in Water Colours*, reprinted several times until 1841; and in 1819–20 he published in parts the first edition of his *Young Artist's Companion*. These manuals all appeared during a period in which there was an enormous upsurge of painting of Romantic and picturesque subjects by amateurs; it was for them that Cox primarily intended his publications, but the *Treatise* especially was also used as a textbook by many professional teachers and artists: among those influenced by it was †Samuel Palmer.

Cox's work, in oil as well as in watercolour, is notable above all for its portrayal of fugitive and ephemeral effects in nature, and in this respect may be seen as foreshadowing the work of French impressionists such as Camille Pissarro (1830–1903) and Eugène-Louis Boudin (1824–98).

Carting Timber, throbbing with the dynamic energy of nature, is a characteristic example, with its lowering sky and desolate moorland landscape, wind-swept and rain-drenched. Wood is being carted in readiness for winter, William Cowper's 'ruler of th'inverted year'. Cox invests such landscapes with his own emotional reaction, expressed, as here, by his spontaneous technique. The colour is thickly and quickly applied, in broad brushstrokes, dashed on so that no passing nuance of the inconstant autumn weather is missed.

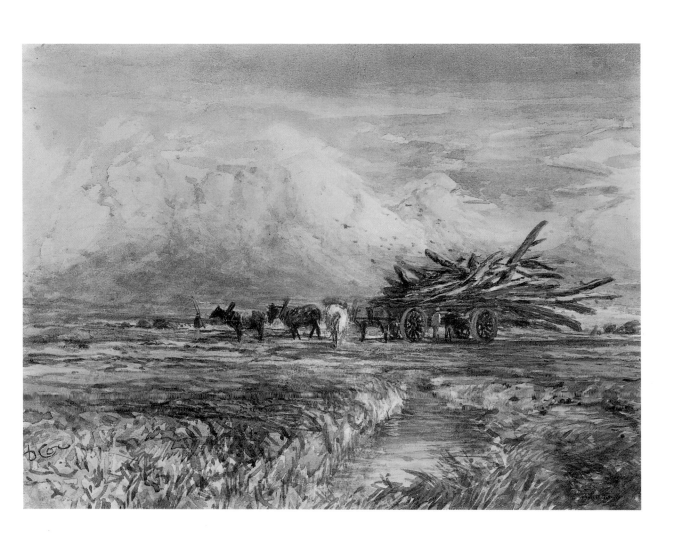

42

EBENEZER GERARD (1783/4–1826)

Miniature of an Unknown Man (*c.* 1820)

Watercolour and body colour, 103 × 86 mm
Private Collection, England

The history of an artistic movement is not restricted to great names. Many lesser known, even unknown, figures contribute – it would hardly be a 'movement' unless they did. Here and there one of them may produce a notable work of art. Among such artists is Ebenezer Gerard, who for three years had a studio at 11 Davey Place, Norwich; he claimed to have painted 'upwards of Four Thousand Portraits', which varied from 'profile shades' (silhouettes) at 1s. (5p) each, through miniatures at one guinea (£1.05) to full-length portraits at three guineas (£3.15). From Norwich he later moved to Liverpool, and finally to Glasgow.

Gerard was noted for portraits of actors in costume, for instance *Henry Wallack of the Norwich Royal in the Character of 'Timour the Tartar'* (a play by Matthew Gregory 'Monk' Lewis, 1775–1818) and *Richard Jones of the Norwich Theatre as Sir Francis Faddle in 'For England Ho!'* (both in the Strangers Hall, Norwich). These, it must be admitted, are rather wooden, with the actors in the exaggerated poses depicted in the contemporary Juvenile Drama (toy theatre sheets; the portrait of Wallack is uncannily like some tinsel portraits issued by the publishers of Juvenile Drama). Gerard must, however, have been held in considerable regard, for Wallack (1790–1870) and 'Gentleman' Jones (1779–1851) were both well-known actors.

The miniature reproduced here is an altogether different affair, a little masterpiece of character portrayal. The identity of the rugged, somewhat churlish-looking sitter is unknown, but one would guess that he was a farmer, a small tradesman, or perhaps a minor official. His sardonic, uncompromising, but disturbingly unfocussed glare, his grimly set mouth with jutting lower lip, and his great hooked nose, with creases reaching down to his chin on each side, suggest a character of hidebound, unalterable views, yet insecure; something of a bully, perhaps. His clothes, dark and severe, serve to emphasise the uncertainty in his expression.

The miniature is painted on paper, and the colours have faded – the carnations have completely disappeared – but this adds, albeit gratuitously, to the scabrous character of the sitter, by throwing into prominence the blue of his chin. The painting of the eyes and hair, on the other hand, is unimpaired.

As a result of a fever, Gerard lost the use of his arms sometime before 1824, and in an attempt to retrieve his income, he took to writing verse, without conspicuous success. He published much of it in *Letters in Rhyme* (Liverpool, 1825), a facetious collection, with lithographic illustrations and caricatures by himself.

While his verse and many of his portraits are at best second rate, Gerard shared in the Romantic ideal of the poet–painter, and in one portrait, at least, demonstrated that he was capable, in the best Romantic tradition, of portraying the *Sturm und Drang* in the character of one of his contemporaries.

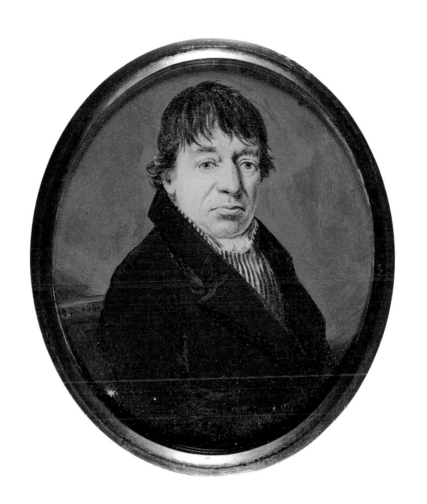

43

WILLIAM MULREADY (1786–1863)
The Younger Brother (1857)

Oil on canvas, 77.5 × 62.5 cm
The Tate Gallery, London

The Mulready family came from Ennis, County Clare, Ireland, to settle in London in 1792. William, whose father was a leather-breeches maker, was apprenticed in 1799 to the sculptor Thomas Banks (1735–1805), and studied at the Royal Academy schools (1800–5). At the age of sixteen he was awarded a large silver palette by the Society of Arts. He also studied for a time with the watercolourist †John Varley.

William began his career as a landscape painter, and in this was much influenced by his friend †John Linnell and by Varley, whose sister he married in 1803; unfortunately this was an unhappy union, and ended in separation after some six years. Mulready was elected an associate of the Royal Academy in 1815 and an academician during the following year.

From 1807 he concentrated on genre, in which he showed great originality both in choice of subject and inventiveness. Sometimes his subjects are comic, sometimes they border on the sentimental, but on the whole they are decisively conceived and controlled. Mulready's work is notable for great accuracy and firmness of drawing and for light but rich, intensely luminous colouring, applied in thin glazes over a white foundation (as in the work of the Preraphaelites, which he anticipated; see plates 72–4).

The Younger Brother, a comparatively simple composition, is among his most pleasing works. It is a study of family love and tenderness, the mother (or perhaps she is an older sister) holding a young child against her breast and cheek, while the child's elder brother caresses him tenderly with his outstretched hand. The composition is based on a main diagonal formed by the woman's body and the tree above her, and two secondary diagonals provided by the two brothers, all tied together by the elder brother's caressing arm.

The pose of the three figures recalls that of Titian's *Venus and Adonis*, and the woman's hairstyle is comparable to that of Venus. Mulready may have known Titian's picture from an engraving by Sir Robert Strange (1769), but he could also have known the original in the National Gallery, London, since the Gallery acquired it in 1824. Such borrowing was common in academic historical painting at this period; here Mulready applies it to genre.

Mulready was also an accomplished painter of the nude, and in this approaches even the mastery of William Etty (see plate 45), though his nudes are less voluptuous than Etty's; a good example is *The Bathers* (1849, National Gallery of Ireland, Dublin). Among his lesser – certainly less successful – works was the design of the Mulready envelopes and covers, depicting Britannia sending winged messengers to every clime, issued simultaneously with the first postage stamps in 1840. They were ridiculed and caricatured, and soon disappeared from use.

44

BENJAMIN ROBERT HAYDON (1786–1846)

Wordsworth on Helvellyn (1842)

Oil on canvas, 125 × 99 cm
National Portrait Gallery, London

Benjamin Robert Haydon was born at Plymouth. He was determined to become a painter, and against the wishes of his parents (his father was a bookseller) he came to London in 1804, with £20 in his pocket. In 1805 he became a pupil at the Royal Academy. Later, not doubting his powers, he began work on his first picture, *Joseph and Mary resting on the Road to Egypt*, enthusiastically noting in his diary, 'I knelt down and prayed to God to bless my career, to grant me energy to create a new era in art, and to rouse the people and patrons to a just estimate of the moral value of historical painting.' He later recalled his pleasure on seeing this painting after a lapse of time: 'It took me six months to paint, and when I saw it twenty-five years after I was astonished.'

After a brief period in Plymouth, where he painted portraits, he returned to London and to historical painting. He also began to see visions, in one of which Michelangelo's spirit reprimanded him for idleness. He got into debt, and remained so for the rest of his life; he was twice imprisoned for bankruptcy. Nothing daunted, he embarked on the creation of huge, unsaleable, historical paintings. He attempted to pay off his debts by accepting portrait commissions, which he loathed, and by lecturing; subscriptions were organised by friends, and his works were put up for sale by raffle. Nothing solved his financial problems and his mind, always unsteady, began to deteriorate. On 22 June 1846, he wrote a last note in his journal, accompanied by a line from *King Lear*: 'God forgive me – Amen – Finis of B. R. Haydon.' He then tried to shoot himself, and when this failed, seized a razor and cut a seven-inch gash in his throat, falling dead before his easel.

It is ironic that the portraits he discounted have survived better than his historical pictures. He was acquainted with many of the great men of letters of the Romantic era, and in the portrait reproduced here he successfully records the brooding personality of one of its greatest poets, William Wordsworth (1770–1850), absorbed in thought during an ascent of Helvellyn in August 1840.

Haydon and Wordsworth were friends for over thirty years, and the poet wrote a sonnet to the painter:

> Haydon! Let worthier judges praise the skill
> Here by thy pencil shown in truth of lines
> And charm of colours . . .

Wordsworth himself maintained that this portrait was no literal-minded study, but was imbued with poetic character, placing him in his beloved mountains. It recalls William Hazlitt's impression of the poet: 'grave, saturnine, with a slight indication of sly humour, kept under by the manners of the age . . . He has a peculiar sweetness in his smile, and great depth and manliness.' Wordsworth later said that this was the best portrait of him ever painted.

45

WILLIAM ETTY (1787–1849)

Cupid and the Maiden (*c.* 1825)

Oil on millboard, 67 × 52 cm (sight size)
Private Collection, England

William Etty is the greatest English painter of the nude. His output is very mixed, its quality uneven, some of it hardly taken beyond the sketching stage, some of it flamboyant, especially to present-day taste; yet much of it is excellent. He was also a first-class portrait painter.

Etty was born in York, and by the time he was ten, was showing some talent as a draughtsman. His parents could not afford to let him study art, and instead apprenticed him to a compositor. Subsequently he went to London, and by 1807 he had entered the Royal Academy schools, studying under †Sir Thomas Lawrence. Two years later an uncle died, leaving him a generous legacy, which gave him some independence. His work began to attract notice, and by 1820 he was employing an assistant. He became an academician in 1828. Between 1815 and 1841 he visited the continent several times, travelling to France, Italy and Belgium, studying art wherever he could, and copying works by great masters, including Giorgione, Titian and Ruisdael.

Though they are sometimes mildly erotic, Etty's nudes are on the whole cool and innocent; despite the often abundant and richly developed charms of his models, they remain virginal. What his friend †Edward Calvert said of Giorgione could equally be applied to Etty: 'Giorgione gives innocence to naked figures in golden glades'. (In passing it may be added that Etty twice copied the *Concert Champêtre* (Louvre, Paris), now thought to be the shared work of Titian and Giorgione.) †John Constable's description of *Youth on the Prow and Pleasure at the Helm* (1832, Tate Gallery, London) as 'Etty's bum boat' was a healthier and apter comment than *The Spectator*'s of 6 May 1837, which called his *The Syrens* 'a disgusting combination of voluptuousness and loathsome putridity'.

Cupid and the Maiden is a tender study symbolising awakening sexuality, set in a landscape that might have been inspired by Delacroix (whom Etty met in England in 1825). It is one of a group of some eighteen similar subjects based on the Venus and Cupid theme, and the most attractively painted of them. The figure of Cupid in another of the group, *Venus and Cupid* (Russell-Cotes Art Gallery and Museum, Bournemouth), has much in common both in its pose and in the painting with that in *Cupid and the Maiden*. The model for the Maiden appears to be the same as that in a *Seated Female Nude* (Rhode Island School of Design, Providence, RI), and the placing of her legs is almost identical with that of the figure in *The Prodigal Son* (National Trust, Anglesey Abbey), where the landscape is handled in much the same way as that in the present picture.

The colouring is restrained, the pearly flesh tints contrasting with the surrounding greens and browns in the landscape. The spot of blue on Cupid's wings provides a contrasting high note.

JOHN MARTIN (1789–1854)

The Great Day of His Wrath (1852)

Oil on canvas, 191 × 299 cm
The Tate Gallery, London

John Martin's paintings provide the most apocalyptic scenes in British painting, but his own beginnings in art were unspectacular. A Northumbrian by birth, he began work in Newcastle-on-Tyne, painting armorial bearings on carriage doors and decorations on porcelain. He moved to London in 1806, settled there, and exhibited at the Royal Academy for the first time in 1812. One of the pictures shown on this occasion was the dramatic, even terrifying, *Sadak in search of the Waters of Oblivion* (Southampton City Art Gallery), illustrating an episode from James Ridley's *Tales of the Genii* (1762). Its luminous glowing colours, rugged landscape and cataract suggest the influence of Loutherbourg's Eidophusikon (plate 28).

The Great Day of His Wrath, a much later work, marks the zenith of Martin's achievements in portraying scenes of catastrophe and terror. His subject is taken from Revelation VI.17: 'For the great day of his wrath is come; and who shall be able to stand?' In Martin's interpretation the whole earth is overwhelmed by quake and lightning, rocks the size of mountains are being hurled through the air as if they were no more than thistledown; on the right of the composition an entire city, struck by a bolt of lightning, is being inverted and flung into the dark valley, upon crowds of struggling, writhing, shrieking mortals. It is a vision of a destruction that has now been made possible by nuclear fission, but which to Martin's contemporaries could only emanate from a wrathful Jehovah, who might be provoked to destroy the world as He had destroyed Sodom and Gomorrah (the subject of another picture Martin painted in 1852, now in the Laing Art Gallery and Museum, Newcastle-on-Tyne).

The extremes of scale and fantasy in this picture suggest a drug-induced dream or hallucination, and Charles Baudelaire (1821–67), himself an opium addict, asserted in his *Paradis artificiels* that Martin's paintings faithfully render 'the colour of an opium landscape'. But Martin's landscapes are also inspired by the glowing, smoking scenery of potteries, foundries and smelting works which he saw in the north of England. His work often shows the influence of contemporary industrial developments, even in details; for instance in one of his illustrations to Milton's *Paradise Lost* (1827), Satan presides over the council of Pandemonium in a hall illuminated by lamps remarkably like early gasoliers.

In his day Martin was known as 'Mad Martin', because of the extravagance of his subjects. He was sane, but he did have an insane brother, Jonathan, who started a fire which caused considerable damage in York Minster. Jonathan was incarcerated in Bedlam, where he made some demented drawings, a typical example depicting a seven-headed bishop rushing into the open jaws of a crocodile.

Many of Martin's paintings were reproduced in mezzotint; the deep, velvety harmonies of that medium well suit the immensity and mystery of his subjects. *The Great Day of His Wrath* was scraped by Charles Mottram (1807–76) in 1857.

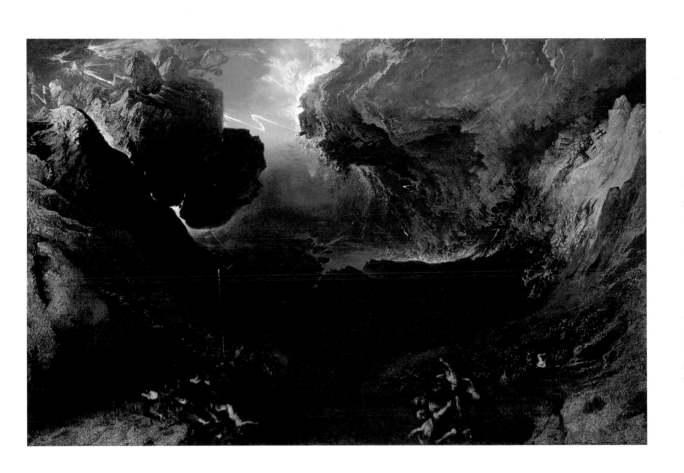

47

JOHN LINNELL (1792–1882)

Shepherd Boy playing a Flute (1831; *possibly* 1837)

Oil on panel, 23 × 16.5 cm
Yale Center for British Art, Paul Mellon Collection

John Linnell was the self-educated son of a London frame-maker, gilder and picture-restorer. After serving an apprenticeship under the artist [†]John Varley, in 1805 he became a probationer at the Royal Academy schools, where five years later he won a medal for modelling.

He travelled widely in Britain, sketching and painting, at times in the company of his former fellow pupil [†]William Mulready and the painter William Henry Hunt (1790–1864). He married in 1817. The most hardworking of men, Linnell imbibed huge quantities of 'vital air' (oxygen) to increase his energy. He established himself as a painter of portraits and more particularly of landscape, and later took his sons into his business, as he preferred to call his studio. It flourished and he became a rich man.

Linnell met [†]William Blake in 1819, and, perceiving his genius, gave him important commissions, including the engraved *Illustrations of the Book of Job* (1825), considered by many to be his masterpiece; these enabled the old man to live out his life in passable comfort. Linnell was probably also indirectly responsible for securing for Blake the commission to illustrate with wood-engravings the first eclogue in *The Pastorals of Virgil* (1821), a school edition by Robert John Thornton, Linnell's family doctor.

In 1822 Linnell met the young [†]Samuel Palmer, who later became his son-in-law. There is considerable controversy about his alleged ill-treatment of Palmer, but there were probably faults on each side. The fact remains that Linnell's early encouragement helped Palmer to develop into one of England's greatest landscape artists.

Shepherd Boy playing a Flute is based on a drawing (private collection, England) made during a visit in 1829, in company with [†]George Richmond, to Palmer's country retreat at Shoreham in Kent. The painting may serve as a reminder of Richmond's statement, 'my opinion is that Mr Linnell owed as much to Mr Palmer in his art, as Mr Palmer did to Mr Linnell – perhaps more', for it contains more than a hint of the visionary landscapes painted at about the same time by Palmer.

The figure of the shepherd boy is obviously based on direct study; this is evident especially in the sensitively observed hands and fingers on the flute. The Kentish landscape, with contentedly grazing sheep in a peaceful countryside, while almost certainly based on direct observation, also recalls the idyllic spirit in Blake's wood-engravings and in Palmer's contemporary watercolours, such as *The Primitive Cottage* (*c.* 1828–9, Victoria and Albert Museum) and *A Cornfield bordered by Trees* (*c.* 1833–4, Ashmolean Museum, Oxford). It may also recall the introductory poem 'Piping down the Valleys wild' in Blake's *Songs of Innocence*. In later life, by way of reciprocation, Palmer used Linnell's young shepherd as a model for the main figure in his watercolour *The Piping Shepherd* (*c.* 1855, Ulster Museum, Belfast).

FRANCIS DANBY (1793–1861)

Disappointed Love (1821)

Oil on panel, 62.8 × 81.2 cm
Victoria and Albert Museum, London

The work of Francis Danby is often bracketed with that of [†]John Martin, and it is true that a proportion of it contains much of the same dizzy vastness and terror – for instance *The Delivery of Israel out of Egypt* (1825, Harris Museum and Art Gallery, Preston), *The Opening of the Sixth Seal* (1828, National Gallery of Ireland, Dublin) and *The Deluge* (1837–40, Tate Gallery, London). But Danby was also an excellent landscapist and a first-rate painter of Romantic narrative subjects.

He was born in Ireland in Country Wexford, where his father was a gentleman farmer. He entered the drawing school of the Dublin Society, where he made friends with James Arthur O'Connor (1792–1841), nicknamed 'the Irish Corot'; another friend was the landscape painter George Petrie (1790–1866). O'Connor may have helped him in the study of the technique of oil painting.

Danby first exhibited his work in Dublin in 1812, and a little later decided to come to London. He was accompanied by O'Connor and Petrie. Petrie soon returned to Ireland; O'Connor and Danby were reduced to walking to Bristol, hoping to catch the Dublin packet. O'Connor embarked on it but Danby elected to stay behind, having married a Bristol girl. He spent the period 1824–9 in London, but for the next ten years he lived in Paris and Geneva, returning to London in 1840. He later moved to Exmouth, where he spent the remainder of his life.

Danby first exhibited at the Royal Academy in 1817, and in 1825 he was elected an associate, but a personal scandal prevented his elevation to academician. His marriage was unhappy, and when it finally collapsed he left his wife in order to live abroad with his mistress, a girl named Helen Evans, who bore him several children. In the eyes of his contemporaries, this was unforgivable.

Disappointed Love is an Ophelia-like subject (cf plate 73): a jilted young girl sits weeping beside a woodland pool, her face buried in her hands, her hair hanging carelessly over her knees. She has torn a letter to pieces, and the fragments float on the surface of the water. Other letters, not yet destroyed, lie beside her on a wallet with an open locket containing a miniature of her beloved. Soon perhaps she will cast herself too into the still waters and, like Ophelia, sing as she drowns.

The gloomy woodland and the bank in the foreground, with here and there white funereal flowers lighting up the greens and browns, seem to encase the frail, white figure, reflected by the water as if it were welcoming her to the release of death. Her scarlet shawl, the colour of blood, adds a portentous note to the *tristesse* of the scene. (For a later variation on this theme, cf plate 74.)

49

JOSEPH SEVERN (1793–1879)

John Keats (1821)

Oil on canvas, 57 × 42 cm
National Portrait Gallery, London

Joseph Severn, a close friend of John Keats (1795–1821), was born at Hoxton. For some seven or eight years he was apprenticed to an engraver, William Bond. He found this an unhappy experience, relieved to some extent because he was able to set aside time to attend painting classes at the Royal Academy; in 1819 he was awarded a gold medal, in a competition, for his painting *The Cave of Despair*.

By this time he had already met Keats. The two young men were drawn to each other and when, in September 1820, the consumptive poet was ordered abroad by his doctor, Severn volunteered to accompany him. From that time until Keats died on 23 February 1821 he attended to his daily requirements, medical, social and domestic, including cooking. He was with Keats when he died in his little bedroom overlooking the Piazza di Spagna in Rome, and it was to Severn that Keats addressed his last words: 'Don't be frightened.'

Severn's later life was largely devoted to perpetuating the memory of his friend. He married, got into financial difficulties, and soon after, in January 1861, was appointed British consul to Rome; his wife died just over one year later. He held the consular appointment until 1872, but continued to paint, although during this time and during the remainder of his life nothing eventful occurred. Two years after he died, his body was reinterred beside that of Keats in Rome's Protestant cemetery, in the shadow of the pyramid of Gaius Cestius.

Severn painted several portraits of Keats, for instance the attractive miniature in the Fitzwilliam Museum, Cambridge. This portrait, painted in Rome after the poet's death, depicts him in a room in the house of his beloved Fanny Brawne, at Wentworth Place, Hampstead; he lived next door for some months during 1819 and 1820. In a letter of December 1858 or 1859 (National Portrait Gallery), Severn tells how this portrait originated. It was painted, he said, to evoke a last graceful memory of his friend at about the time when he first began to feel ill. It was as he had seen him on the morning of one of his visits to Hampstead, with the two chairs standing exactly as he painted them; he was struck by the first real symptoms of the sadness Keats expressed so marvellously in the *Ode to a Nightingale* (1819). Everything in the painting – chairs, carpet, the open window and the engraving of Shakespeare hanging on the wall – is faithfully drawn. But is it pure coincidence that the pattern on the carpet is so similar to the design of the painted ceiling of Keats's room in Rome?

The apparently close and shadowy atmosphere of the room, the youthful sick poet reading a book, the suggestion of late summer perfumes and zephyrs in the buoyant vegetation beyond the heavy gathered curtain, all contribute to the emotive quality of this Romantic portrait of one of the greatest Romantic poets.

50

EDWARD CALVERT (1799–1883)

A Primitive City (1822)

Watercolour, 70 × 101mm (painted area)
Reproduced by courtesy of the Trustees of the British Museum

Calvert was one of the young men who gathered around †William Blake during his old age and who were much influenced by him, particularly by his wood-engravings for Thornton's *Pastorals of Virgil* (see commentary to plates 26 and 27). The central figure of the circle was †Samuel Palmer, but among the rest Calvert was one of the more important. These young men, during what was undoubtedly an extended adolescence, imparted a new dimension to Romanticism, bringing to it a felicitous view of a golden age set in the English landscape. In Calvert's case this was achieved mainly through engravings, but also through one or two small paintings like *A Primitive City*.

In art, the very big and the very small acquire an added emotive dimension, inducing in the beholder a sense of wonder of how they were achieved. Obviously Michelangelo's Sistine Chapel ceiling and the colossi of Ancient Egypt are impressive, but there is something equally awe-inspiring in being able to hold in the palm of the hand a tetradrachm by Kimon of Syracuse, which has the qualities of a fine sculpture hundreds of times its size; or a portrait miniature painted in the seventeenth century by Samuel Cooper, of whose work Horace Walpole said, 'if a glass could expand Cooper's pictures to the size of Vandyck's, they would appear to have been painted for that proportion'. Calvert's tiny painting, with its clarity of line, jewel-like colouring and exquisite detail, has the same quality.

A Primitive City is a vesper scene; a waning moon looms over the distant walled city. A eucharistic element is expressed by the group at the right – a peasant leading a donkey laden with baskets of enormous grapes (wine), followed by a waggon laden with grain (bread). The pastoral element is accentuated by the presence of a shepherd and his flock in the middle distance at the left. The city, symbolising perhaps the unity of a perfect soul, stands peacefully in the background, with a woman in the courtyard drawing water, watched by another standing at the head of the staircase between the towers. The innocence of the scene is underlined by the beautiful nearly naked girl about to plunge into the stream – probably symbolising the river of life – with kingfishers flying above it. Throughout his art, Calvert (who incidentally was a friend of †William Etty) used the naked human figure to express innocence: naked, blameless, prelapsarian humanity. The richly fruiting tree beneath which the main figure stands is a symbol of abundance.

A Primitive City is one of the most perfect examples of miniature art painted since the great age of illuminated manuscripts.

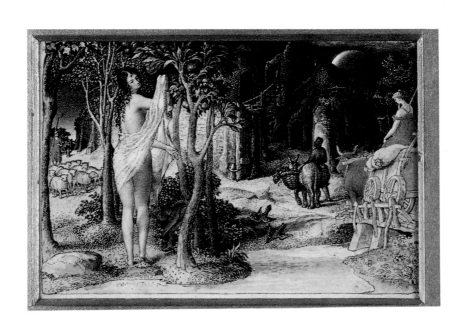

RICHARD PARKES BONINGTON (1801–28)
Scene on the Coast of Picardy (1825 or 1826)

Oil on canvas, 76 × 99 cm
Ferens Art Gallery: Hull City Museums and Art Galleries

The son of a former gaol governor who became a drawing master, Richard Parkes Bonington was born at Arnold, near Nottingham. Richard's mother opened a school for girls, and when it failed in 1817 or 1818 the Boningtons emigrated to Calais, where Bonington *père* set up as a designer and manufacturer of lace.

Richard was trained in draughtsmanship by his father, who wanted him also to design lace, but he was more interested in drawing the scenes and townscapes in Calais. The artist François Thomas Louis Francia (1772–1839), a friend of †Thomas Girtin, noticed his work and was so impressed by his skill that he took him up and instructed him in the finest details of watercolour technique. Thwarted by his father, Richard ran away to Paris, where he attended the École des Beaux Arts and practised in the studio of Antoine-Jean, Baron Gros (1771–1835).

Bonington first exhibited at the Salon in 1822, and at the 1824 Salon he was awarded a gold medal. At this seminal exhibition, †John Constable showed three landscapes, and there were works by several other English artists; these were much admired by the French Romantic artists Eugène Delacroix (1798–1863) and Théodore Géricault (1791–1824), and in general the English paintings in the 1824 Salon had considerable influence on the development of French art during the nineteenth century. Bonington himself was better known during his lifetime in France than in England; he is an important link between the French and English schools.

Bonington visited the north of France in 1821–2, Flanders and Belgium in 1823, north Italy and Venice in 1826, and England in 1825, probably in 1826, and in 1828. Delacroix accompanied him on his 1825 visit to England. In addition to the Paris Salon, his work was shown at the British Institution in 1826, and at the Royal Academy in 1828. He died just before his twenty-seventh birthday, from brain fever caused apparently by sunstroke.

Bonington's subjects included scenes from history and literature, and he especially favoured subjects from the Middle Ages and the Renaissance; examples are *Don Quixote in his Study* (?1825, Nottingham Castle Museum) and *Anne of Austria and Cardinal Mazarin* (?1824, Louvre, Paris). His work was nevertheless at its best in landscape, as in *Scene on the Coast of Picardy*. In its realism and intimacy, this shows Dutch influence, while the discreet tonal contrasts impart a quiet, idyllic atmosphere. The uncompromising horizontal of the horizon, accentuated by the nearly vertical masts of the boats at the right; the tranquillity of the left half of the composition and the upward sweep of the detailed group of its right half; the gentle curve of the shore reaching from below the boat near the horses to the woman and child; all these, taken together with the great expanse of sky, absorb the viewer in peaceful contemplation of the scene, and impart a sense of equilibrium.

52

FRANCIS OLIVER FINCH (1802–62)

Classical Landscape with a Sea Coast (*c.* 1840?)

Watercolour, 379 × 305 mm
Ashmolean Museum, Oxford

Like †Edward Calvert, †Samuel Palmer and †George Richmond, Francis Oliver Finch was a member of the group of young men who took †William Blake as their mentor. But unlike the others, he manifests little of Blake's influence in his work. Its Romanticism is derived rather from a backward look at the early masters of landscape painting, particularly Claude Lorrain, whose vision dominated Finch almost exclusively, and helped him to recall in his watercolours some of that artist's sublime serenity.

Finch's technique owed much to †David Cox and to †John Varley (whose pupil he was); but for the elements of the composition of this painting he was deeply indebted to Claude. Some may be traced directly to Claude's *Liber Veritatis*: the temple at the right is paralleled by a structure in its plate 151, *Landscape with Journey to Emmaus*; the trees in front of it recall those on plate 92, *Landscape with Apollo and Mercury*; the rocky cliffs and mountains are like those on plate 141, *Coast Scene with Acis and Galatea*. Finch would have known these from Richard Earlom's engravings of the *Liber*, a copy of which was in the British Museum Print Room.

The general conception and inspiration of Finch's works are summed up well by his friend Edward Calvert, in a note contributed to Mrs Finch's *Memorials of the late Francis Oliver Finch* (1865), entitled 'On the late Francis Oliver Finch as a Painter':

> . . . he is as genial as Claude. The spell of love is on both. When Finch descends to the valleys, dear to his tastes are the garden and the grove, sacred places, bowers votive to peace, and to friendship, seats and walks, where what is noble in converse with men and with Gods, may be safe from disturbance.
>
> The persons of his scenery are few, and have an expression of simple contemplative beauty, and of a certain cultivated renewal of the past. His figures are always in accordance with his scenery, and they have an expression elevated, yet tender. In this he resembles Claude, whose figures are frequently most gracious in motive . . .
>
> His tastes are, perhaps, more frequently engaged with sanctities of the temple and elegancies of the villa, than with interests of the herdsman's cot or tent; but he sheds over all alike, an unfailing sentiment of native courtesy – sincerity mixed with refinement. He seldom culls any particular fable from out the body of the Mythus. The Genius of his choice insists on an extended Mythic sense and on conditions of eternal law. His ethics suggest a heaven of love and wisdom in past and present manners, and introduce a people uninterrupted in a life of thought, mid waters and shadowy recesses of grove; where, robed in peace and in presence of Athéne, they mark her virgin gravity, and meditate the depths of her principles.

53

SIR EDWIN LANDSEER (1802–73)

Queen Victoria and Prince Albert at a Costume Ball (1842)

Oil on canvas, 137.1 × 108.5 cm
Reproduced by gracious permission of Her Majesty the Queen

Landseer, who was born in London, was a precocious boy, and by the age of twelve was already exhibiting at the Royal Academy. He became a pupil of †Benjamin Robert Haydon, and the next year entered the Royal Academy schools. In 1818, when he was sixteen, his painting of *Fighting Dogs getting Wind* (private collection) was bought by the connoisseur Sir George Beaumont.

Animals, dogs in particular, are among his most frequent subjects, and although his studies of them were based on scientific knowledge gathered from his own dissections, his paintings are often merely sentimental. Yet at his best he was a remarkably good painter, not just of animals, but of people, for example his excellent portrait of Sir Walter Scott (1824, National Portrait Gallery, London). His study of *Queen Victoria on Horseback* (*c.* 1839, National Trust, Anglesey Abbey) splendidly combines portraiture and animal studies, as, on a grander scale, does *Queen Victoria and the Duke of Wellington reviewing the Life Guards* (1839, private collection). These works make a painting like *Dignity and Impudence* (1839, Tate Gallery), a sentimental study of a bloodhound and a tiny dog peeping out of a kennel, look fatuous, though in their day they were immensely popular.

Queen Victoria and Prince Albert at a Costume Ball illustrates the Romantic preoccupation with the past – particularly the medieval past – and the attempt to resurrect it. This attempt manifested itself in many ways: in books produced to look like illuminated manuscripts, bound in *papier-mâché* bindings moulded to look like Gothic tracery; in the pretty buildings of Holly Village at Highgate, erected in 1865 by Angela Burdett-Coutts; in Alfred Waterhouse's depressing additions (1870–89) to Gonville and Caius College, Cambridge; most fantastic of all, in the Eglinton Tournament of 1839, a contest at Eglinton Castle organised by the thirteenth Earl of Eglinton, in which fourteen fully-armoured and mounted knights jousted in lists watched by crowds in grandstands, presided over by a Queen of Beauty. Alas! torrential rain swept down and reduced the area to mud, and the event was ruined.

In this sumptuous painting (which alludes to Veronese in the beautiful rendering and lighting of the two pages at the left), Landseer has achieved one of his best figure studies, and one of the best medieval revival studies of its kind. Queen Victoria and her Consort are indulging in a *jeu d'esprit* at a ball held on 12 May 1842. The Queen wrote about it to her uncle King Leopold I of the Belgians:

> I am quite bewildered with all the arrangements for our *bal costumé*, which I wish you could see; we are to be Edward III and Queen Philippa, and a great number of our Court to be dressed like the people in those times, and very correctly, so as to make a grand *Aufzug* [procession]; but there is such asking, and so many silks and drawings and crowns, and God knows what, to look at, that I, who hate being troubled about dress, am quite *confuse*.

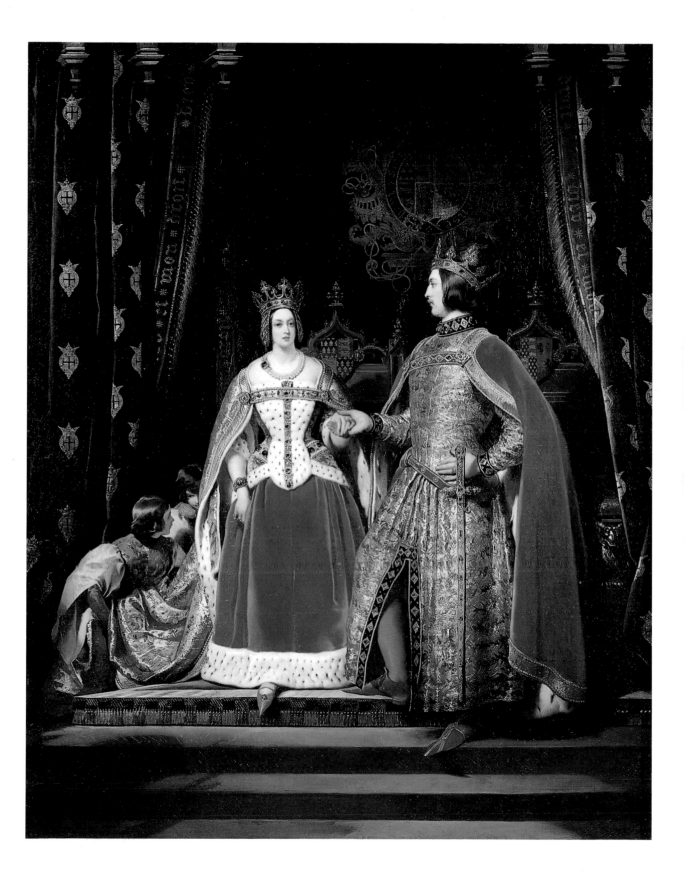

54

SAMUEL PALMER (1805–81)

The Sleeping Shepherd (c. 1831–2)

Pen and ink and wash, 157 × 188 mm
Whitworth Art Gallery, University of Manchester

Samuel Palmer was the pivotal figure among 'the Ancients', the group of young admirers of †William Blake who gathered around the old man in his last years (see also plates 50, 52 and 58). The son of an eccentric bookseller, Palmer was born at Surrey Square in London. He was a quiet child, never happier than when curled up in a big chair, reading books; he took no part in outdoor games. William Wate, an obscure art master, gave him lessons in watercolour, but his artistic outlook was transformed in 1822 when he met his future father-in-law, †John Linnell, who introduced him in 1824 to William Blake.

At about this time he began to see the English landscape as a visionary experience: a paradisal land flowing with milk and honey. This transformation is particularly evident in a sketchbook he began to use in 1824 (British Museum) and in the well-known series of detailed brown pen and wash drawings of 1825 (Ashmolean Museum, Oxford).

In spring 1826, partly as a result of ill-health, Palmer decided to move to the country, and settled at Shoreham in Kent. Here he continued to draw and paint, and his work reached an apogee of intensity in which the Kent countryside, rich with harvest, is illuminated by vast moons under which shepherds tend their flocks. In places his watercolours have a Preraphaelite minuteness of detail, wrought with painstaking care; for example *A Cow-Lodge with a Mossy Roof* (c. 1828–9, Yale Center for British Art). Elsewhere there is an incredible fecundity in landscapes which recall the abundance described in Psalm LXV; for example *Cornfield by Moonlight, with the Evening Star* (c. 1830, British Museum), *In a Shoreham Garden* (c. 1829, Victoria and Albert Museum) and *The Magic Apple Tree* (1830, Fitzwilliam Museum, Cambridge).

Palmer also painted more restrained but no less moving works, like *The Sleeping Shepherd*. He repeated this subject in several works at different periods of his life; it was partly inspired (as was much of his work) by poetry – a passage from John Fletcher's play *The Faithful Shepherdess* (c. 1610; I.iii) – and partly by a Graeco-Roman sculpture in the British Museum, *Endymion the Shepherd Boy asleep on Mount Latmos*; he once wrote that this had a 'hard-to-be-defined but most delicious quality to perfection so have the best antique jems and bas reliefs and statues'. The same might be said of this little nocturne, its trees and bushes silhouetted against the crescent moon, and the shepherd at rest among his flock in a cornfield.

After a honeymoon visit to Italy in 1837–9, Palmer returned to England and settled down to more conventional art and teaching, but from 1850 his visionary art had a second flowering, with a fine series of etchings, a series of large watercolours illustrating Milton's works, and a set of illustrations to his own translation of Virgil's *Eclogues*.

55

WILLIAM DYCE (1806–64)

Jacob and Rachel (1853)

Oil on canvas, 58.4 × 57 cm
Hamburger Kunsthalle

Dyce was born in Aberdeen; his father, a physician, hoped that he too would become a doctor, to which end he was educated at Aberdeen University. But William, determined on other things, studied art secretly. He obtained an introduction to †Sir Thomas Lawrence, who was so impressed by what he saw that he persuaded William's father to allow him to enter the Royal Academy schools. Impatient to make progress, William soon visited Rome, where he first came into contact with members of the Nazarenes, a brotherhood of young Romantic artists (comparable in many ways with the Preraphaelites), whose chaste and precise vision, firm drawing, and clear, strong colouring were to have a profound influence on his work.

On his return to Scotland, he took up portraiture, and during a seven-year period in Edinburgh painted over a hundred portraits. But it is for his history, religious and narrative subjects, in watercolour, tempera, oil or fresco, that he is now best remembered. During a successful career his patrons included Queen Victoria and the Prince Consort. His interests were wide and included music, architecture, high-church ritual, science and industrial art. He became superintendent of the Government Schools of Design, professor of artistic theory at King's College, London, and successively an associate of the Royal Academy and an academician. He died at Streatham.

Jacob and Rachel presents love and pastoralism in an aspect comparable with Richmond's *The Blessed Valley* (plate 58), but within a biblical narrative setting. The subject is in Genesis XXIX.9–11: 'And while [Jacob] yet spake . . . Rachel came with her father's sheep: for she kept them . . . Jacob went near, and rolled the stone from the well's mouth, and watered the flock of Laban his mother's brother. And Jacob kissed Rachel, and lifted up his voice, and wept.'

There are, or have been, four versions of the work. The original version, now untraced, was painted in 1850, at about the time of Dyce's marriage, and some have seen the choice of subject as a joyful echo of that event. Like the version reproduced here, it had full-length figures, whereas in the other two the figures are reduced to three-quarter length, which detracts from their apparent movement (Knodishall Parish Church, Suffolk; Leicestershire Museums and Art Gallery).

When *Jacob and Rachel* was first exhibited, prospective buyers were legion, and to help him meet the demand, Dyce commissioned †Holman Hunt to make copies (present whereabouts untraced). It has been suggested that the pose of the shepherd in Hunt's *Hireling Shepherd* (plate 71), begun soon afterwards, was derived from the attitude of Jacob, with his outstretched arm reaching to Rachel's shoulder. Dyce's figure may in turn owe something to the version of the subject by the Nazarene Joseph Führich (1800–76), painted in 1836 (Österreichische Galerie, Vienna). A pencil and silverpoint drawing of the subject, made *c*. 1859, is in Aberdeen Art Gallery.

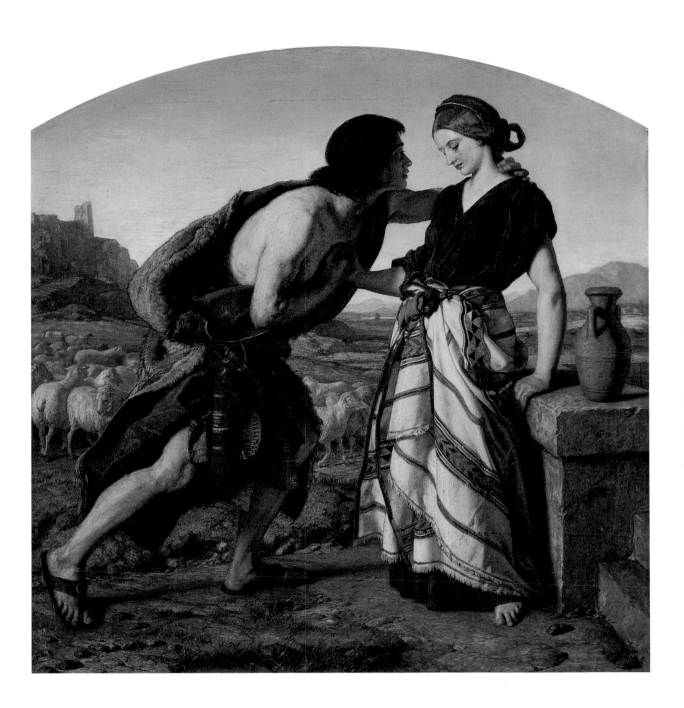

56

DAVID SCOTT (1806–49)

Wallace, Defender of Scotland (c. 1844)

Oil on canvas, 101 × 78 cm
Museum and Art Galleries, Paisley

David Scott, who was born in Edinburgh, was the son of the engraver Robert Scott (1777–1841), a gloomy Calvinist; according to Sir Walter Scott, the household was a place where 'merriment was but another name for folly'. This gloom was inherited by David and characterises much of his output. A key work which stimulated his imagination during his early years was the series of illustrations to Robert Blair's *The Grave* by †William Blake (first published 1808); some of his own works, including a set of six outline designs entitled *Monograms of Man* (1831), are clearly indebted to Blake.

After working for a time as an engraver, Scott put all his effort into painting, and executed many historical, symbolic and mythological subjects, such as *Peter the Hermit preaching the Crusades*, *Fingal or the Spirit of Lodi* and the morbid *The Hopes of Early Genius dispelled by Death*. One of his later subjects, the over-life-size *The Dead rising after the Crucifixion*, which he sent to the Scottish Academy exhibition in 1845, was heavily imbued with Romantic terror; his brother described it as 'a work to be looked upon once, with awe and wonder, not to be imitated, not to be spoken lightly of'. He also illustrated several books, including editions of Bunyan's *Pilgrim's Progress* and Coleridge's *Rhyme of the Ancient Mariner*.

Scott became an associate of the Scottish Academy in 1830. In 1832 he visited Italy, but characteristically was disappointed with what he found there; even the Sistine Chapel frescoes he considered 'full of defects'. After this visit his health deteriorated and he died aged only forty-three, having just finished his last painting, *Hope passing over the Sky of Adversity*.

Wallace, Defender of Scotland is one of Scott's heavily symbolic historical paintings. It depicts the Scottish hero Sir William Wallace (1272?–1305) placing the shield of Scotland on the body of Hugh Cressingham, Treasurer of Scotland, who was killed at the Battle of Stirling Bridge in 1297, at which the advance of Edward I of England was arrested. The painting was intended as the central panel of a triptych. The costume and armour worn by the figures bear little, if any, resemblance to true thirteenth-century attire, and are closer to the costume of the contemporary stage, as portrayed in the toy theatre sheets and tinsel-portraits of the nineteenth century. A preliminary design for the figure of Wallace is in the National Gallery of Scotland, Edinburgh.

In 1842 the same subject was one of two cartoons Scott submitted, without success, in the competition for paintings in the new Houses of Parliament, the other being *Drake witnessing the Destruction of the Armada*.

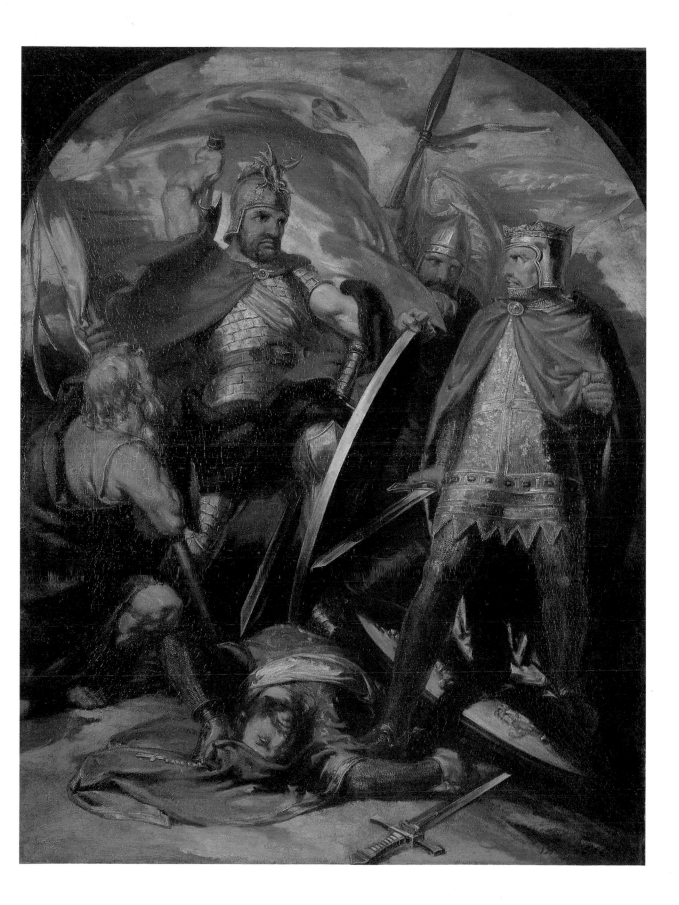

DANIEL MACLISE (1806–70)

Undine (1844)

Oil on panel, 44.4 × 60 cm
Reproduced by gracious permission of Her Majesty the Queen

Maclise came from a Scottish military family and was born in Cork. He started his working life as a clerk, but soon began attending Cork School of Art. Here he acquired some skill in portraiture and earned money sketching portraits of army officers which enabled him to get to London, where in 1828 he entered the Royal Academy schools. After winning silver and gold medals he set up as a painter of historical and narrative pictures and as an illustrator, in all of which he prospered.

Undine, the faery romance which provided the subject of this painting, was written in 1811 by a German cavalry officer and author, Friedrich, Baron de la Motte Fouqué (1777–1843). The story parallels a theme from a Romantic ballet, Jules Perrot's *Ondine ou la Naïade* of 1843. Undine, a sylph, is a kind of changeling for the child, presumed drowned, of a fisherman and his wife; when she grows up, a knight, Huldbrand von Ringstetten, falls in love with her and marries her. In this way she acquires a soul, but earns the enmity of her uncle, a wicked water-goblin, Kühleborn. Huldbrand's love for Undine cools and he is attracted to Bartalda, a girl who proves to be the fisherman's child, not drowned after all. Huldbrand and Undine go sailing on the Danube, where they hear the jeers of Kühleborn and his followers; the knight blames his wife for this and rebukes her, and she is snatched into the water by the goblin. Huldbrand, thinking her dead, proposes to Bartalda, but before they can be married, Undine reappears and kisses Huldbrand, who dies.

In Maclise's painting Huldbrand is escorting Undine through a wood after their marriage, followed by the monk who has married them. They are confronted by Kühleborn, who is surrounded by sprites, gnomes and kelpies, and Huldbrand draws his sword to defend his wife. In the story he aims a blow at Kühleborn's head, and the goblin is transformed into a waterfall.

The viewer is first impressed by Maclise's sparkling colours and enamel-like clarity of outline, but the composition is equally detailed. The central oval of Huldbrand, Undine and the horse is complicated by a pattern of diagonals, most noticeably the positions of the lovers' arms, which echo each other, and by a series of triangles: one formed by the knight's straddling legs; another consisting of his left leg, slanting body and Undine's head, her body, the horse's forequarters and its uplifted foreleg, and the line of sprites below; another formed by the upper left corner of the painting with the outspread arms of Kühleborn as its base; and yet another formed by Kühleborn's arms, the horse's neck and the fern-encrusted rocks at the left. The composition is tied together by the curve containing the oak leaves and chestnut tree at the right, and reaching down into the creeper and sprites at the base, extending up into the rocks at the left, and connected at each end to Kühleborn's outstretched arms.

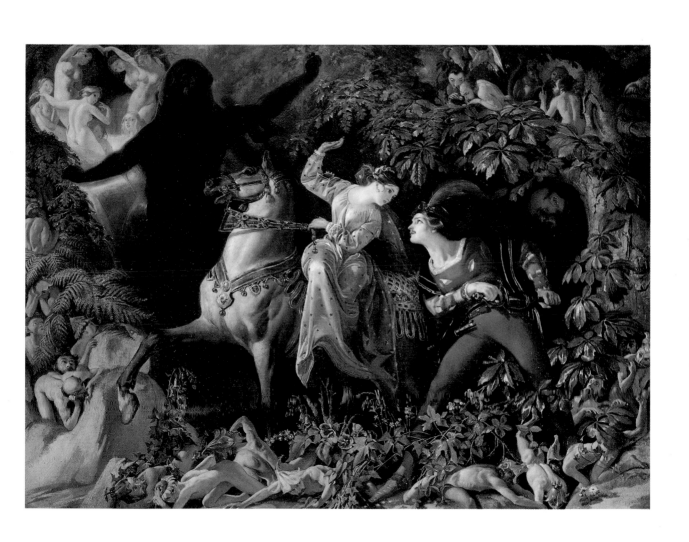

58

GEORGE RICHMOND (1809-96)

The Blessed Valley (1829)

Watercolour, pen and brown ink, 330 × 215 mm
Private Collection, England

George Richmond, son of Thomas Richmond the miniaturist, was the youngest member of †Samuel Palmer's circle, 'the Ancients'. In their company for a few years he painted and engraved his own version of their pastoral, visionary art, and was much influenced by them and by their mentor, †William Blake. Richmond was the only member of the Ancients who achieved worldly success, eventually becoming a fashionable portrait painter.

In the meantime, while he was not creating such visionary works as *Abel the Shepherd*, *Christ and the Woman of Samaria* (both Tate Gallery, London) and *The Eve of Separation* (Ashmolean Museum, Oxford), he was studying art under †Fuseli in the Royal Academy schools, at the British Museum, and in continental galleries. In 1831 he eloped with Julia Tatham, daughter of Charles Heathcote Tatham (1772–1842); their marriage was supremely happy and lasted for fifty years, but at first it was financially hard going, which was Richmond's main reason for taking up portraiture: it was easier to obtain portrait commissions than to sell visionary works.

The Blessed Valley was painted during the period of Richmond's association with the Ancients. It has elements taken from their visionary work, such as the Blake-like sheep, lightly indicated at the right, and what seems to be a thatched cottage or shelter just behind them. It shows also an awareness of Italian painting, for there appear to be allusions to the Giorgione–Titian *Concert Champêtre*, which Richmond would have seen in the Louvre (his painting is inscribed 'Paris'), and to Titian's *Venus and Adonis* in the National Gallery, London. The pose of the figures in *The Blessed Valley* loosely resembles that of the man and woman in *The Eve of Separation*, painted some months later (see Introduction).

The atmosphere of idyllic, sanctified, romantic love which Richmond evokes is reminiscent of that in John Bunyan's country of Beulah,

> whose Air was very sweet and pleasant ... they solaced themselves there for a season. Yea, here they heard continually the singing of Birds, and saw every day the flowers appear in the earth: and heard the voice of the Turtle in the Land. In this Countrey the Sun shineth night and day ... In this Land also the contract between the Bride and Bridegroom was renewed: Yea here, *as the Bridegroom rejoyceth over the Bride, so did their God rejoyce over them*. Here they had no want of corn and Wine: for in this place they met with abundance of what they had sought for in all their Pilgrimage.

The Blessed Valley (which may be compared with Dyce's *Jacob and Rachel*, plate 55) perhaps indicates how Richmond's art might have developed if he had not become a portrait painter: something resembling the work of †William Etty, with added richness derived from Venetian painting. As it was, after his visionary period and apart from his portraits, Richmond painted only conventional, though attractive landscapes.

G.R. Paris 1829

59

WELBY SHERMAN (*fl.* 1827–36)

Christ in the Wilderness (*c.* 1828)

Pencil and watercolour, 109 × 63/64 mm
Private Collection, England

Little is known about Welby Sherman, and that little is mostly discreditable. Primarily an engraver, he became a member of †Samuel Palmer's circle, 'the Ancients'. He was perpetually short of money and Palmer and his friends went out of their way to help him; Palmer, †Calvert, and probably †Richmond even allowed him to engrave their designs, the engravings to be sold for Sherman's benefit. In September 1836 he repaid their kindness by swindling Palmer's weak brother William over wagers on games of billiards, notwithstanding that William was married and his wife pregnant.

The quality of Sherman's engravings is mixed. One or two of his plates, especially the mezzotint *Evening*, after a design by Palmer (1834), are excellent; conversely the line-engraving *The Shepherd* (1828), also after Palmer, is a poor, botched affair. Sherman seems to have been more skilled in mezzotint than in other techniques, which suggests that it was the medium in which he was trained. His engravings are all rare, in some cases only one or two impressions being recorded.

If his engravings are scarce, his drawings are of even greater rarity. *Christ in the Wilderness* is one of only two recorded: the other, a study in pen and ink and watercolour of a couple seated on a bench, was sold by Sotheby's in 1967 and its present whereabouts are untraced. *Christ in the Wilderness* once belonged to George Richmond and was handed down in his family until 1976, just before its acquisition by the present owner.

Meticulously executed, it is drawn firmly with a sharp pencil – as if it has been traced onto a block or plate for engraving – and painted, apart from small areas of wash, with tiny, short brushstrokes. It is conceived on the same lines as visionary works by Sherman's fellow Ancients; obviously he attempted to emulate these, but the face of Christ is strangely unspiritual, and bears little connection with the spiritually orientated beings depicted in contemporary works by Palmer, Richmond and Calvert. Yet details culled from them and from Blake make up the design. The stance of Christ, with his right foot in advance of his left, is a motif sometimes used by Blake to indicate spirituality in the ascendant. The figure itself is reminiscent of figures by Richmond, for example *Isaac going forth to Meditate in the Eventide* (private collection, England) and *Christ and the Woman of Samaria* (Tate Gallery). This last, and designs in Palmer's 1824 sketchbook (British Museum), contain the prototypes of Sherman's distant city and rising sun. The texture of the moss and leaves on the rock by which Christ is standing resemble those in Calvert's miniature *A Primitive City* (plate 50) and in Palmer's drawing *Early Morning* (1825, Ashmolean Museum).

60

PHILIP HENRY GOSSE (1810–88)

Three-horned Chafer on a Mushroom (1838)

Watercolour, 80 × 65 mm (sheet size 200 × 150 mm)
Private Collection, England

The son of the engraver and miniature painter Thomas Gosse (1765–1844), and the father in Sir Edmund Gosse's masterpiece *Father and Son* (1907), Philip Henry Gosse was a naturalist, described by T. H. Huxley (1825–95) as 'the great hodman of science' – the porter of bricks for other men to assemble.

He was born at Worcester, and after working in a counting house at Poole, where his father had settled in 1812, he emigrated first to Newfoundland and then to Canada, where he tried unsuccessfully to farm; he then moved on to Philadelphia and subsequently to Alabama, working as a schoolmaster, but also finding time to study natural history. From 1839 to 1844 he was back in England, but in the autumn of 1844 he visited Jamaica, returning home again in 1846. From this time he devoted himself exclusively to natural history; he was elected a Fellow of the Royal Society in 1856. But having achieved an enviable reputation, he threw it away by opposing the theories of Charles Darwin, for he was never able to accept that Genesis was not a literal account of the Creation.

He wrote many books on religion and natural history, many of them for the general reader (these include *The Aquarium*, 1854, and *The Romance of Natural History*, 1860), which he illustrated with minutely detailed drawings, reproducing with complete veracity everything he observed. As a Plymouth Brother he would have considered it sacrilegious to alter or distort one iota of the Creator's handiwork: the perfection of Jehovah shone in all His works, and Gosse saw it as the duty of the scientist–artist to represent everything without addition or subtraction. This detailed focus places Gosse among the Romantics, who, like †William Blake, delighted in 'minute particulars'; like the Preraphaelites but for different reasons, Gosse shows every seed-case on a plant, every nuance of a bird's plumage, every hair on a mammal's coat, every scale on the wing of a butterfly.

One of Gosse's minor masterpieces is the little drawing reproduced here. It appears on a page of an unpublished book, *Entomologia Alabamensis*, which contains a series of 233 vivid studies of insects Gosse made during his 1838 visit to Alabama. He has delineated the chafer with the observation and sense of design and colour of Dürer, in a miniature technique he doubtless acquired from his father, and with the same loving care that he lavished on the descriptive passages in his books; for example in *Evenings at the Microscope* (1859) he writes of the wing-case of the South American diamond beetle:

> We see a black ground, on which are strewn a profusion of what look like precious stones blazing in the most gorgeous lustre. Topazes, sapphires, amethysts, rubies, emeralds seem here sown broadcast; and yet not wholly without regularity, for there are broad bands of the deep black surface, where there are no gems . . . These gems are flat transparent scales, very regularly oval in form.

61

EDWARD LEAR (1812–88)

Study for Lithograph of the Red and Yellow Macaw (1828)

Pencil, ink and watercolour, 368 × 377 mm
The Houghton Library, Harvard University

Edward Lear was a protean artist: he was an excellent landscape painter in oil and watercolour, a first-class illustrator of travel books and an important natural history draughtsman. He was also a writer, especially of comic verse illustrated by himself with curious witty sketches; his illustrated *Book of Nonsense* (1846) is a classic of juvenile literature.

Lear was born in Holloway, of Danish descent. The youngest sibling of a large family, he had to earn his own living early in life, and practised as a jobbing artist. At the age of nineteen he secured a post as draughtsman at the Zoological Gardens in London; he also assisted the ornithological artist John Gould (1804–81), and did illustrative work for other naturalists, including Sir William Jardine (1800–74). From 1832 to 1836 he worked for the Earl of Derby at Knowsley, where he drew illustrations for the folio *Gleanings from the Menagerie at Knowsley Hall*, published in 1846. He subsequently travelled widely, in Europe, the Middle East and India.

The startling beauty of his bird sketches takes them into the sphere of the Sublime, one of his greatest achievements in this field being his series of lithographs for *Illustrations of the Family of Psittacidae, or Parrots*, which he published privately in twelve fascicles, 1830–2. He drew the subjects from life in the Zoo and in private collections, and from stuffed specimens in the Zoological Society of London's museum in Bruton Street. He preferred to draw from living specimens, and in this he was something of an innovator, for such practice was highly unusual before his time. Moreover, the finished book was the first work ever published to be devoted exclusively to illustrations of one species, and the lithographs were of greater dimensions than any hitherto made in England.

This watercolour is a preliminary study, and is of great interest in showing Lear's repeated attempts to obtain the exact colour and gradation of each feather, not only on the drawing itself, but in the trial brushmarks in the margin. It marks one stage in Lear's working process: first there was an accurate drawing which was traced on to another sheet of paper, on which he then inserted the first broad washes of colour; then came a series of progressively more detailed colour studies (like this one), until he reached the effect he wanted. After this the drawing was ready to be transferred to the stone.

On many of his preliminary studies, Lear made mnemonic notes – also a common feature of his landscape drawings – such as 'soft undulating feathers', 'rather too deep', and so on. Such annotations are also a feature of many studies by his contemporary †Samuel Palmer, whom Lear met briefly in Italy.

62

RICHARD BUCKNER (*c.* 1830–79)

Adeline Plunkett (*c.* 1854)

Oil on canvas, 88.9 × 53.2 cm
Birmingham Museum and Art Gallery

One of the most pleasing artistic products of Romantic art is the series of lithographs of contemporary dancers and scenes from the ballet published between about 1830 and 1850. There still exist a number of paintings and drawings by the artists who designed them, including the somewhat shadowy figure of Richard Buckner, who was born in Chichester and spent most of his working life in London.

Adeline Plunkett (1824–1910), ballerina and courtesan (terms frequently interchangeable in the nineteenth century), was a noted figure of her day. According to that ballet critic *par excellence*, the poet Théophile Gautier (1811–72), she was not a brilliant dancer, but even he had to admit that she was 'pretty, well-formed, with a dainty foot, slender leg, and charming features' – compliments fully confirmed by Buckner's painting, even if, as seems likely, it is somewhat idealised. She was a rival of the dancer Elisa Scheffer (d. 1862) for the affections of the balletomane twelfth Earl of Pembroke, a rivalry in which Elisa was victorious. It is difficult to explain how this came about, as the Earl, when asked why he had spent so much on Elisa, could give no other reason than that 'she has got rather nice shoulders'.

The ballet, more than any other aspect of the Romantic movement outside literature, successfully portrayed the themes of myth, legend, fairytale and the exotic. A few titles of ballets taken at random indicate this: *La Sylphide* (1832), *Le Corsaire* (1837), *La Gipsy* (1839), *Robert le Diable* (1839), *Le Lac des Fées* (1840), *Ondine* (1843; cf plate 57), and *Giselle* (1841), even now still a popular ballet. The stage embodiment of supernatural beings such as wilis, sylphides and fairies was directed at representing their gossamer qualities: the recent innovation of dancing *sur les pointes*, probably first used by the ballerina Geneviève Gosselin (1791–1818) in 1815 at the Paris Opéra, in Charles Didelot's ballet *Flore et Zéphire*, was the single most important nuance of technique in the portrayal of weightless spirits skimming over the surface of earth and water. Added to this were wires, suspended from hidden pulleys, and operated by ropes, on which the dancers gave the impression of actually flying; in *La Sylphide* Marie Taglioni and fifteen *coryphées* flew among the branches of a fairy grove. In the words of a contemporary writer, Charles de Boigne, '*La Sylphide*, borne on the wings of Taglioni, soared to the skies.'

Like Sir Joshua Reynolds in his portrait of Thomas Lister (plate 3), Buckner based Adeline's pose on the classical statue of Mercury in the Uffizi Gallery, Florence. With great success he has used the resources of oil painting to show the rich texture of the 'Spanish' costume; the many lithographs of the period do not always succeed in conveying such opulence.

HABLOT KNIGHT BROWNE (1815–82)

'Major Bagstock is delighted to have that Opportunity' (*c.* 1846)

Pencil and watercolour, 157 × 125 mm (sheet size)
Rare Book Department, Free Library of Philadelphia

Hablot Knight Browne, better known by his pseudonym 'Phiz', was one of the finest book illustrators of his time. He illustrated many novels, including works by Harrison Ainsworth, Robert Smith Surtees, Charles James Lever and Francis Edward Smedley, but is particularly associated with Charles Dickens. In his early years, Dickens wrote under the pseudonym of 'Boz', a variant and diminutive of Moses, his nickname for a younger brother; Browne called himself 'Phiz' because he was the artist who gave 'phizzes' (physiognomies, faces) to Dickens's characters, and also because it chimed well with 'Boz'. Formerly he had used the pseudonym 'Nemo' (no one).

Browne was born at Kennington in Surrey, the son of a merchant. After education at a private school he was apprenticed to Finden's, a well-known London firm of steel-engravers, but he found the work monotonous, obtained his release, and set himself up as a watercolourist, sharing an attic with another young student. He attended a life class in St Martin's Lane, where †William Etty was a fellow student, and in due course won a medal and a prize awarded by the Society of Arts.

In 1836 he made the most of a chance to succeed Robert Seymour (1800?–36), who had committed suicide, as the illustrator of Dickens's *Pickwick Papers*, then being issued in parts. It is to Browne, who usually had little more than a verbal description to guide him, that we owe the familiar representations of such characters as Sam and Tony Weller. The rewarding partnership continued for many years, concluding with the publication of *A Tale of Two Cities* in 1859.

Among Dickens's finest novels, and containing some of Browne's best illustrations, was *Dombey and Son* (1846–8), a story characteristically combining high and low life, tragedy, comedy, pathos and romance. As in *Pickwick*, Browne's delineations of character are excellent, though in *Dombey* they are less caricatured. In the adroitly conceived drawing illustrated here, he shows Mr Dombey gravely raising his hat as the ogling, insolent and lobster-eyed old Major presents him to the mummy-like Mrs Skewton in her bathchair, attended by an adolescent page, and to her haughty daughter Edith, as they meet in a street in Leamington Spa. Only the Major's Indian servant is left somewhat smudgy, which may have been due to Dickens's having asked Browne, after an initial attempt, to depict him in European dress. Perhaps at this stage the artist was not clear what was wanted; in the etched illustration the servant has been given a showy footman's uniform.

There is as much of Phiz as of Dickens in this work: the grouping of the figures, the townscape and the incidental passers-by in the background, as well as the physiognomies of the main characters, are all Browne's own conceptions, based on Dickensian hints.

Major Bagstock is delighted to have that opportunity

64

RICHARD DADD (1817–86)
The Fairy-Feller's Master Stroke (1855–64)

Oil on canvas, 53.9 × 39.3 cm
The Tate Gallery, London

One Romantic idea of the artist is of a man possessed – in the sense that his whole creative function is taken over by an obsession completely beyond his control, welling up from his subconscious and unconscious. Nowhere is this more apparent than in the work of a mad artist, in whom the obsession becomes paranormal. One of the most gifted of such artists was Richard Dadd.

The son of a Chatham chemist, Dadd attended the Royal Academy schools, where he was considered one of the most promising pupils. His training at an end, he came into some money, and at about the age of twenty-five visited various parts of Europe and the Middle East. He returned a changed man; from being an open and agreeable character, he had become paranoid. There is no doubt that he was now mad (perhaps the result of sunstroke), and he was often violent and otherwise unpredictable. His mania reached a climax in August 1843, when he stabbed and killed his father. For his remaining forty-three years he was incarcerated, first in Bethlem Hospital, Southwark, and then, from 1864, in Broadmoor. But he soon began to paint again and was encouraged especially by his physicians, notably W. C. Hood (1824–70), and by the Steward of Bethlem Hospital G. H. Haydon (1822–91); for the latter, over a period of ten years, he painted *The Fairy-Feller's Master Stroke*, one of the strangest and psychologically most menacing paintings of the Romantic period.

It is minutely painted, none of its dozens of figures being more than three inches high, some considerably less. Each flower, each blade of grass, each fruit and nut is depicted individually and with loving care. The atmosphere is breathless and trancelike. The exact meaning is obscure, but it is clear that all hinges on the central figure, with uplifted hammer, about to break open the nut that lies before him. In some convoluted verse, *Elimination of a Picture & Its Subject – Called the Feller's Master Stroke* (reprinted in Patricia Allderidge, *The Late Richard Dadd*, 1974), Dadd describes the various protagonists and ends with a couplet: 'For nought as nothing it explains / And nothing from nothing nothing gains.' The picture remains a series of visions derived from the mind of its demented creator.

The Feller is the centre of attention of the many characters in the composition, most of whom are, in one way or another, distinctly disturbing and malicious: the hard-faced, huge-calved ballerinas, the insect-like figure just above the Feller, and especially the little old man with a white beard, looking on with crazed concentration and appalled terror.

Though demented, Dadd observed the rules of art. The muted colours are completely controlled, and the composition, despite being crowded and complicated, is carefully devised, so as to lead the eye in a triple curve from bottom to top, and along the near-horizontal planes, ranged one above the other.

JOHN RUSKIN (1819–1900)

Church and Vista on the Bay of Naples (1841)

Watercolour, 397 × 286 mm
The Vassar College Art Gallery, Poughkeepsie, NY

John Ruskin was one of the most influential writers on art during the nineteenth century, and it is as a critic and aesthete that he is best known; his *Modern Painters* (1843–60), his *Stones of Venice* (1851–3) and his manual *The Elements of Drawing* (1857) are among pivotal studies of the period. He was also an accomplished draughtsman and watercolourist; at seventeen he studied under Anthony Vandyke Copley Fielding (1787–1855) and later he was a pupil of James Duffield Harding (1798–1863). Above all, he was influenced by †Turner, whose work he admired and whose reputation he helped to establish. Later he became a sympathetic supporter of the †Preraphaelites.

Ruskin was brought up very strictly, and when in 1848 he married Euphemia (Effie) Chalmers Gray, the marriage was a disaster, not least because of the interference of his mother. Effie fell in love with †John Everett Millais, whose fame her husband had helped to build; the Ruskin marriage was dissolved, which left Effie free to remarry soon afterwards.

Apart from the arts, Ruskin interested himself in religion, natural history, economics and political and social reform. He was Slade Professor of Art at Oxford for two periods. In 1871 he moved to Brantwood on Coniston Lake; in 1878 his health broke down, and from then until his death he suffered from increasingly frequent attacks of insanity.

Ruskin's art is dominated by an exact, minutely observed realism, comparable with the work of some of the Preraphaelites. 'Go to nature in all singleness of heart', he advised, 'rejecting nothing, selecting nothing.' In this context his admiration for photography was boundless; it was, he told his father, 'a noble invention, say what they will of it. Anyone who has blundered and stammered as I have done [for] four days and then sees the thing he has been trying to do so long in vain, done perfectly and faultlessly in half a minute, won't abuse it afterwards.'

So insistent was Ruskin's preoccupation with nature that he made a collection of such things as rocks, minerals and fossils in order to encourage his disciples to take their inspiration for colour and form from them. Sometimes he allowed his drawing greater breadth, or more strictly he left off elaborating it in time, as in *Church and Vista on the Bay of Naples*. Of the setting of this picture he wrote in his diary: 'I never saw a finer thing . . . a little chapel pitched half way up, with a bold arch of natural rock, and another of a ruined bridge; and the tower of a convent on the walls bright against the uppermost blue sky, formed a scene almost too theatrical to be quite right'.

The tree at the right unites the winding road at the left with the hill and cliff at the right so adroitly that one wonders if here Ruskin overrode his advice never to alter nature, and introduced a compositional device of his own.

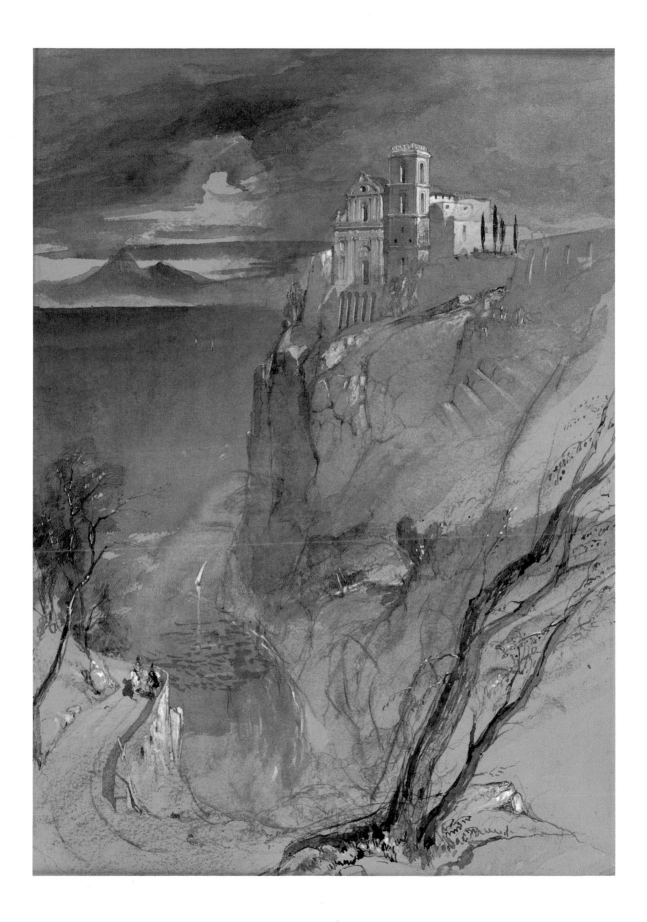

66

THOMAS GRIMSHAWE (*fl.* 1844–64)
John Clare (1844)

Oil on canvas, 73 × 59.3 cm
Northampton Public Library

Little is known of the painter of this haunting portrait of the peasant–poet John Clare (1793–1864), so completely different from the one by William Hilton (1786–1839) in the National Portrait Gallery, which shows the poet in the vigour of early manhood. Here, Grimshawe has captured the troubled and morbid personality of his subject's later years, as he stares into space with bulging eyes (reminiscent of photographs of patients suffering from hallucinations reproduced in L. Forbes Winslow's study *Mad Humanity*, 1898). When it was painted, Clare was an inmate of the Northampton General Lunatic Asylum, where he wrote the poignant sonnet *I Feel I Am*:

> I feel I am, I only know I am,
> And plod upon the earth as dull and void:
> Earth's prison chilled my body with its dram
> Of dullness, and my soaring thoughts destroyed.
> I fled to solitude from passion's dream,
> But strife pursued – I only know I am.
> I was a being created in the race
> Of men, disdaining bounds of place and time,
> A spirit that could travel o'er the space
> Of earth and heaven, like a thought sublime;
> Tracing creation, like my Maker free,
> A soul unshackled – like eternity:
> Spurning earth's vain and soul debasing thrall –
> But now I only know I am, that's all.

The Romantics were fascinated by madness, for it was an aspect of man's individuality and hidden soul, and they were anxious to know how the mind of the madman worked, how his perceptions were affected, what forms were taken by his thoughts and hallucinations. Grimshawe's portrait of Clare is a manifestation of such enquiry, and shows something of the nature of Clare's derangement. According to recollections of a Northampton journalist, G. J. de Wilde, published in *The Times Literary Supplement* on 30 June 1921, Clare quoted lines which he claimed to have written, and, when it was pointed out to him that they were by Shakespeare and Byron, replied: 'I'm John Clare now. I was Byron and Shakespeare formerly. At different times you know I'm different persons – that is the same person with different names.' De Wilde added, 'And then he went on to identify himself with a most miscellaneous and unselect lot of celebrities – great warriors, prize fighters and some eminent blackguards.'

JAMES SMETHAM (1821–89)

Imogen and the Shepherds (*c.* 1864?)

Oil on canvas, 25.4 × 62.2 cm
Birmingham Museum and Art Gallery

Like his preceptor †William Blake and his friend †Dante Gabriel Rossetti, James Smetham was both painter and writer. But whereas in their cases, Blake's especially, this duality was a Renaissance-like aspect of their artistic strength, in Smetham's it was an indication of indecision and weakness, and probably a symptom of a neurotic condition that eventually (in 1877) became psychosis. Like many depressive characters, he thought God was angry with him and had damned him eternally.

He was born at Paley Bridge, Yorkshire, the son of a Wesleyan minister. From the first he wanted to be a painter, and he was initially encouraged by his father who, however, when the boy's schooling had been completed, placed him with E. J. Willson, a Lincoln architect. Willson, himself fond of painting and realising James's preferences, sent him to draw the Gothic sculptures in Lincoln Cathedral. Even so, James remained thoroughly unhappy in his work, so much so that Willson asked one of his acquaintances, the painter Peter de Wint (1784–1849), for an opinion; de Wint advised him to cancel the indentures.

Smetham then set up as an itinerant portrait painter, but before long this profession was terminated by the invention of the daguerreotype. In 1851 he became drawing teacher at the Wesleyan Normal College, Westminster, which provided him with an income that gave him freedom to indulge in imaginative painting.

†John Ruskin was much impressed by Smetham's work, but found disturbing elements in it; he advised him to go carefully and not to fatigue himself or overheat his imagination. That this was good advice is confirmed by the artist's bouts of deep neurosis. †Ford Madox Brown and Rossetti also admired Smetham's work, and he became a peripheral Preraphaelite, painting in a style closely akin to that of the brotherhood. He also made a series of etchings. Smetham's inextensive but pleasing literary works were published in 1893 in a now scarce book: they include a sensitive essay on Blake.

Imogen and the Shepherds is a rendering of one of the climactic events in Shakespeare's *Cymbeline* (IV.2), in which Arviragus and Guiderius, sons of Cymbeline disguised as shepherds, discover their sibling Imogen, dressed as a boy, and apparently dead, though really only drugged. The painting depicts the brothers as they are about to place her in a grave, singing the famous threnody beginning 'Fear no more the heat o' the sun'.

The setting is painted with minute care: every leaf, every blade of grass, every flower in the foreground is represented in almost excited detail (compare plate 64). The figures, however, are stiff and wooden, as if superimposed on the composition, which indeed is probably the case. Figures were not Smetham's strongest point, though occasionally he made them entirely convincing, as in *The Lobster Pot Mender* (1864, private collection) and *Mary Magdalene* (1868, The Stone Gallery, Newcastle-on-Tyne).

SIR JOSEPH NOËL PATON (1821–1901)
The Reconciliation of Oberon and Titania (1847)

Oil on canvas, 76.2 × 122.6 cm
National Gallery of Scotland, Edinburgh

Joseph Noël Paton was born at Dunfermline. He was artistically gifted as a boy and initially followed in his father's footsteps as a textile designer, practising drawing and painting for recreation. In 1843 he began to study at the Royal Academy schools in London, but he soon returned to Scotland, where he set up as a painter, becoming firmly established by 1847, when he won a premium of £300 for *The Reconciliation of Oberon and Titania* and a vast canvas of *Christ on the Cross*. The former was bought by the Royal Scottish Academy in the same year, when Paton was elected an associate; he became an academician in 1850. A companion picture, *The Quarrel of Oberon and Titania* (1849), was bought by the Royal Association; both works are now in the National Gallery of Scotland.

Paton doubtless acquired his interest in faery subjects from his mother, who was learned in Highland legends and lore. Oberon and Titania, king and queen of the fairies, appear in Shakespeare's *A Midsummer Night's Dream*, a play much admired by Romantics: it was given incidental music by Felix Mendelssohn (1809–47), adapted by Carl Maria von Weber (1786–1826) for his opera *Oberon*, translated by William Sotheby in 1798, and illustrated by [†]Fuseli.

The fairy king and queen, having quarrelled, are now reconciled, and the unhappy human couple in whom their quarrel has been reflected lie asleep, to be reconciled in their turn on awakening. But Paton has taken the story onto another level, the crowded surging composition being full of psychological suggestions, close in many ways to Richard Dadd's *The Fairy-Feller's Master Stroke* (plate 64), but in Paton's work the creations of a sane artist who has dipped into the mysteries of the subconscious.

His discoveries are not invariably pleasant; for instance at the front of the composition a goblin attacks a fish which attempts in retaliation to swallow one of its attackers. There are perverse and malicious spirits, such as the horned Puck above the head of the sleeping man, and the evil leering hatted figure beside him, whose attitude is accentuated by the herm of Pan within the circle of flying fairies to the right of Titania. Many of the figures are distinctly erotic, for example the small group of oriental musicians on the ground to the left of Oberon and the writhing couple in the left foreground. Perhaps most disturbing is the conspicuous variation in the size of the figures, from tiny elves and fairies small enough to hold in the palm, through the commanding stature of the fairy monarchs, to the giant proportions of the human beings.

It is a powerful work, perfectly composed in all its complication, the eye being compelled to travel from right to left and back again through the sweeping curve of the trees on either side and the sleepers between them.

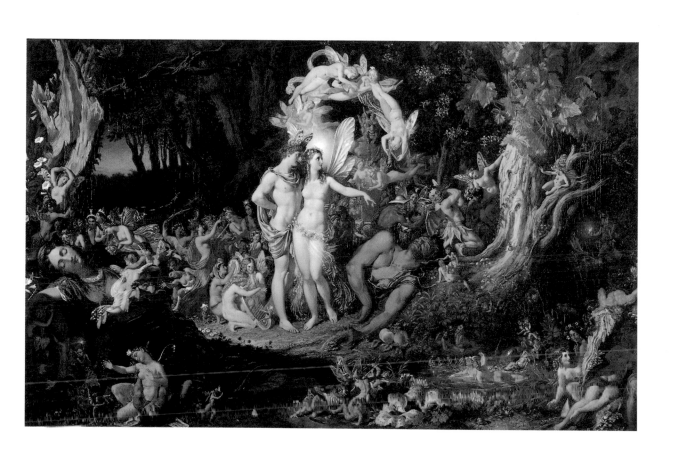

69

FORD MADOX BROWN (1821–93)

The Last of England (1860)

Oil on canvas, 46.4 × 42.3 cm (oval)
Fitzwilliam Museum, Cambridge

Ford Madox Brown was born at Calais of English parents, who sent him to study art at Bruges, at Ghent, and under Baron Wappers (1803–74) at Antwerp. Thereafter he studied at Paris, where he saw the work of Eugène Delacroix (1798–1863) and Paul Delaroche (1797–1856). In 1844–5 he visited Rome, where he met the Nazarenes Peter von Cornelius (1783–1867) and Johann Friedrich Overbeck (1789–1869), whose 'Early Christian style', as he called it, he much admired and sometimes imitated.

He subsequently settled in England. In 1848 he met †Rossetti, whom he taught for a short period, and through whom he met the other Preraphaelites. Although he never became a member of the brotherhood, he both contributed to and was much influenced by their ideas.

By 1850 he was painting innovative *plein air* studies. Of one of the best known, *The Pretty Baa Lambs* (Birmingham Museum and Art Gallery), the painter R.A.M. Stevenson (1847–1900) exclaimed, 'By God! the whole history of modern art begins with that picture. Corot, Manet, the Marises, all the Fontainebleau School, all the Impressionists, never did anything but imitate that picture!'

Much of Brown's work carried social and didactic overtones, for example his realist *Work* (1852–65, City of Manchester Art Galleries). *The Last of England* was inspired by contemporary emigrations, which included some artists. Thomas Woolner (1825–92), the Preraphaelite sculptor, emigrated in 1852 to seek his fortune in the Australian goldfields; Brown, hard up and unsuccessful, thought of emigrating to India, and this picture was the result, for the chief figures are himself and his second wife, Emma, with whom he had eloped when she was only fifteen. Brown's description of the picture emphasises the nice combination of social and artistic considerations so often present in his work:

> This picture is in the strictest sense historical. It treats of the great emigration movement . . . I have . . . singled out a couple from the middle classes, high enough, through education and refinement, to appreciate all they are now giving up . . . The husband broods bitterly over blighted hopes and severance from all he has been striving for . . . To insure the peculiar look of *light all round*, which objects have on a dull day at sea, it was painted for the most part in the open air on dull days, and when the flesh was being painted, on cold days . . . The minuteness of detail which would be visible under such conditions of broad day-light, I have thought necessary to imitate, as bringing the pathos of the subject more home to the beholder.

There are several secondary incidents, of which the most prominent is an emigrant shaking his fist at the white cliffs of England, a curse on his lips, while his old mother holds out her hand to restrain him. The young wife nestles her baby under her shawl; only its hand is visible, holding hers.

Brown painted three versions of the picture; the others are an oil, in the Museum and Art Gallery, Birmingham (1852–5), and a watercolour, in the Tate Gallery (1860).

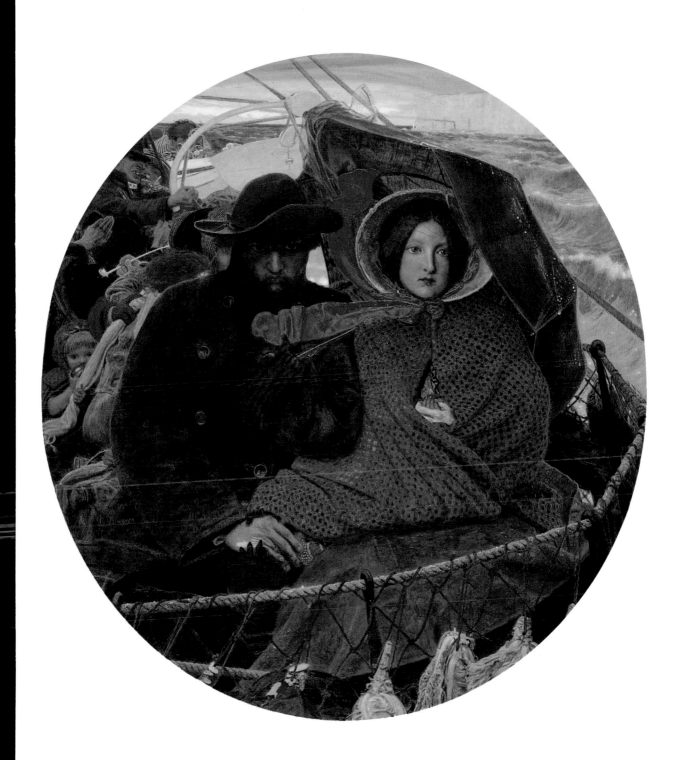

70

JOHN MIDDLETON (1827-56)
Landscape with Pollards (*c.* 1847)

Oil on canvas, 51.4 × 61.5 cm
Norfolk Museums Service (Norwich Castle Museum)

Middleton was born in Norwich, where he spent most of his life; his mother was a flower painter. He came under the influence of John Crome (1768–1821) through his first instructor in painting, John Berney Ladbrooke (1803–79), Crome's nephew and one of his pupils. This apart, little is known of Middleton's early art studies, but it is known that he worked with his friend the Suffolk painter Henry Bright (1814–73), whose influence is evident. He lived in South Kensington for a short period during 1847 and 1848, and exhibited at the Royal Academy and the British Institution from that time. His final years were spent in Norwich, where he died of tuberculosis.

Many of Middleton's paintings are now in the Castle Museum, Norwich. That he was appreciated in his own day is evident from a report in a local paper, *The Norfolk Chronicle and Norwich Gazette*, on 11 December 1847:

> We have been favoured with a private view – and can speak to the merits of most of them. Four, in particular, attracted our attention – two landscapes by one of the most rising young artists of the day, Mr. J. Middleton ... There is a brilliancy of colouring, and a charming alternation of light and shade, with admirable drawing and grouping.

Middleton's work was influenced by the Dutch school, perhaps through his knowledge of Crome, who revered the work of Cuyp, Van Goyen, Hobbema and other Dutch masters. Not surprisingly it also shows the influence of painters of the Norwich school; yet it is also entirely original, with a fresh outlook that, if he had lived longer, might have developed into the finest landscape art.

Middleton was especially skilled in portraying the seasons and their different lights and emphases. The bright but subtle summer light in *Landscape with Pollards* recalls Tennyson's

Witch-elms that counterchange the floor
Of this flat lawn with dusk and bright ...
(*In Memoriam*, LXXXIX.i)

It is said to be an unfinished painting, and may indeed be so, but it is singularly satisfying. As in some of the works of †Samuel Palmer, a high finish has been given to some areas, while others have been left lightly sketched, almost scribbled and daubed, so as to concentrate the eye on essentials. Middleton seems to have known at what point to stop working on a picture, a gift not shared by many Victorian artists.

As the 1847 *Norfolk Chronicle* hints, light and shade held no terrors of technique for him; he used them masterfully and with adroit skill to give depth and form to his compositions. In this respect *Landscape with Pollards* bears comparison with Cotman's *Chirk Aqueduct* (plate 40).

WILLIAM HOLMAN HUNT (1827–1910)
The Hireling Shepherd (1851)

Oil on canvas, 76.2 × 107.9 cm
City of Manchester Art Galleries

Holman Hunt was born and died in London. After spending his early working years in commerce, he entered the Royal Academy schools in 1844; here he met †John Everett Millais. Not long afterwards he met †Dante Gabriel Rossetti, and the three of them became founder members of the Preraphaelite Brotherhood. Hunt was the most religious of the group, and provided the major impetus for its formation. At the time he was much influenced by the poems of Keats (see plate 49) and by the writings of †Ruskin, especially *Modern Painters*. He travelled abroad to France, Belgium, Italy and the Middle East. In Egypt and Palestine he was able to sketch and paint the actual settings of his many biblical subjects.

Hunt lived long enough to know, and to dislike, impressionism; he was literal in mind and sight, and like his near contemporary, another deeply religious man, †Philip Henry Gosse, he concentrated on minutest details. This is vividly apparent in *The Hireling Shepherd*.

The landscape was painted in Surrey in the summer and autumn of 1851, and the figures were added during the following winter, in the artist's studio. The picture has an inner unity, the composition being founded on and built around the symmetrical shape formed by the pose of the two protagonists. It is also packed with symbolism, Hunt's primary intention being to point a moral. He said it was 'a rebuke to the sectarian vanities and vital negligencies of the day', and he compares his shepherd with

> muddle-headed pastors who instead of performing their services to their flock – which is in constant peril – discuss vain questions of no value to any human soul. My fool has found a Death's Head Moth, and this fills his little mind with forebodings of evil, and he takes it to an equally sage counsellor for her opinion. She scorns his anxiety from ignorance rather than profundity, but only the more distracts his faithfulness. While she feeds her lamb with sour apples, his sheep have burst bounds and got into the corn.

The painting demonstrates Hunt's sometimes discordant colours and his sensitive use of light: his deft handling of colour in shadow and reflections of sunlight, and his mastery of *plein air* effects (cf commentary to plate 69). From the Nazarenes (see Introduction) Hunt took the idea of painting on a white, sometimes moist ground, which had the effect of lightening his colours; he hoped thus to impart to them something of the quality of the colours of Italian primitives so much admired by the Preraphaelites. The same source prompted the concentration on outlines and contour present here and throughout Preraphaelite painting.

For the possible derivation of the shepherd's attitude see the commentary to plate 55.

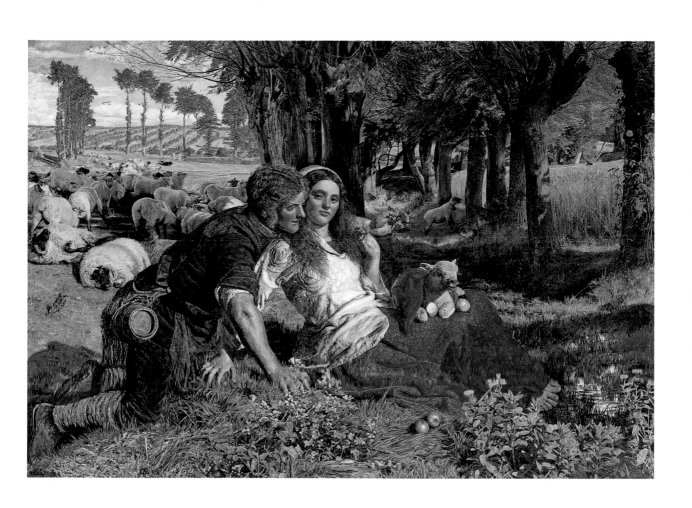

72

DANTE GABRIEL ROSSETTI (1828–82)
How They Met Themselves (1864)

Watercolour and body colour, 339 × 273 mm (irregular)
Fitzwilliam Museum, Cambridge

Dante Gabriel Rossetti, like †William Blake, was both poet and painter. He was the son of an Italian *émigré* poet of liberal leanings, who was professor of Italian at King's College, London, where Dante Gabriel himself was educated. Already devoted to art at an early age, with a group of other young artists, among them †John Everett Millais and †Holman Hunt, he founded the Preraphaelite Brotherhood, which, as its name implies, looked back to the Middle Ages for its inspiration and practice. Rossetti was initially regarded only as a painter, but he composed poetry from his youth; the accomplished *Blessed Damozel* was written when he was nineteen.

In 1860 he married Elizabeth (Lizzy) Eleanor Siddal (1829–62), an assistant in a milliner's shop, whose singular personal beauty became the epitome of the brotherhood's ideal of feminine beauty (see plate 73). Less than two years later she died of an overdose of laudanum, taken to relieve a bad attack of neuralgia.

Rossetti's paintings and drawings often contain disturbing psychological accents, suggesting and evoking sensations of claustrophobia and vertigo. In later life, as his addiction to chloral (taken partly in an attempt to overcome insomnia) became more intense, his work became more imbued with fantasy: a typical example is *The Bower Meadow*, a disquieting painting of women dancing and making music together, whose remote, brooding expressions both suggest unrequited desire and repulse the viewer (1872, City of Manchester Art Galleries).

The sinister psychological phenomenon of the *Doppelgänger* is the subject of the watercolour reproduced here. Two lovers walking together come upon haloed clones of themselves; the man is transfixed with terror, the woman faints at this premonition of their death. Supernatural apparitions were a favourite subject of Romantic literature and art, the *Doppelgänger* being considered particularly horrific (cf Schubert's song of this name, 1828). †Fuseli described how, in his rendering of the scene in *Macbeth* of Macbeth's second encounter with the witches, he confronted the king with

> a colossal head rising out of the abyss, and that head Macbeth's likeness. What, I would ask, would be a greater object of terror to you, if, some night, in going home, you were to find yourself sitting at your own table, either writing, reading or otherwise employed? would not this make a powerful impression on your mind?

The elaborately wrought detail of this work, typical of the Preraphaelites, was probably inspired by similar detail in such works as miniatures in illuminated manuscripts: everything is carefully drawn, and the textures of the figures and of their clothing are rendered by myriad stipples and cross-hatchings. Even so, the effect is not unrelieved and flat, but fully modelled. It is one of Rossetti's most convincing smaller works.

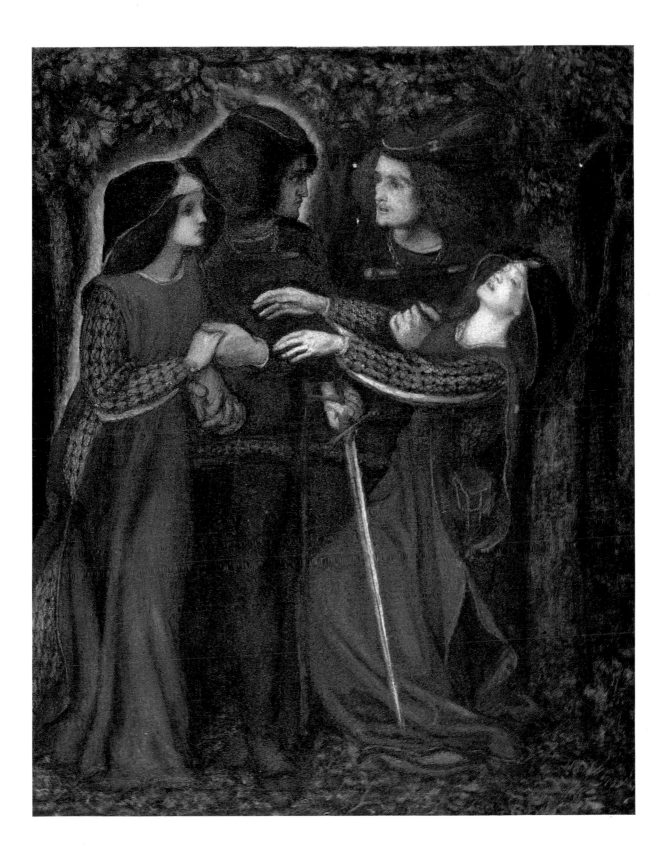

SIR JOHN EVERETT MILLAIS, BT (1829–96)
Ophelia (1851–2)

Oil on canvas, 76.2 × 111.8 cm
The Tate Gallery, London

The prodigious talents of John Everett Millais, scion of an old Jersey family, were evident at an early age: in 1838 he became a pupil at Henry Sass's art school in London, and in 1840, aged eleven, he entered the Royal Academy schools, its youngest ever student. In 1843 he won a silver medal, and in 1847 a gold. At sixteen he first exhibited at the Academy, a brilliantly executed painting of *Pizarro seizing the Inca of Peru* (Victoria and Albert Museum). In 1848 he became a founding member of the Preraphaelite Brotherhood, and in 1853 he visited Scotland with †John Ruskin and his wife Effie, with results described in the commentary to plate 65. His career was crowned in 1885 when he was made a baronet, and in 1896 he was elected president of the Royal Academy.

Ophelia illustrates the passage in *Hamlet* IV.vii in which Hamlet's mother describes the mad Ophelia's death by drowning:

> Her clothes spread wide,
> And, mermaid-like, awhile they bore her up:
> Which time she chanted snatches of old tunes.

The model for Ophelia was Elizabeth Siddal (see commentary to plate 72), who posed for Millais in a bath filled with water, kept warm by lamps underneath. One day Millais, probably too absorbed in his work to notice, allowed the lamp to go out, and Miss Siddal caught a severe chill; under threat of legal action from her father, the artist was compelled to pay her doctor's bill. For Ophelia's attire, Millais bought a dress which, despite being old and dirty, was 'really splendid . . . all flowered over in silver embroidery'.

Millais went to immense trouble to portray every detail of the painting with photographic verisimilitude. The representations of botanical life are convincing and impressively various. Dozens of flowers and plants are depicted – violets, pansies, daisies, fritillaries, poppies, loosestrife, forget-me-nots, nettles, willows and many more. Nor, apparently (with typical Victorian Romanticism), did he overlook the symbolic meaning of some of the flowers: the pansies signify love in vain or thought (the name is derived from the French *penser*), poppies signify sleep and death, fritillaries sorrow, violets death in youth and daisies innocence. Some of these, and some of the other flowers Millais includes, are referred to in Act IV scene v of Shakespeare's tragedy, in which Ophelia recites the names of flowers she has been gathering.

Millais painted all this plant life, the stream and its setting at an actual location, near Ewell in Surrey, where he worked in considerable discomfort from the attentions of a bull, the wind, the flies, and a pair of swans which continually got into his line of vision; and he was summonsed for trespass and damage to a hay crop.

A small watercolour version of *Ophelia* (175 × 245 mm) was sold at Sotheby's in June 1987.

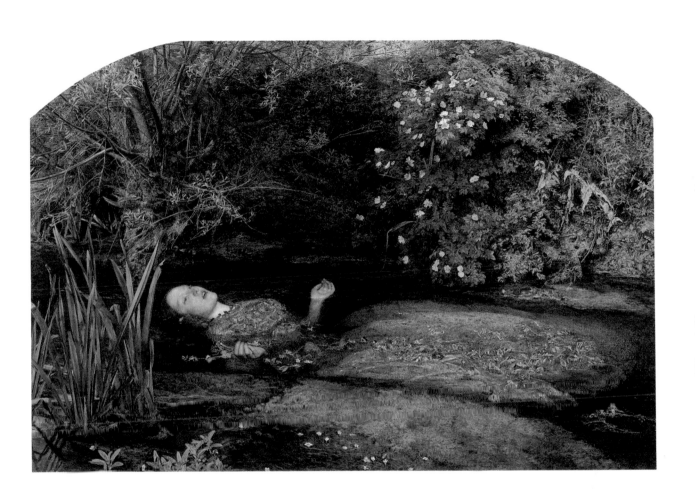

74

ARTHUR HUGHES (1832–1915)
April Love (1856)

Oil on canvas, 88.9 × 49.5 cm
The Tate Gallery, London

Arthur Hughes was born and educated in London and joined the classes of Alfred Stevens (1818–75) at Somerset House at the age of fourteen; he progressed so well that during the following year he gained an art studentship at the Royal Academy schools. When he was seventeen he won a silver medal and had his first work accepted for the Academy's annual exhibition.

He was profoundly influenced during his formative years by the works of the [†]Preraphaelite Brotherhood founded in 1848, and by its short-lived journal, *The Germ* (January–April 1850). Although he was never a full member of the brotherhood, he had many close contacts with its members; he was especially influenced by [†]Millais, whom he met in 1852 at the Academy schools. In 1857, invited by [†]Rossetti, he worked on the murals of subjects from the *Morte Darthur*, painted by himself, Edward Burne-Jones (1833–98), William Morris (1834–96), Val Prinsep (1838–1904) and others in the debating room of the University Union Society, Oxford.

April Love had been exhibited the previous year at the Academy, with a quotation from Tennyson's *The Miller's Daughter*:

> Love is hurt with jar and fret.
> Love is made a vague regret.
> Eyes with idle tears are wet.
> Idle habit links us yet.
> What is love? for we forget:
> Ah, no! no!

It was bought by Morris, then still an Oxford undergraduate.

The subject was first conceived as a period piece, but Hughes finally painted the protagonists in contemporary dress. The mauve tones of the girl's frock add an extra note of dolour (the colour symbolises penance) to the already nostalgic ambience: the damp, ivied arbour with rose petals strewn on the floor, and lilac in blossom outside the window; the shadowed lover's head buried in his hands; the girl clutching her scarf to her breast, tears trembling and overflowing. It is a distillation of disappointed young love dying away like the sun amid April showers; they both regret its passing, and would reincarnate its magic if they could. The evanescence of a moment intensely charged with feeling was one of the universal themes of Romantic art (captured most memorably in Keats's great odes), and Hughes's portrayal of it won the admiration of [†]Ruskin.

April Love was painted during Hughes's best period; this lasted from the early 1850s to the early 1860s, after which his work lost its poetic intensity and became merely sentimental. The painting illustrates both his commitment to the Preraphaelite precepts that art must be founded on nature and that every detail is important and must be painted with loving care, and his skilful control of detail, creating a closely knit composition without monotony of surface.

SIMEON SOLOMON (1840–1905)
Night and Sleep (1888)

Pencil and chalk, 349 × 286 mm
Birmingham Museum and Art Gallery

Simeon Solomon was the youngest of eight children of an eminent Jewish hat importer and fancy-goods manufacturer in the East End of London. His brother Abraham (sixteen years his senior) and his sister Rebecca were painters, and he began his training in Abraham's studio before progressing to Leigh's and Cary's academies and then, still aged only fifteen, the Royal Academy schools.

Solomon was witty and attractive, and his talents brought him into contact with the Preraphaelites (he much admired †Rossetti, and there was mutual influence between himself and Burne-Jones) and with leaders of the new Aesthetic Movement, notably Walter Pater (1839–94), who sat to Solomon for one of the very few portraits he allowed of himself, and Algernon Swinburne (1837–1909). He designed stained glass for William Morris (1834–96), and collaborated with the Preraphaelites in decorating the great bookcase designed by William Burges (1827–81) with mythological representations of the arts (Ashmolean Museum); but he was chiefly known for his paintings on Hebraic historical and ritual themes and, later, his classical and symbolist studies. Between 1866 and 1870 he visited Italy three times, where he came under the influence of Leonardo and his school, and he probably saw the work of the French symbolists in Paris. During the years 1858–72 he regularly exhibited at the Royal Academy.

In 1873 Solomon's fortunes changed dramatically, following his conviction for homosexual offences. Society and the artistic world (including Swinburne, who had encouraged his provocative behaviour and whose flagellant romances he had illustrated) closed ranks against him; he became a confirmed alcoholic, and earned a pittance as a vagrant pavement artist and hawker of matches and shoelaces; and he spent the last twenty-one years of his life intermittently in St Giles's Workhouse, Seven Dials, where he died. This was apparently his choice – increasingly he resisted his family's attempts to rescue him (though he took their money), and those who befriended him, such as the Catholic writers Francis Thompson (1859–1907) and Alice Meynell (1847–1922), found him unrepentantly cheerful.

The drawing reproduced here was made after his fall from grace, when dealers who had paid an advance on his work found they had to lock him up to get him to finish a painting. His early reputation as a brilliant colourist was now ended, in part by his inability to afford paints. The charged feeling in the faces of his Hebraic subjects was already giving way in the 1860s to suggestions of the aftermath of intense but inscrutable experience that the poet Browning (an early admirer) considered 'too affected and effeminate'. But the sexually ambivalent, emotionally enervated and heavily symbolic aspects of *Night and Sleep* are characteristic of a major part of his output, and typify one direction that Romanticism took in its final phase in the period under review.

The subject, in common with many of Solomon's late works, comes from his prose poem *A Vision of Love revealed in Sleep*, begun in Rome in 1869 and published at his own expense in 1871; this culminates in the Soul's 'Beatific Vision' of 'the Very Love, the Divine Type of Absolute Beauty'. On its journey the Soul encounters Night and Sleep, and in his review in *The Dark Blue* Swinburne particularly praised the image of 'Night as a mother watching Sleep her child'.

NIGHT AND SLEEP

1888

Suggestions for Further Reading

(Unless otherwise stated, the place of publication is London)

Antal, Frederick: *Classicism and Romanticism with other Studies in Art History*, 1966

Arts Council of Great Britain: *The Romantic Movement*, 1959

Bicknell, Peter: *Beauty, Horror and Immensity*, Cambridge, 1981

Binyon, Laurence: *Landscape in English Art and Poetry*, 1931

Boase, T.S.R.: *The Oxford History of English Art*, X, *English Art 1800–1870*, 1959

Brion, Marcel, trans. D. Carroll: *Art of the Romantic Era*, 1966

Clark, Kenneth: *Landscape into Art*, 1949
Moments of Vision, 1973
and others: *La peinture romantique anglaise et les Préraphaélites*, Paris, 1972

Fletcher, Ian (ed.): *Romantic Mythologies*, 1967

Gaunt, William: *The Great Century of British Painting: Hogarth to Turner*, 1971

Guest, Ivor: *The Romantic Ballet in England*, 1954, rev. edn 1972

Halsted, John (ed.): *Romanticism*, 1969

Hardie, Martin: *Water-colour Painting in Britain*, II, *The Romantics*, 1967

Harvey, John: *Victorian Novelists and their Illustrators*, 1970

Hussey, Christopher: *The Picturesque*, 1927

Irwin, David: *English Neoclassical Art*, 1966

Klingender, Francis D., rev. Arthur Elton: *Art and the Industrial Revolution*, 1968

Lister, Raymond: *British Romantic Art*, 1973
Victorian Narrative Paintings, 1966

Maas, Jeremy: *Victorian Painters*, 1969

Paley, Morton D.: *Apocalypse Sublime*, 1986

Parris, Leslie: *Landscape in Britain c. 1750–1850*, 1973

Piper, David: *Painting in England 1500–1880*, 1960

Piper, John: *British Romantic Artists*, 1942

Praz, Mario: *The Romantic Agony* (1933), trans. Angus Davidson, 1954

Redgrave, Richard and Samuel: *A Century of Painters of the English School*, 1866

Reynolds, Graham: *Victorian Painting*, 1966

Sansom, Christopher: *Aurora's Glade*, Castle Cary, Somerset, 1968

Sitwell, Sacheverell: *Narrative Pictures*, 1937

Staley, A.: *Romantic Art in Britain 1760–1860*, Detroit and Philadelphia, 1968

Tate Gallery: *The Pre-Raphaelites*, 1984

Vaughan, William: *German Romanticism and English Art*, 1979

Wordsworth, Jonathan, Michael C. Jaye and Robert Woof: *William Wordsworth and the Age of English Romanticism*, 1987

Yorke, Malcolm: *The Spirit of Place: Nine Neo-Romantic Artists and their Times*, 1988

APR